A comprehensive study of the techniques of drawing, this is both a historical work, covering the period from the late Middle Ages to the present, and a useful manual for contemporary artists. It presents the old masters' techniques by means of a thorough study of the historical and written evidence of the tools and materials used. The author also includes a series of workshop procedures he has developed with which the contemporary artist may produce the equivalents of the techniques of earlier draughtsmen. This book comprises a body of knowledge which is essential to students of art history, curators, collectors, and artists, and is a significant addition to the literature on drawing.

In addition to his scholarly investigation of earlier practices, the author identifies materials and processes used by such important artists as Rembrandt, Van Gogh, Romney, Picasso, Michelangelo, Watteau, Holbein, Tiepolo, and Delacroix. For the artist interested in reproducing the effects achieved by these and many other acknowledged masters, there are full discussions and specific directions concerning the making of inks, styluses, reed and quill pens, fabricated chalks, and instructions for preparing grounds for metalpoint drawings. At every step, the discussion is supplemented with illustrations from laboratory experiments and from drawings by both old and contemporary artists. Of the more than sixty illustrations included,

Continued on back flap

tute Award for graphic arts, and the Wisconsin Salon Award for watercolor painting.

The craft of Old-Master drawings

D0762090

The craft
of Old-Master drawings

JAMES WATROUS

The University of Wisconsin Press

Madison, 1957

Published by the
University of Wisconsin Press
430 Sterling Court
Madison 6

Copyright © 1957 by the Regents of the University of Wisconsin
Copyright, Canada, 1957
Distributed in Canada by Burns and MacEachearn, Toronto

Library of Congress Catalog Card Number 56–9307 ✓

Manufactured in the United States of America

TO OSKAR HAGEN

Foreword

The critical re-evaluation of the technical resources of artists and artisans of the past, and the inventive use of materials and procedures new with the twentieth century are contemporary preoccupations of many professional people associated with the arts. The interest of art historians, curators and conservationists in technical matters can be attributed to their desire for both a more complete understanding of the masterworks which compose a large portion of our artistic heritage, and the devising of improved methods by which these great works may be preserved. On the other hand, the exploitation of modern materials and the re-evaluation of techniques of earlier masters by contemporary artists are stimulated by the desire to discover the technical resources, whatever they may be, which will most effectively assist them in attaining their goals of personal artistic expression. The adaptations of the old painting media of encaustic and egg tempera, the revitalization of woodcut and intaglio processes by graphic artists, and the interest of contemporary masters in designing for mosaic, stained glass, and tapestry are only a few examples indicative of the study and acceptance of old techniques as appropriate and sympathetic technical resources of modern art.

Both as a reflection and as a stimulation of these interests in art technology, there have been published—especially within the last two decades—an unprecedented number of works on technical subjects. It is the hope of the author that this volume will, in its presentation of historical and technical features of drawing media, make a contribution to this type of literature.

The technical studies which the author has undertaken during a decade were initially conceived after a reading of the impressive work, *Die Handzeichnung* by Joseph Meder, one time curator of the Albertina Collection in Vienna. The broad scope of his book, and particularly the section which presented a discussion of the media of drawing, provided a rich and unparalleled body of information for the student of old-master drawings. The very breadth of Meder's work, however, posed numerous questions, especially with reference to the sources and physical nature of the materials of drawing, their behavior during processing and during the act of

drawing, and the final effects which they displayed in finished works. Therefore, this volume places its principal emphases on the results of laboratory experiments and studio studies, and the critical evaluations of drawing materials and processes. In addition, it also introduces both new and corroborating historical data on old drawing techniques.

This work has been consciously written to present the craft of old-master drawings to contemporary artists, scholars, and students of drawings in the United States. Consequently, it contains special sections describing workshop procedures, lists sources of materials in this country, and uses, as examples of master drawings produced with given techniques, works which are in American collections. In these matters the author acknowledges that he was influenced by the requests of his artist friends and former students for a work which would be at once a critical and historical study of drawing techniques and a usable handbook. It is hoped that this effort may repay, in some degree, his indebtedness to the artists and students who collaborated with the author, through their use of many materials and recipes, in the determination of the characteristics and values of numerous media.

For their encouragement and generous help during the study of original drawings, I am grateful to Miss Agnes Mongan and Miss Helen Willard of the Fogg Museum, Miss Felice Stampfle of the Morgan Library, and various members of the staffs of the Cleveland Museum of Art, The Art Institute of Chicago, and the Metropolitan Museum of Art. I wish to express thanks to Mr. James K. Ufford of the Photographic Department of the Fogg Museum and Mr. David Dressen of the University of Wisconsin Photographic Laboratory for their preparation of microphotographs. And I gratefully acknowledge in the text the assistance of many others who have been helpful in these technical studies.

To the Research Committee of the Graduate School of the University of Wisconsin I am indebted for their expressions of confidence in this project through the awarding of grants on two occasions. And finally, I am appreciative of the generous assistance of Mr. Merrill C. Rueppel who suggested valuable changes in the organization of the manuscript.

J. W.

November, 1955

Contents

PART ONE
The fine drawing media

I *Metalpoint drawing* 3

TECHNICAL REQUISITES 10

PHYSICAL PROPERTIES OF STYLUSES

 AND GROUNDS 16

CHARACTERISTICS OF METALPOINT DRAWING 22

WORKSHOP PROCEDURES 24

II *Chiaroscuro drawings* 34

TOOLS AND MATERIALS 34

WORKSHOP PROCEDURES 40

III *Pen drawing* 44

QUILL PENS 44

REED PENS 52

METAL PENS 59

WORKSHOP PROCEDURES 62

IV *Inks for drawing* 66

BLACK CARBON INKS 67

IRON-GALL INKS 69

BISTRE INK 74

SEPIA INK 78

COLORED INKS AND WASHES 83

WORKSHOP PROCEDURES 86

Contents

PART TWO

The broad drawing media

V *Chalks, pastels, and crayons* 91
 NATURAL CHALKS 91
 FABRICATED CHALKS AND PASTELS 112
 CRAYONS 118
 WORKSHOP PROCEDURES 122

VI *Charcoal and graphite* 130
 CHARCOAL: SOURCES AND CHARACTERISTICS 130
 GRAPHITE 138
 WORKSHOP PROCEDURES 145

 APPENDIX 149
I *Commercial and noncommercial sources of materials* 149
2 *List of masterworks cited* 150

 REFERENCES AND NOTES 154

 INDEX 164

Illustrations

page

5 Perugino, "A Music-Making Angel"

7 Legros, "Head of a Man"

9 Tchelitchew, "Portrait of Nicolas Kopeikine"

11 Metalpoint styluses

15 Fig wood and boxwood

20 Microphotographic enlargement of a detail from Perugino's "Music-Making Angel"

21 Microphotographic enlargement of a detail from Kubota's "Young Girl"

23 Microphotographic enlargement of metalpoint strokes

25 Metals in usable forms for preparing styluses

27 Diagrams illustrating methods of making styluses

35 Burkert, "Warrior"

37 Moore, "Madonna and Child"

39 Degas, "Mounted Jockey"

41 Hans Leu the Younger, "Pietá"

45 Tiepolo, "Group of Female Figures Seated on a Cloud"

46 Microphotographic enlargement of pen strokes

47 Quills: Goose quill, crow quill, wild swan quill

48 Microphotographic enlargement of a detail from "A Triumphant General" (Venetian School)

49 Microphotographic enlargement of a detail from Rembrandt's "Three Studies of a Child and One of an Old Woman"

51 Rembrandt, "Nathan Admonishing David"

53 Matisse, "Crouching Nude"

54 Reeds from Holland, the United States, Japan, the Near East, India

55 Van Gogh, "Tree in a Meadow"

57 Grosz, "The Survivor"

59 Drawing of Perry's steel pens

61 Picasso, "A Reclining Female Nude"

63 Diagrams illustrating the cutting of quill pens

Illustrations

page

64 Diagrams illustrating the cutting of reed pens

71 Basic ingredients of iron-gall inks

75 Cambiaso, "Three Figures"

77 Romney, "Lady Hamilton as Ariadne"

79 Gericault, "An Artilleryman Leading His Horses into the Field"

81 Fragonard, "L'Invocation à l'Amour"

92 Microphotographic enlargement of chalk, charcoal, and crayon strokes

93 Microphotographic enlargement of chalk and crayon strokes

95 Earths from which natural chalks may be cut

97 Michelangelo, "Study for the Libyan Sibyl"

99 Watteau, "Sheet of Studies of Women"

101 Andrea del Sarto, "Study for the Figure of a Young Man"

102 Microphotographic enlargement of a detail from Watteau's "Six Studies of Heads"

103 Watteau, "Six Studies of Heads"

104 Microphotographic enlargement of a detail from Clouet's "Head of an Unknown Man"

105 Clouet, "Head of an Unknown Man"

107 Rembrandt, "The Mummers"

109 Watteau, "Head of Luigi Ricoboni"

111 Holbein the Younger, "Portrait of a Leper (so-called)"

113 Basic materials for binding media of fabricated chalks

114 Microphotographic enlargement of a detail from Degas' "Study for a Portrait of Diego Martelli" (Chalk)

115 Degas, "Study for a Portrait of Diego Martelli" (Chalk)

117 Degas, "After the Bath"

119 Basic materials for the binding media of crayons

120 Microphotographic enlargement of a detail from Greuze's "Seated Nude Woman"

121 Greuze, "A Seated Nude Woman"

123 Toulouse-Lautrec, "Yvette Guilbert"

131 Ingres, "Study for a Portrait of Madame d'Haussonville" (Graphite and Crayon)

133 Burgkmair, "Bearded Man Wearing a Turban"

134 Microphotographic enlargement of a detail from Degas' "Study for a Portrait of Diego Martelli" (Charcoal)

135 Degas, "Study for the Portrait of Diego Martelli" (Charcoal)

137 Ingres, "Study for a Portrait of Madame d'Haussonville" (Graphite)

139 Delacroix, "An Arab on Horseback Attacked by a Lion"

140 Microphotographic enlargement of a detail from Degas' "Study for the Portrait of Madame Julie Burtin"

141 Degas, "Study for the Portrait of Madame Julie Burtin"

143 Matisse, "Nude Study"

Tables

page

18 The effectiveness of different types of metalpoints on various grounds

72 Variations in iron-gall inks prepared from old recipes

84 Pigments and dyes available to draughtsmen

162 Results of experiments with recipes for fabricated chalks

The fine drawing media

Metalpoint drawing

Chiaroscuro drawings

Pen drawing

Inks for drawing

Metalpoint drawing

The literature of art and commerce, and especially the old manuscripts and manuals devoted to the techniques of the artist, indicated that metalpoint tools were styluses made from simple metals or alloys. Each of the metals, or their alloys, possessed different physical characteristics and, consequently, each metalpoint tool provided a different type of stroke although as a group these styluses produced lines of a homogeneous nature. Drawing with them under optimum conditions will demonstrate that more than any other group of drawing tools they sympathetically assist the artist who wishes to create drawings of delicacy and restraint.

Again and again the technical history of art indicates that materials adopted by artists for all types of masterworks had humble origins and uses, and that they frequently served other professions and trades. This is true of metalpoints. It is well known that medieval scribes used a metallic stylus as an accessory in preparing handscript texts and ornamentations on the vellum or parchment leaves of manuscripts. There, the stylus was used for ruling guides for the textual format, for proper spacing of the lines of the handscript letters, and for laying out preparatory delineations for the ornamental or pictorial illuminations. These functions, traces of which are still observable in some old manuscripts, were mentioned in sources such as that of Alexander Neckam, who, in the twelfth century, indicated that the scribe should have, in addition to various accouterments for writing, "a piece of lead and a ruler with which he may rule the margins on both sides."[1]

By the beginning of the fifteenth century, or possibly earlier, Italian merchants were using metalpoint booklets whose sheets were covered with a coating which Cennino Cennini described as being made from white lead and linseed oil.[2] This coating, or ground, was simply a technical aid for improving the strength of the metallic writing and was analogous to the grounds which artists adopted for their metalpoint drawing. The use of metalpoints in commerce seems to have paralleled metalpoint drawing for many centuries. De Mayerne, in the seventeenth century, described the preparations necessary for making writing tablets to be used with a silverpoint, and Joseph Meder has discussed extant account books, simi-

3

larly prepared, which date from the sixteenth and seventeenth centuries.[3] The frequency of this use of metallic styluses for accounts and writing is subject to conjecture. But it seems reasonable to infer from a statement in the colophon of the *Catholicon* of Johannus Balbus, that the practice had some currency. Published at Mainz in 1460, a very few years after the introduction of printing with movable type, the colophon proudly stated that the volume was produced by "a wonderful agreement, conformity, and precision of patrices and forms" rather than by the traditional handscript methods with "reed, stylus, or quill,"[4] and it thereby implied that metalpoints were of sufficient importance to warrant mention.

Indications of the use of metalpoints for artistic purposes, other than those mentioned in connection with manuscripts, were rare until the late fourteenth century, a period which can be associated with the early flourishing of drawing as an important art form. Therefore, instructions for the use of metalpoints by the monk Theophilus, written sometime during the tenth to twelfth centuries, were exceptional. In *Diversarum Artium Schedula* Theophilus wrote that preparatory designs for windows were delineated upon large boards or "tables" which had been rubbed with chalk. Over this surface one drew images with lead or tin. Moreover, in his directions for designing figures to be incised on ivory Theophilus recommended that the ivory tablet be covered with chalk, upon which one drew figures with a piece of lead.[5] These medieval "grounds" of chalk dust were antecedents of a rudimentary method of preparing metalpoint surfaces with the dust of bones, chalk, or white lead which was described by Cennino in the late fourteenth or early fifteenth century, and of a similar practice used during the seventeenth, eighteenth, and nineteenth centuries for quickly preparing a metalpoint ground for sketching outlines for miniatures or for writing on little ivory sheets.

It is impossible to determine when metalpoint media were first used for producing sketches and studies in the form and character we now assign to master drawings. But during the fourteenth century both Petrarch and Boccaccio mention drawing with the stylus. The former, in his sonnets to Laura, wrote of Simone (Martini) taking the likeness of his love with the metalpoint and the latter in the *Decamerone* expressed his admiration for the skill of the incomparable Giotto in the statement that there was nothing in nature which the master could not draw or paint with the stylus, pen, or brush. Although we may hesitate to accept these statements at face value, nevertheless they indicate that the metallic stylus was an accepted instrument for drawing by artists of the late middle ages.

Tested in both art and commerce, the metalpoints were widely used by artists of the late middle ages and the Renaissance. The unequivocal linearism and the limited but suggestive shading obtainable with the styluses

"A Music-Making Angel" by Pietro Perugino.—*Courtesy of The Fogg Art Museum, Harvard University (Gift of Mr. and Mrs. Robert Woods Bliss).* Silverpoint on a white ground.

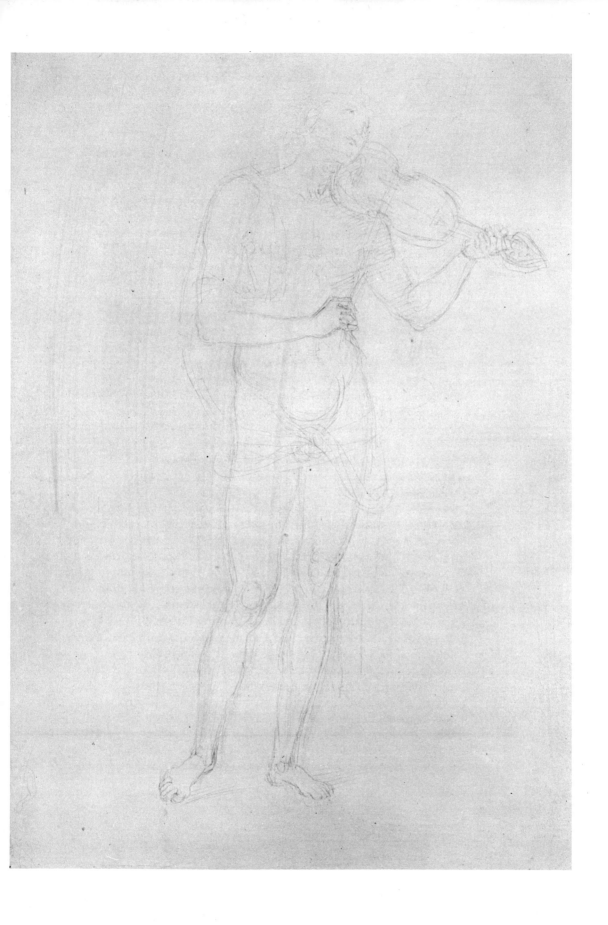

satisfied many of the artistic requirements of master draughtsmen both in the North and in Italy. Botticelli or Leonardo in the South, Petrus Christus or Gerard David in Flanders, Dürer or Cranach in Germany were representative of many artists, active in widely dispersed centers of art, who found the metalpoint media responsive both to the stylistic tastes of those epochs and to the diversity of individual expression. The linear-plastic type of draughtsmanship favored during those periods required drawing instruments which would permit the defining of precisely conceived images. And in retrospect, it appears almost inevitable that the metalpoints, because of the physical resources inherent in them, should have been among the most serviceable of drawing media in the workshops of the time.

However, like any given technical medium of the arts, the metalpoints did not possess unlimited adaptability, and therefore the masters of the sixteenth century, seeking artistic means and ends distinct from those of their predecessors, gradually began to neglect the metallic styluses in favor of drawing media which could, with greater expeditiousness, assist them in the creation of broader, bolder, and more spontaneously executed pictorial images. The characteristics of the fine linearism and lightly tinted grounds of metalpoint drawings were akin to the effects which the lean, cool medium of egg tempera contributed to the art of painting. And for a time, the flourishing of these two artistic media coincided. But as the aqueous paints of the late middle ages and early Renaissance gave way before a developing preference for oil media, their counterpart in drawing also was chosen less and less as artists began to seek broader, more illusionistic, and more painterly effects.

The knowledge and use of the metalpoints did not entirely disappear in the succeeding centuries. Although occasional references to styluses appeared in later literature, it is noteworthy that one of the last original sources which presented instructions for preparing metalpoint tools and grounds was the seventeenth-century manuscript of de Mayerne.[6] Similarly, among old master drawings, the metalpoint portrait of Rembrandt's beloved Saskia, drawn in 1633, attracts our attention because of the rarity of the use of this medium by Rembrandt or other masters of the century.

During the late seventeenth, the eighteenth, and most of the nineteenth centuries, the metalpoints lost much of their identity as drawing media in their own right and were reduced to the role of tools for laying-in the preliminary designs of miniature paintings. The reverse side of a print or drawing was rubbed with graphite, natural red chalk, or charcoal. This was then placed over a piece of parchment with a prepared ground on which the miniature was to be painted, and the outlines transferred by tracing the principal lines with a stylus. A variation was to prick tiny holes along the outlines of the original drawing or print and transfer the design

"Head of a Man" by Alphonse Legros.—*Courtesy of the Metropolitan Museum of Art*. Silverpoint on a white ground.

6

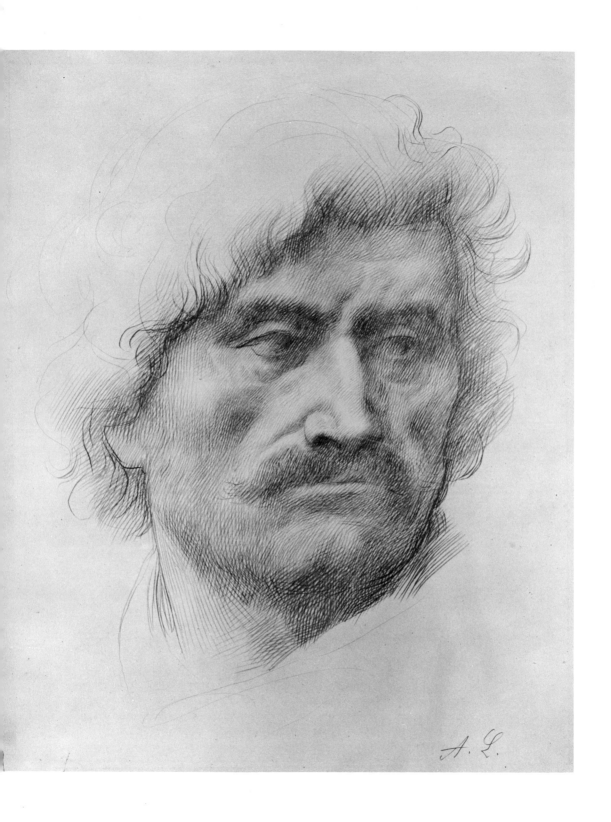

by pouncing charcoal dust onto the parchment surface beneath. In both methods the images were subsequently strengthened with a silverpoint.[7] Metalpoints of lead, copper, silver or gold were considered good substitutes for French or English graphite pencils if the miniature was to be completed on ivory, parchment or a coated paper [*papier plâtre*].[8] Meanwhile, to a modest degree, their use for writing continued into the nineteenth century, particularly for day-to-day memoranda on bone tablets, ivory slips, or especially prepared papers.[9] But in the later decades conservative artists of draughtsman-like tastes brought about a modest revival of metalpoint drawing, especially in England. Perhaps the use of metalpoints of gold and silver by Muirhead Bone, Sir Frederick Leighton, Alphonse Legros, and William Strang was in part influenced by the publication, from the middle of the century on, of numerous late medieval and Renaissance manuscripts on art techniques, and an awareness that the styluses had been a favored medium of drawings for famous artists of the past. Drawings by Strang on pink-colored grounds, such as his "Nude Study of a Girl, Seated," appear to be an echo of the preferences for tinted grounds by many Renaissance masters. And it is possible that the publication of old recipes led some of these artists to prepare their own metalpoint papers, as was the case of Legros in two "Studies for the Portrait of Edward D. Adams," where obvious brush strokes and pellets of undissolved pigment reveal that the papers were not commercially produced but received their coatings in the studio of the artist. Despite the use of metalpoints by the above draughtsmen and the fact that there developed a sufficient demand by artists for silverpoints kits to warrant their production by Winsor and Newton, Ltd., in the 1890's,[10] Hamerton in *The Graphic Arts* ventured the opinion that only two or three people in Europe knew how to use silverpoint.[11] And the nineteenth-century conception of the silver stylus as an antique and perhaps somewhat esoteric drawing medium seems to be reflected in Robert Browning's "One Word More," written at London during September, 1855:

> Rafael made a century of sonnets,
> Made and wrote them in a certain volume
> Dinted with the silver-pointed pencil
> Else he only used to draw Madonnas:
> These, the world might view—but one, the volume.

In our day the knowledge of the distinguished history of drawing with metalpoints, and even of their very existence, is limited to some art historians, curators, and a few practicing artists. Although this is not surprising when we reflect upon their continuous decline in importance from the sixteenth to the end of the nineteenth century, nevertheless, it seems a

"Portrait of Nicolas Kopeikine" by Pavel Tchelitchew.—*Courtesy of The Fogg Art Museum, Harvard University (The Meta and Paul J. Sachs Collection)*. Silverpoint on a white ground, with a few accents added with a graphite pencil.

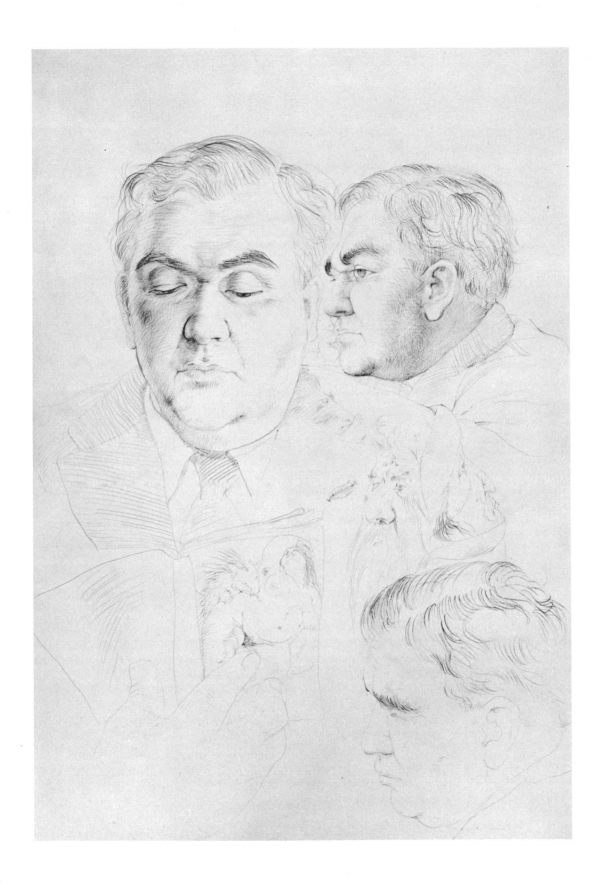

pity that they are not more widely recognized, especially among contemporary artists whose tastes indicate a disposition toward delicate calligraphy. The occasions when metalpoints are used are still rare, although one may find metalpoint drawings by a few well-known contemporary artists. Otto Dix, whose "Head of a Child" (1935) was produced on a white ground, has indicated to the author that he began drawing with silverpoint in 1925. Pavel Tchelitchew's "Portrait of Nicolas Kopeikine" (1937) and his "Portrait of Frederick Ashton" (1938) are both delicately drawn silverpoints on white grounds, the former having a few accents added with a graphite pencil. They are representative of numerous drawings created by the artist with silverpoint and which Kirstein's catalogue of Tchelitchew's drawings indicates were largely completed during the years 1936–38.[12] Bernard Perlin's "Landscape with Tree" and "Beggar" (1942) are both silverpoint studies on white grounds, as is "Seated Female Nude" (1942) by Paul Cadmus, although the strokes of this last drawing have not completely changed their coloration to the brown typical of silverpoint lines.

Technical requisites Metalpoint drawing has two major technical requisites: the tool or metallic stylus, with which the artist draws, and a surfacing or ground which is brushed over a carrier of paper, parchment, or other material.

Metalpoint tools We know that earlier artists had drawing points made from a wide variety of metallic substances. These were silver, gold, copper, lead, tin, the alloys brass and bronze, and alloys—perhaps less familiar to artists—of lead-tin and of lead-bismuth. The many references to the metals and alloys used for drawing found in manuscripts, manuals, encyclopedias, and general literature would form a long and repetitious list. The following will serve for a synoptic and suggestive chronology.

> Lead, tin: Theophilus, tenth to twelfth century (Theobald, p. 37)
> Silver, bronze, brass, copper: Alcerius, 1398 (Merrifield, I, 274 ff.)
> Silver, lead, lead-tin: Cennino, late fourteenth or early fifteenth century (Thompson, *The Craftsman's Handbook,* pp. 5, 7, 100)
> Silver, lead: The Anonimo, 1530 (Frimmel, p. 108)
> Silver, lead-tin: Borghini, 1584 (ed. of 1826, p. 115)
> Lead, lead-tin, lead-bismith; also for writing, gold, silver, copper, brass: De Mayerne, 1620–46 (Berger, IV, 153, 155, 177)
> Lead-tin, silver: Baldinucci, 1681 (p. 158)
> Silver: *L'Ecole de la mignature,* 1759 (Ch. IV, pp. 4, 7)
> Silver, lead, copper, gold: Constant-Viguier, 1830 (p. 66)

At one time or another all of these metals or alloys were widely used for commercial purposes or for art-metal crafts, and therefore were available to draughtsmen for making drawing styluses or for having them made by the metalsmiths. Although any one of the metals or alloys would have served for making an entire tool, a number of sources reveal that the shafts were not always made of the same metal as that used for the drawing tip. In one

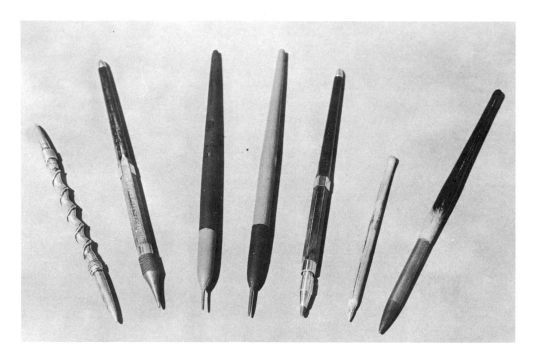

Metalpoint styluses. *Left to right:* Silverpoint cast in the form of Mabuse's stylus; commercially produced stylus with tapered brass nut and tip of silver; brasspoint; copperpoint; leadpoint with lead slip inserted in modern mechanical pencil; lead-tin stylus cast in reed shaft; lead-bismuth stylus cast in a brass tube.

instance, Cennino suggested that an artist could make a shaft of any metal if the tip were of silver.[13] This type of construction may be seen in a painting of St. Luke drawing the likeness of the Virgin by the Flemish master Roger van der Weyden (Boston Museum of Fine Arts). The various parts of the stylus which St. Luke holds are divided by shades of ochre-brown in order to simulate the color of brass or bronze for the shaft and an off-white color to feign the silver of the two drawing tips, one at each end. Styluses of varied shapes and construction were described by Meder who also reproduced the diagrams of metalpoint tools found in the notebooks of Hans Baldung and Hans Kranach, and a few extant examples with which he was familiar.[14]

The form of the styluses used for writing or drawing admitted of variations subject to the conveniences of manufacture and the nature of the metals or alloys. When Cennino stated that one could prepare a stylus from "two parts lead and one part tin, well beaten with a hammer," he was describing a rude method of shaping a soft alloy into a tool for drawing.[15] De Mayerne commented on the procedure of the Dutch artist Retermond, who proposed that the leftover meltings of window lead could be shaped into a leadpoint with a knife.[16] Mitchell stated that the metallic "pencils" used for writing in the eighteenth century were made by casting lead or lead alloys into rods which were then wrapped in paper holders.[17] And metallic "pencils" of the nineteenth century had tips which were

fitted into wooden shafts of cylindrical shapes. A number of years ago the author obtained a silverpoint of modern English manufacture. Its shaft was made of bakelite onto which was screwed a knurled and tapered nut of brass. Fitted into the end of the tapered brass nut was a short tip or point of silver—a type of construction basically like that of the stylus depicted by Roger van der Weyden. Metalpoint tools are no longer commercially produced and the declining demand led Winsor and Newton to the abandonment of their manufacture—and also that of silverpoint papers—after the first world war.

Some of the metalpoint tools were more than simple styluses. Those represented in the paintings of van der Weyden and Mabuse's "St. Luke Drawing the Madonna" (Vienna Court Museum) were reversible, with a drawing point at each end. The advantage of this arrangement is a matter of conjecture, but it is probable that the tapering of both ends was preferred because of a better balance in the artist's hand and a doubled life expectancy for the tool. Nowadays we are so concerned with the utility of our equipment that it is intriguing to find that the old metalpoints were sometimes very ornate. The styluses represented in the painting of Mabuse or the diagrams of Hans Kranach have twisted and ornamented shafts, and Meder has illustrated or described several highly embellished tools, including one which bore, at the end opposite the drawing tip, a miniature figure of the Virgin Mary.[18] The willingness of some old masters to expend time and craftsmanship in order that their metalpoints mights be endowed with a decorative flourish having no bearing upon utility, must have been stimulated in part by artistic taste and in part by the knowledge that metalpoint tools were studio possessions which would wear for years.

The frequent mention of silver in all types of historical literature suggests that it was the preferred metal. Moreover, the high value placed upon a silver stylus was clearly stated by Alcerius who observed that one could draw with "a stile of brass, or bronze, or copper, or still better, of silver."[19] It is doubtful that any condition of availability of the metal would have had much to do with these expressions of preference for silver. Rather they must have been qualitative judgments, which also can be endorsed by anyone who has drawn with the various metals or alloys.

Grounds and carriers

In addition to a metallic stylus, another important requisite was the expressly prepared surfacing or ground upon which the image was drawn. Usually these grounds were made of ingredients which permit them to be called aqueous paints, although linseed oil was sometimes used as a binding medium. The materials of which the grounds were composed and the even textures produced by polishing their surfaces were superficially similar to those of a gesso ground, a more familiar surfacing material used by artists to prime painting panels or canvases. In a liquid state these grounds were brushed over structures or carriers of paper, parchment, vellum, wood, or cloth. Paper and parchment were the most widely used carriers, although there are a few extant metalpoint drawings on boxwood. Fig-

wood was also recommended by Cennino and Borghini, and Alcerius included the use of *sindone,* a fine cloth, probably in this case one of linen.[20]

Although styluses of lead or lead alloys will leave marks on unsurfaced papers or parchment, the metalpoints made of gold, silver, or brass will not mark without some form of ground. Therefore, expressly prepared metalpoint grounds were necessary for most of the old metalpoint drawings and for producing more distinct and attractive strokes with lead or lead alloy tools. Moreover, for any of the metalpoints, a fine ground had the attractions of reducing the uneven surface of a carrier and, by its smoother surface, increasing the probability that the strokes would not be interrupted by rough texture or grain.

Early recipes indicated that the principal dry ingredients for the preparation of these grounds were white lead or bone dust—or a combination of the two—with occasional additions of dry pigments. Materials used with less frequency included the scrapings of sea shells and uncalcined eggshells.

A variety of bones were used. Cennino wrote of the second joints of fowls or the thigh bone of a gelded lamb, while Borghini mentioned the legs of fowls and the shoulders of geldings.[21] Alcerius observed that "if you have no stag's-horn, the bones of the stag are good, and also those of any other animal or bird."[22] And de Mayerne added that the sources of these cheap white pigments were the bones of horses, swine and sheep and the horns of goats and stags.[23] It is possible that the last was the most prized source of bone dust for Dossie remarked that of the bone whites used in painting hartshorn was the finest.[24] Bone dusts must have been familiar substances in artistic circles, because in addition to their employment in drawing and painting those made from the leg bones of horses, donkeys, and mules were described by Biringuccio, the Renaissance metallurgist, as useful for the processing of other types of art objects such as the preparation of fine coatings over the molds used in the casting of small bronzes.[25]

The bones were burned until they became very white and friable. Then the fragments were ground down with water in order to make a fine dust. Sea shells[26] and eggshells[27] were processed without calcination. The latter had their membranes removed before grinding[28] or were soaked in vinegar for three or four days before being washed and pulverized.[29] Despite the different methods of processing, all of the above substances are similar, being principally either calcium carbonate or calcium phosphate.

In order to establish the relative merits of the ingredients cited in the old recipes for metalpoint grounds, and to determine their behavior during processing, experimental grounds were prepared for testing purposes. In addition, grounds made with the modern dry pigments, zinc and titanium whites, were also compared. Grounds made with these substances displayed distinct characteristics. During the preparation of the mixtures, bone dust, eggshells, and calcite had the unfortunate tendency to disperse unevenly in the liquid binder, to sink instantly to the bottom of the mixing pots like grains of sand, and to pile up when brushed over the carrier.

In coloration, the zinc, titanium, and white lead pigments produced bril-

liant white grounds while pulverized calcite and eggshells gave a warm cast to the coatings, and bone dust displayed a warm, gray tint. Bone dust and eggshells, despite long grinding of the particles, produced grounds which were rough and horny in texture. Consequently, they required extensive burnishing with an agate burnisher before metalpoint strokes could be made with any satisfaction. The necessity for burnishing bone-dust grounds is substantiated in the comments of both Cennino and Alcerius, the latter instructing the artist to use "a boar's tooth, or a hard and polished stone, or any other instrument fit for burnishing." This requisite of burnishing, however, has its dangers because extensive polishing will toughen the surfaces to such a degree that the metalpoint tool will be resisted by the grounds and the strokes made with difficulty, a feature recognized by both Cennino and Alcerius.[30] This hardening of the ground may in part explain the fact that some old metalpoint drawings were executed with such pressure on the stylus that depressions in the grounds coincide with the metallic strokes.

Of all the old materials, white lead produced the smoothest and most receptive surface for metalpoints—a circumstance which probably accounts for Cennino's suggestion that a white lead coating may be laid over undercoats made of bone dust. Similar in their fine texture and excellent receptivity to the drawing tools were the grounds produced with zinc and titanium whites, and the permanence of these modern pigments, when contrasted with white lead, makes them the most desirable and most easily processed ingredients for metalpoint surfaces.

Meder observed that with increasing frequency, as the Renaissance advanced, drawings were produced with thin grounds which were casually swiped over the carriers in the manner of Perugino's "Music-Making Angel" where the quickly stroked coating does not entirely obscure a preliminary sketch underneath, or that of "Two Male Figures" by Filippino Lippi in which the pink ground is so lacking in body that the underlying texture of the paper retains a pronounced topography.[31]

The pale tints of many metalpoint grounds of the fifteenth and early sixteenth centuries were made by mixing small portions of colored dry pigments with the basic white. To have used any of a great number of colored pigments alone would have been unsatisfactory for several reasons. Some dry pigments are inherently transparent, as for example terre verte, and need white to increase the covering power necessary to obscure the surface of the carrier. Other pigments, unmixed, have a chromatic strength so great and an intrinsic value so dark that metalpoint strokes are overpowered by the color, obscured by the darks, or can be seen only by their metallic reflections when held obliquely to a source of light. Moreover, so many pigments, especially the colored earths commonly used in paintings of the late middle ages and Renaissance, are inferior substances for the transfer of metallic strokes from the styluses. Often an increase in the proportions of these pigments used in a mixture decreases the qualities associated with an optimum ground for drawing.

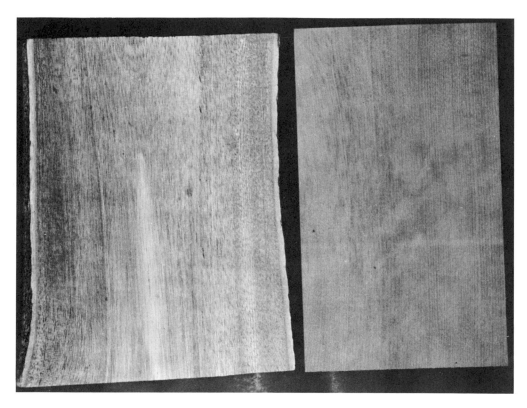

Fig wood (*left*); boxwood (*right*).—*Courtesy of the U.S. Forest Products Laboratory, Madison, Wisconsin.*

The most elaborate directions for the preparation of tinted grounds were those of Cennino. However, despite his extensive recipes, one discovers that his directions and proportions were couched in vague although picturesque terms. It is impossible to reconstruct these mixtures accurately because he gave such amounts as "a half a nut of terre verte," "a bean of bone dust," "a leaf of druggists' glue," or "as much clear, clean water as two common goblets will hold."[32] Nevertheless, Cennino and others provided the basic information from which old methods can be understood and reconstructed.

After the white and colored pigments were thoroughly ground, they were incorporated into the chosen liquid binding medium. The old recipes mentioned glue water, gum water, linseed oil, or saliva. The best glue waters were made by soaking parchment clippings, glove leather, or similar skins. Gum water was usually prepared from gum arabic (the exudation of the acacia tree), although other gums were occasionally used in making these waters, especially the gums of the cherry and plum trees. Saliva was hardly a binder of strength, and it must have been used to make a metalpoint ground for a most impermanent sort of sketching. The old treatises also indicated that the resulting aqueous or oil ground was to be applied to the carrier with as few as one or two coats,[33] or as many as nine![34]

15

Cennino described another, but inferior, method of preparing a surface so that metalpoint strokes would register. Pulverized bone was dusted over the carrier and the excess brushed away with a hare's foot.[35] This method, although it was probably a simple adaptation of the scribes' practice of rubbing chalk dust over parchment or vellum manuscript leaves in order to cut the oiliness of the skins before writing with pen and ink, was similar to that proposed by Theophilus for ivory. And today one must still rub a pinch of dry white pigment over surfaces of ivory or obtain the modern commercially produced ivory leaves for miniature work which come with a fine white dust on the working surfaces.

The recommendations of fig wood (*Ficus carica*) or boxwood (*Buxus sempervirens* L.) as carriers were expressions of a preference for woods of exceedingly fine textures, the latter having as high as 25,000 pores per square inch.[36] Despite the use of these woods, extant examples are very rare, and the little booklet of drawings on wooden leaves in the Pierpont Morgan Library assigned to an anonymous Franco-Flemish artist of the fourteenth century or those in the Berlin Staatliche Bibliothek attributed to the fifteenth-century master Jacques Daliwe[37] are very exceptional.

Boxwood leaves, cut plankwise and dressed to a thickness of approximately one-eighth inch, make excellent carriers after sanding and polishing, and they may be drawn upon and regrounded indefinitely. Because of their smoothness and long-term utility, one can understand why Cennino recommended the use of wood carriers for apprentices whose trial ventures in drawing were to be expunged in order to permit succeeding studies.

The hides of sheep and calf, which had been used for centuries as the pages of manuscripts, or the leaves of pattern-books, became durable carriers for metalpoint grounds. The surfaces of well-dressed parchment or vellum are light in color and value, of an even texture, and may be coated with grounds without difficulty. Although metalpoint drawings on skin carriers seem to have been produced with greater frequency than those over wood, neither was as commonly used as was paper.

Physical properties of styluses and grounds

Among the metals formerly used for drawing, one notes many differences such as the softness of lead, the harshness of tin, and the brittleness of bismuth. Lead, and the alloys bearing a high percentage of lead, will produce strokes whose appearance more nearly approximates that of a "medium soft" graphite pencil than the marks of any of the other metallic styluses. This relative similarity is caused by an obvious shininess and "coarseness" of line, and by a suggestion of greasiness. The last, a characteristic of graphite, is most noticeable during the act of drawing when the slight viscousness of the lead is felt. Despite these similarities the differences between graphite and leadpoint lines can be distinguished without too much difficulty, and under a microscope one finds that a leadpoint produces a more striated stroke and leaves more eccentrically deposited particles than does graphite. Although the old literature had numerous references to the use of lead styluses, an unalloyed lead, when tapered to

a point, is too pliant for real satisfaction in drawing. The lead tip will become blunt very quickly under the most modest pressure, and worse, a fine point of lead will bend into an ungainly shape.

Tin, because of its harshness, will leave acceptable strokes only on grounds which have a toughness from the use of a high content of glue. Its tendency to score soft grounds, leaving incisions with powdered edges, or to produce light strokes on normal grounds, affords little justification for its recommendation. On the other hand, the alloy of two parts lead and one part of tin mentioned by Cennino and de Mayerne, and drawing points made of equal parts of lead and tin, as cited by the latter, will minimize the unattractive features which exist when either of the parent metals is used alone.[38] These simple alloys were not restricted to the metalpoints; they had other important uses, for example the preparation of solder described by Theophilus and by Biringuccio in his *De La Pirotechnia* of 1540.[39]

Bismuth, a metal identified by Basil Valentine in 1450, will make a clean, strong stroke on a good ground. De Mayerne, although he gave no proportions, suggested that it be fused with lead, and in amounts of one part bismuth to one part lead this alloy makes a stylus of excellence, although the point wears down, like those of the lead-tin alloys, more readily than one would wish.[40] Unusual as they may seem in association with the art of drawing, the alloys of lead-tin and lead-bismuth, and the alloys of similar fusible metals, were common in their many uses. In the eighteenth and nineteenth centuries metallic "pencils" for writing were manufactured with such alloys and one suspects that the leadpoint (*Bleigriffel*) writing instrument of about 1830 discussed by Meder was one containing bismuth similar to those described by Mitchell and Buchwald.[41] Moreover, because of their low melting points the bismuth alloys had numerous commercial uses, such as the casting of metal toys and trinkets.

The alloys of brass (copper and zinc) and bronze (copper and tin) make satisfactory drawing styluses. Exactly what their composition may have been at the time when they were mentioned as metalpoints is difficult to judge. And Biringuccio, from whom we might have expected the most precise information, did not propose any proportions in his description of the processing of brass from copper and calamine (zinc carbonate).[42]

Bronze is usually considered to be a copper-tin alloy, but it too may vary greatly in its proportions or in the metals introduced. Modern bronzes, such as those used for casting sculpture or other art objects, may have proportions of copper to tin ranging from 28:1 to 90:1 with frequent additions of lead and zinc. During the Renaissance similar variations occurred in the proportions and nature of the metals chosen for making the bronze alloys. Biringuccio, in his chapter entitled "Concerning Bronze and Mixed or Alloyed Metals in General" wrote: "Some, for less expense, put in some lead. Thus, this compound material of copper with tin and brass or lead is called bronze . . . [the zinc entering the alloy through the addition of the brass]. Another kind of composition is made from copper, which is called 'metal' just as the other is called bronze. Nor is it other than bronze, but it

changes its name into this general term in accordance with the greater or lesser amount of tin that it contains."[43] Therefore, the references to bronze or brass drawing styluses in the treatises of the late middle ages and Renaissance should be interpreted as broad designations of alloys having substantial amounts of copper.

Bronze and brass, by their nature, must be alloys and we recognize that when we use the terms. On the other hand, because gold and silver can be pure metals, we are apt to disregard the fact that for any utility in metalwork they must be alloyed with other metals in order to reduce the softness which they possess in pure or near pure states. Pure gold is indicated as 24-carat, while the more usable alloys such as 18K or 14K are 75 per cent and approximately 58 per cent respectively; the other metals in the alloy usually are copper or silver. Silver requires copper in order to obtain a desirable hardness, as in the case of sterling silver which has 7.5 per cent copper, or silver for coinage which may contain 10 per cent or more of copper. The metals in these alloys correspond to those introduced by Biringuccio, although he gave no fixed proportions, and broadly stated that "if half the value is surpassed it is no longer called silver but copper containing silver, as I told you of gold."[44]

Over a number of years my students, colleagues, and I developed preferences for certain metalpoint styluses and grounds, partly because of personal tastes, but also as a result of comparative tests. One of these tests was designed to observe the results obtained when metalpoint strokes initially were made. The evidence obtained from the processing and use of combinations of noble and base metal alloys and prepared grounds clearly demonstrated a diversity of characteristics. In addition to the metals and white pigments mentioned in the old literature, zinc and titanium whites were also tested, being pigments of widespread use in our time although unknown to artists before the end of the eighteenth and the twentieth centuries, respectively.

The qualities of the strokes obtained from combinations of grounds and styluses were judged by the strength, the smoothness, and the continuity of the lines, and the ease with which the metalpoints glided over the surfaces during the act of drawing. Although the evaluations presented in Table I would require some adjustments if the compositions of the alloys were modified or the kinds and amounts of the binding media used in the preparation of the grounds were changed, nevertheless, the judgments are generally indicative of the relative virtues of the styluses and grounds.

Since it is a matter of surprise to some people, it should be mentioned that all metalpoint strokes when first made appear gray regardless of the color differences usually associated with the light grays of silver, tin, bismuth, and lead, or the yellowish browns of gold, copper, bronze, and brass. Moreover, metals which are light in appearance when in the form of solid pieces, such as silver, tin, bismuth, and gold, instantly produce strokes which are darker in value.

Some metals and their alloys undergo coloristic changes or become lighter or darker when exposed to the air at ordinary temperatures.

18

TABLE I

The effectiveness of different types of metalpoints on various grounds

The grounds and their ingredients	The metalpoints and their composition										
	Silver (sterling)	Gold (14K)	Copper	Lead	Tin	2 parts Lead to 1 part Tin	1 part Lead to 1 part Bismuth	Bismuth	Brass (approx. 70% Copper, 30% Zinc)	Bronze (96% Copper, 4% Tin)	Bronze† (90% Copper, 5% Tin, 5% Lead)
3 measures glue water* mixed with 2 measures zinc	Excellent	Excellent	Good	Fair	Fair	Good	Good	Good	Good	Good	Good
3 measures glue water mixed with 2 measures titanium white	Excellent	Excellent	Excellent	Fair	Fair	Good	Good	Excellent	Excellent	Excellent	Excellent
6 measures glue water mixed with 5 measures bone dust	Good	Good	Poor	Fair	Fair	Fair	Good	Fair	Fair	Fair	Fair
1 measure glue water mixed with 1 measure calcite	Good	Fair	Fair	Good	Poor	Fair	Fair	Fair	Fair	Fair	Fair
6 measures glue water mixed with 5 measures pulverized eggshells	Fair	Poor	Fair	Poor	Poor	Poor	Fair	Poor	Poor	Poor	Poor
linseed oil and white lead mixed to a paste	Good	Good	Poor	Poor	Fair	Fair	Good	Good	Poor	Fair	Fair

* The glue water was prepared with 1 ounce of rabbit-skin glue to 25 ounces of water.

† This leaded bronze, in the opinion of Dr. David Mack, of the University of Wisconsin Department of Mining and Metallurgy, may more nearly resemble many of the old bronzes than it does most modern bronzes. However, the strokes produced with it did not differ noticeably from those of other bronzes.

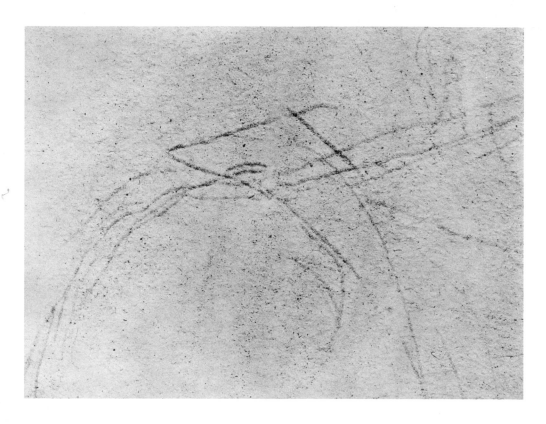

Microphotographic enlargement of a detail from "A Music-Making Angel"
by Perugino (see p. 5). Silverpoint.

Silver. The formation of silver sulphide will produce a brown color and a
 darker value.
Gold. No change should occur except with heavily alloyed golds.
Lead. The formation of basic lead carbonate will make lead appear more
 bluish and darker. Dr. David Mack has suggested that many of the old
 leads, being less pure, would probably have had less tendency to turn
 bluish.
Tin. The formation of tin salts would sustain the light value of the metal.
Bismuth. Usually this metal will not tarnish in normal atmospheric condi-
 tions. It might darken under conditions of extreme atmospheric pollu-
 tion.
Copper. The formation of basic copper carbonate produces the familiar
 greenish patina.
Brass. The light gray tarnish of zinc would tend to modify the greenish
 patina of the copper.
Bronze. The light gray tin salts would tend to modify the greenish pa-
 tina of the copper.

So too the strokes made with some of the metallic styluses will be sub-
ject to color and light-dark value transformations. However, one should
not suppose that changes occurring on the surfaces of solid pieces of metals

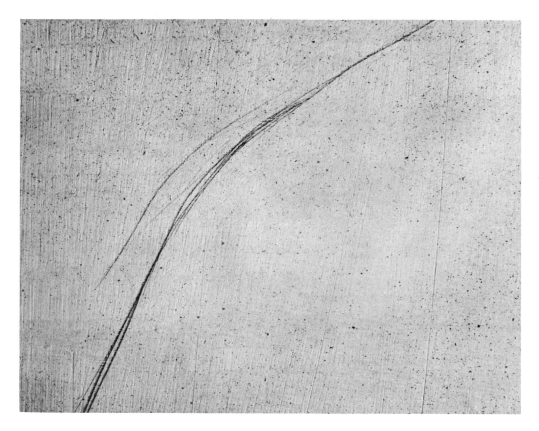

Microphotographic enlargement of a detail from "Young Girl" by Jean Kubota.—*Department of Art History, University of Wisconsin.* Silverpoint on an unburnished white ground prepared with zinc white dry pigment and rabbit-skin glue solution.

or alloys would be precisely similar in appearance to those produced in the "thin" metalpoint strokes after the latter have had extensive exposure to the atmosphere.

In view of the fact that all metalpoint strokes originally appear gray to dark gray, the following changes which were observed in a set of test strokes exposed for four years were, in some cases, quite pronounced.

Silverpoint strokes turned brown and became lighter in value.
Copperpoint strokes turned yellowish and became lighter in value. On a
 titanium white ground they became very yellowish.
Brasspoint strokes turned grayish-yellow and became lighter in value. On
 a titanium white ground they became very yellowish.
Bronzepoint strokes turned warm gray and became lighter in value. On a
 titanium white ground they became yellowish.
Lead and the lead alloys (with tin or bismuth) displayed no observable
 color or value changes.

In addition to the above transformations, one can observe in strokes of silver, copper, brass, and bronze a gradually developing appearance of

transparency. This tends to create the effect of very delicate light brown or yellowish lines, especially when the drawings are produced on white grounds which give the greatest opportunity for these effects.

In books, catalogues and periodicals, one encounters, more often than one would wish, the thoughtless and erroneous designation "silverpoint" applied to drawings made with other types of metalpoints. Sometimes this occurs with reference to drawings which have no hint of warm color in their lines, and obviously were not produced with a silver stylus. On the other hand, one should not instantly conclude that a drawing displaying warm colored strokes is a silverpoint and thus dismiss the possibility that it might have been made with a copper, brass, or bronze stylus, despite the evidence that these were used less frequently by old masters. The color tints of the grounds also may present complicating features, as in cases where warm pigments, such as yellow ochre, were added. Under these circumstances a casual glance gives the impression that the strokes are grayish, and it may require careful examination to sense the warm brown of silverpoint lines.

It is impossible to predict how swiftly changes in coloration will occur in strokes of silver, copper, brass, or bronze. Drawings produced with these metalpoints, when placed under glass, have retained the original grayness of their strokes for as long as two years; but when removed and exposed to our city atmosphere they have changed their colors within a month or two. The pollution of city air, by coal smoke among other things, undoubtedly hastens the transformation.

The manner in which a finely dispersed metallic stroke will be transferred from the stylus can be observed by a modest experiment. A single brush stroke of ground mixture can be swiped over a portion of a sheet of paper. When this is dry, a metalpoint of the type which will not mark on ungrounded papers, such as silverpoint, may be drawn uninterruptedly across both the exposed and the covered parts of the paper. A light scoring, which is the only effect the tool produces on the uncoated portion, changes quickly to a distinct metallic line as the stylus passes into the area where the ground is concentrated.

Although metalpoints and grounds may appear somewhat esoteric because they are so little known today and have been usually associated with the periods of the late middle ages and Renaissance, nevertheless, they have their commonplace counterparts on every hand. The interior walls of our houses and buildings, if painted with a good oil-base paint, are very receptive to metallic styluses. In fact, on such surfaces the contents of one's purse or pocket—pennies, dimes, and keys—although hardly attractive drawing instruments, will produce quite strong strokes.

Characteristics of metalpoint drawing

Each drawing medium of the artist, differing from all others in its physical properties, reveals distinct characteristics in the effects it produces during the creative act of drawing. If this were not so artists would use a single, hypothetical tool, with convenience as the only consideration for its selection. But just as a perceptive painter, sculptor, or architect is sen-

22

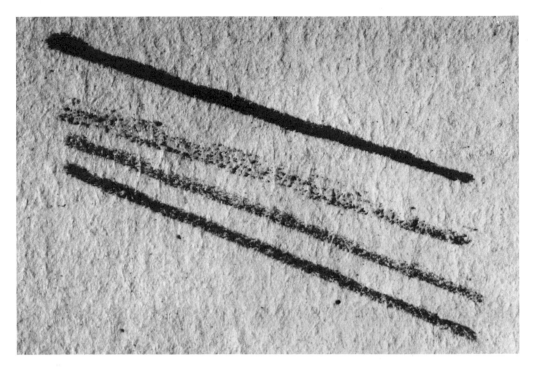

Microphotographic enlargement showing the differences in density and texture of various tools when used on paper without prepared ground. *Top to bottom:* Modern graphite pencil (Venus—Velvet 3557); leadpoint; lead-tin point; lead-bismuth point.

sitive to the resources peculiar to any given material, so too the artist-draughtsman will discover the various resources which the drawing media provide. It is justifiable to generalize that there are conditions affecting the creation of a beautiful drawing wherein it would be preferable to select a given tool rather than to favor another; and that an artist who exercises such selective discrimination contributes one more positive factor toward the probability of success in attaining the quality of drawing which his artistic conception requires. Therefore, there are times when an artist may happily choose metalpoint styluses and grounds in preference to all other drawing media, because they provide the possibility of effects which could not be obtained otherwise. The truth of this can be seen, historically, in drawings of the old masters; or it may be discovered by the creative artist through acquaintance with the metalpoint media. Although one cannot define the particular conditions under which an artist might select metalpoints rather than other drawing instruments, nevertheless, one can suggest the general province of drawing wherein, aesthetically and stylistically, their resources become very attractive to the artist.

Within the maximum value range from white to black, the metalpoints produce strokes which are relatively light. No amount of pressure by the artist's hand, even when using the lead or lead alloys which provide the darkest of metallic strokes, will produce a black line. Moreover, as has

Light-dark value range

23

already been mentioned, the strokes of several of the metalpoints become lighter in value as they turn brown or yellowish in color. Therefore, the styluses perform most handsomely when delicate effects rather than bold or powerful strokes are requisites of drawing.

Flexibility of line Probably no group of drawing media provides less flexibility within lines where contrasting variations of thickness and thinness may be sought. Although minor differences in the width of a stroke may be achieved through pressure on the stylus, they are negligible when compared to those possible with many other drawing tools. And although it is possible, in order to make wider strokes, to draw with the side of the metallic point, the effects which one may assume are being sought by such a manipulation can be obtained with more ease and authority in other media. On the other hand, the constancy of the metalpoint lines, and the preciseness and lightness of the strokes, provide the artist with means of creating an impression of great linear purity in his drawings.

Textural substance Metalpoint strokes have little textural substance—even less than those made with a moderately hard graphite pencil. The almost imperceptible topography of the finely dispersed metal, when compared with the friable particles of soft graphite, chalks, or charcoal, appears to the eye like a thin metallic ribbon pressed onto a flat, polished surface. Consequently, it has little suggestion of the three-dimensional texture which occurs in other drawing media because of the crumbling particles of their pigments, the open areas within their strokes, or the ragged edges of their lines. On smooth metalpoint grounds, delicate strokes will appear like fine metallic traces, and can provide a gentle elegance of linearism, or restrained and half-fulfilled modeling, in drawings which are intentionally gracious.

Scale The metalpoints are among those media which possess limited value range, relative inflexibility of line, and scant textural substance in such degrees that they serve best for the creation of drawings of small scale— drawings which invite examination at close range and are enjoyed for the delicacy of their minute details. To enlarge metalpoint images or compound their number over a widely extended area of a large drawing surface will cause the dissipation of their limited strength and tend to obscure the finesse of their fine strokes. In contemporary metalpoint drawings, as in those of the old masters, a small or modest scale is appropriate.

WORKSHOP PROCEDURES

The workshop directions presented on the following pages will admit of many modifications and the individual artist may wish to make adaptations which will satisfy his personal tastes and needs. Some of my colleagues and students, skillful in drawing and metal work, have favored minor changes in the proportions of alloys or recipes for grounds which reflected their individual preferences in metallic styluses or in the color and texture of drawing surfaces. Recipes and procedures given here are of the simplest kind.

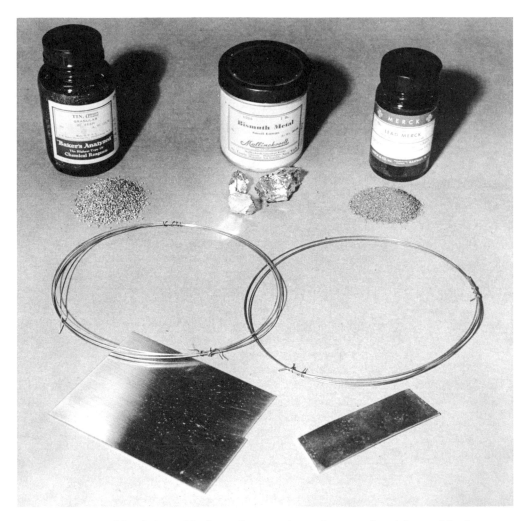

Metals in usable forms for preparing styluses. *Left to right, top:* Tin; bismuth; lead. *Middle:* Silver wire; gold wire. *Bottom:* Copper plate; brass plate.

Rudimentary styluses may be made with short lengths of silver, gold, copper, brass, or bronze wire; or of slips cut from metal sheets which should be filed into cylindrical shapes and polished with steel wool. In tapering the final drawing points, care should be taken so that they will not become so sharp that they will incise the ground like a needle rather than ride the surface while leaving a metallic trace.

Styluses of silver, gold, copper, brass, and bronze

These bits of metal may be inserted into shafts of soft wood in which small but deep holes have been drilled. An even more expedient method of making a very simple metalpoint tool is to select a metallic wire of a gauge which will fit tightly when inserted into a mechanical pencil in place of the customary graphite "lead."

More permanent and finished metalpoint styluses, which are light and well balanced, may be made with the wooden shafts of ordinary pen holders. The cork or rubber on which the fingers usually rest (Diagram 1, I–a) and the metal ferrule beneath (I–b) should be removed. The recessed por-

25

tion of the wooden shaft, which is then exposed, is drilled in order to make a longitudinal hole slightly smaller in diameter than the metal wire or cylindrical slip to be inserted (II–a). After it is drilled a half to three quarters of an inch, the wood is slit with a sharp knife parallel to the hole so that two "jaws" are formed (II–b). If desired, the corners at the end of the recessed shaft and the shaft proper may be curved with a knife, or sandpapered, in order to produce an improved contour in that portion of the finished stylus where the fingers will rest (II–c). The metal wire or slip is inserted (III–a), and a fine cord or stout string is wound evenly and tightly along that portion which forms the jaws in order to bind the metal point securely. The cord or string may be brushed lightly with shellac to bind it permanently, as one layer is wound over another, while building up an even, curved coil which will end flush with the main portion of the wooden shaft (III–b). For those who might wish to give the stylus a further finish, plastic wood may be moulded over the cord, sanded smooth and painted, as may be seen in examples in Diagram 1. Metalpoint tools prepared in this manner are light, attractive, and will last for years.

Styluses of lead, lead-tin, and lead-bismuth

Take an ordinary penholder and strip it as described in the preceding section; or, for a lighter lead alloy stylus, take a commercial tit-quill penholder and cut a recessed cylindrical shank about three quarters of an inch long. Then place a short section of a brass tube over the exposed shank Diagram 2, I–a). If the shank stands free inside the brass tube and is cut unevenly or notched, the hot lead or lead alloy will flow into the open spaces and lock the whole ensemble tightly when it cools. Next take a strip of heavy brown wrapping paper and obliquely and tightly wrap it around the brass section, letting it form a cylinder which will extend an inch or an inch and a half beyond the end of the brass tube. Tape this with brown paper tape so that it forms a stiff tube or mould (II–a). A hole bored in a block of wood will serve to hold the wooden shaft in an upright position during the pouring of the hot metal (II–b).

The metal or metals may now be placed in a small iron crucible or other vessel resistant to heat. For a stylus prepared in the manner outlined in the preceding paragraph, a total of two to four ounces of metal should be sufficient. Tin and bismuth will usually melt on an ordinary electric hot plate, but it may require an open flame burner to melt lead. The materials for metalpoints of the lead alloy type may be used in various proportions, two of which are presented here:

2 parts lead : 1 part tin (by weight)
1 part lead : 1 part bismuth (by weight)

After the metals are fused, the hot alloy should be poured in a steady stream into the paper mould. Let it cool gradually, and under no circumstances let it come into contact with water. After ten or fifteen minutes the paper mould may be removed. Then the excess alloy (III–a), may be filed away to form a uniformly curved shaft, and the point of the stylus may be polished with steel wool to its final form (III–b).

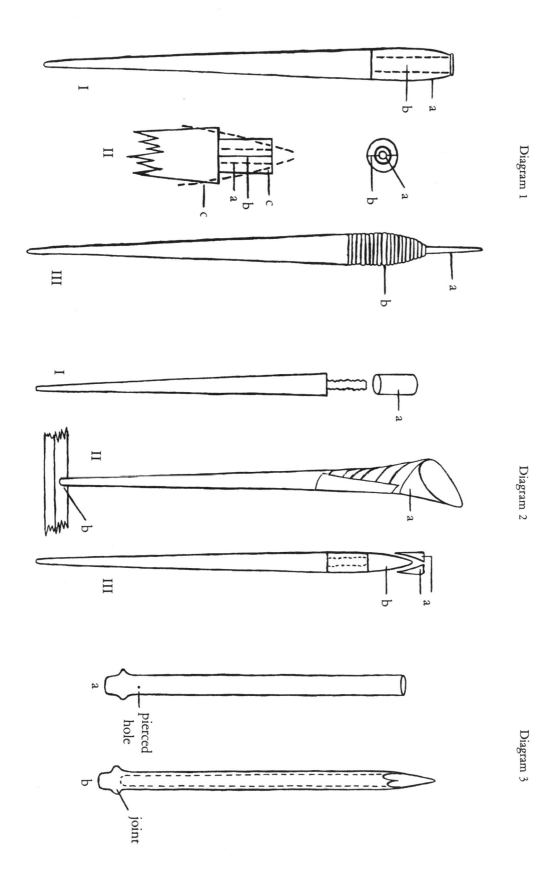

Diagram 1

Diagram 2

Diagram 3

Another simple method of preparing a lead or lead alloy stylus, but one which is less desirable because it forms a somewhat heavy tool, is to select a thin reed which otherwise would be used for pen drawing. It should be a reed (or thin cane, or bamboo) with a clear hollow within the barrel. Cut a section of the reed leaving a joint at one end (Diagram 3, a). Clean out all of the pithy matter from the hollow interior of the barrel. Then pierce the barrel with a very tiny hole near the joint so that the air will escape when the hot lead or alloy is poured into the shaft (a) and will insure a continuous rod when the metal cools. The pierced hole should be very small, otherwise the hot metal will flow out of the reed in a gushing stream.

When the alloys are fused as described above, the hot metal should be poured into the barrel of the reed quickly and in a steady stream so that no gaps will occur in the finished rod. When the ensemble is cool, an inch of the reed sheathing may be cut away and the exposed metal tapered and finished to a point with file, sandpaper, and steel wool as described above (b). The metal rod remains in the reed, the latter serving as a casing.

The preparation of metalpoint grounds

The directions for preparing metalpoint grounds presented below are basically similar to those found in the old recipe books, although modifications have been made which may produce, in convenience and quality, grounds with more appeal to contemporary artists. These recipes are but a few of many tried and tested in the workshop; they in turn may be modified at the artist's discretion.

For those who have never attempted metalpoint drawing it should be observed that care and some patience should be exercised in the initial attempts to prepare the grounds. Metalpoint surfaces which are rough or coarse, either from careless application of coats or from papers or woods of pronounced grain, can be impediments to the creation of delicately wrought metalpoint drawings.

Select a heavy, smooth-surfaced paper, parchment, vellum, a thin wood panel, or masonite such as painters use for panels. A paper with a heavy grain, or one with a slick, enamel-like surface are equally undesirable. It is preferable to have a paper with a smooth but mat finish. Well prepared parchment or vellum will provide a fine carrier, although genuine skins are expensive. Commercially prepared skins are frequently coated and one may draw on them with metalpoints in that state. Wood panels of small dimensions may be made from thin sheets of boxwood. These should be well sanded, since any machine marks produced in their plankwise cutting will persist through the coats of ground. As a substitute one may also use the smooth side of modern wood fiber boards, such as commercial masonite.

If paper is to serve as the carrier, wet it thoroughly and tape it quickly but firmly with brown paper tape to a square of plywood, a drawing board, or a similar surface as one would do in making a water-color paper "stretch." Let the paper become dry and taut before applying the first coat of the metalpoint ground. Because most carriers will tend to warp after the application of several coats of the ground mixture it is also desirable to tack

skins, along their edges, to a heavy board, and boxwood panels should be covered both front and back with one or two coats of clear glue water in order to reduce their absorbency and to minimize warping.

The materials for metalpoint grounds using titanium or zinc white dry colors may be prepared in the following manner. Take 25 ounces of water (by weight) and heat it over a fire or hot plate until it is very warm. Turn off the heat so that boiling will not occur when the glue is added. Add one-half ounce of rabbit skin glue chips or grains, and stir until they are dissolved. This glue water (size) also may be prepared by soaking the glue overnight in the proper amount of water, then warming the solution before using. Place 5 measures of this warm glue water in a clean vessel and gradually, while stirring, add 4 measures of titanium or zinc white dry color.

If one prefers to prepare a ground with a colored tint it is advisable to grind the dry colors on a ground glass slab with a muller, otherwise many pellets may not dissolve in the glue water. These will cause little pocks in the ground when their tops are removed in burnishing, or may streak the surface when rubbed, creating undesirable color smudges. For the tinted grounds a small amount of the dry pigment or pigments chosen should be mixed with the white while all of them are in a dry state. This practice is advisable if one wishes to have a uniform tint to all the layers of a ground, and by using only a portion of this controlled mixture of colors, each batch made with glue water will be similar to all others.

The addition of colored pigments should be made with restraint for two reasons. Many dry colors by the nature of their physical properties do not cause a good attrition of metal from the styluses, and therefore will tend to diminish the effectiveness of the strokes. Moreover, as the amounts of dry colors added to a ground are increased, the contrast of the ground with the metalpoint lines will be progressively reduced. With some pigments the light-dark value of the metallic strokes are so close to the value of the colored ground that the drawing can become innocuous or indistinct. (See the section, "Modeling with applied whites.")

With a wide brush, preferably a red sable about an inch wide, lay the coats over the carrier. Let each coat "set," and the carrier, if it is paper or skin, become taut before adding the next coat. In order to achieve smoothness, it is infinitely better to brush on three, four, or more very thin coats than to load or "pool" the surface of the carrier with one or two heavy coats. In fact, *after* a ground mixture is prepared with the glue water, the addition of a little warm water, not more than a half a measure, may increase the probability of producing coats without topography.

With grounds prepared according to any of the above recipes, one may burnish the dry ground lightly with "00" steel wool or a damp (not wet) cloth folded to form a wide pad. This procedure will improve the final surface, making it more smooth and more receptive to the stylus. If steel wool is used, one may find it advisable to run the damp cloth over the surface once or twice to remove any dust caused by the cutting action of the steel wool.

Test the ground with a stylus. If the ground has been properly prepared the strokes will be made with effortless ease, the weight of the metalpoint being almost sufficient to make a good line. If the recipe has not been followed correctly and a surplus of glue has been used, the tool will require undue pressure. On the other hand, if too little glue has been incorporated, the stylus will tend to score the surface of the ground, leaving ridges of powder to each side of the track of the tool.

After finishing a drawing, if one wishes to obliterate the images, they may be burnished away with steel wool or removed with a damp cloth, and the clear ground can then be used for further drawing. It should be pointed out that if the ground has a very heavy content of glue the steel wool will neither cut the surface nor eradicate the probable indentations caused by the stylus, and worse, will leave a gray smudge over the surface. In such cases it would be better to follow a practice similar to the old one mentioned by de Mayerne, that is, to brush warm water over the ground, thereby loosening the top layer and letting the action of the brush form a regenerated surface.

The materials for a metalpoint ground with white lead dry color are processed in a manner similar to those outlined for titanium and zinc white dry colors, but with the following modifications. The proportions for the glue water are one-half ounce of rabbit skin glue to 10 ounces of water (by weight). And the proportions for mixing the ground are 10 measures of glue water, 10 measures of white lead, and one-third measure of refined linseed oil. Since water and oil are not miscible this ground cannot be made as thin as the others previously discussed, and consequently it is more difficult to obtain a very smooth series of coats.

Contemporary artists or art students may wonder if commercially prepared white paints will serve as satisfactory materials for grounds. It is true that casein whites or the so-called gouache or opaque "tempera" whites with gum arabic binders will produce metalpoint strokes of good quality. On the other hand, in the processing of the finished surfaces those products have some limitations. One cannot burnish them with steel wool without creating an offensive gray smudge, and the use of the damp cloth will rather quickly form a slick, tough and therefore less receptive ground. Likewise, these methods for expunging images cannot be used as satisfactorily, while an eraser will leave an unpleasant streaking. Personal preferences, as always, will dictate the choice between making one's own grounds or accepting commercially prepared materials.

Modeling with applied white pigments

The modeling of figures, drapery and other details in many old metalpoint drawings frequently was consummated by a heightening with additions of white pen or brush work. The three elements in such drawings were the "halftone" color tint of the ground, the dark metalpoint contours and shadings, and the complementing contrasts of white strokes used to model areas of high relief or of high light.

In contrast to simple metalpoint drawing on a light ground the introduction of applied heightening through the use of whites presented a

modest complex of drawing procedures. For these drawings the grounds were usually darker and often of an increased chromatic intensity. The darkened value of the ground allowed the whites to function more effectively, and the greater coloristic strength encouraged a broader range of personal color choices. Modeling over these darker grounds with light strokes assisted the artist in suggesting a more conclusive, three-dimensional volume in the images. The procedures and effects of this manner of drawing were counterparts of the traditional processes of modeling as practiced in egg tempera painting of the late middle ages and the early Renaissance.

Despite the many extant metalpoint drawings produced in this manner, most of the technical writings from the fourteenth, fifteenth, and sixteenth centuries do not provide exact directions for drawing with metalpoints in conjunction with applied lights through the use of white pigments. However, Cennino and Giorgio Vasari described procedures which were adaptable, with slight modifications, to metalpoint drawing. The former proposed that the initial forms were to be sketched lightly with charcoal, and the contours and the folds of the garments fixed with silverpoint. Afterward one modeled the darks with fine brush strokes of diluted ink and added the effects of relief and high lights with white lead, judiciously applied. Vasari, although he was familiar with metalpoint drawing[45] described this procedure for pen and wash drawing. Nevertheless, it may be easily associated with old metalpoint drawings, especially those which were reinforced or finished with pen work.

Other drawings in light and shade are executed on tinted paper which gives a middle shade; the pen marks the outlines, that is, the contour or profile, and afterwards half-tone or shadow is given with ink mixed with a little water which produces a delicate tint; further, with a fine brush dipped in white lead mixed with gum, the high lights are added. This method is very pictorial, and best shows the scheme of colouring.[46]

The designation "heightening with white" which one encounters frequently as a reference to such a procedure in drawing, or that of "modeling with applied white pigments" used in the title of this section, are both too strong in their implications of a use of pure whites to be accurate descriptions of the subtle modeling of light areas which one finds in sensitive metalpoint drawings. The introduction of powerful, opaque whites is desirable only for the select accents which conclude the lightest areas of the object drawn.

Metalpoint strokes have their strength reduced by the darker tinted grounds while the whites become more prominent. Consequently, strong white strokes will easily overwhelm the metalpoint portions of a drawing. Cennino was aware of this pitfall when he directed the artist to dress the brush on his thumb, squeeze and almost empty it, before applying the strokes to the ground. Moreover, he proposed that opaque white should be used only for the final accents, and should be added to the drawing with the very tip of a pointed brush.[47] For these reasons, "height-

ening with white" or "modeling with applied white pigments" more correctly refers to the use of diluted whites which create semiopaque tints, with powerful whites used sparingly, if at all.

Although the references to this type of heightening are not common, those that occurred mentioned no alternative to the use of a white lead pigment.[48] It is true that white lead carried the risk of turning black with time and the old masters were aware of the possibility. Where it has happened in old drawings one finds an odd distortion of the modeling sequence, with blacks where the light relief areas were originally created. Apparently, the old masters were willing to risk this reaction of white lead, there being no other white available at the time which matched this pigment in its fineness of texture, covering power, excellent suspension in solution, and ability to be extensively diluted while retaining an evenly dispersed tint—features which must have been attractive to artists who sought to apply strokes with the maximum of subtlety. It is possible that white pigments which were used for other artistic purposes—such as bone, chalk, gypsum, powdered sea shells or eggshells—may have been used on occasion, but because of their limited resources, they must have been less favored. Compared to white lead they display a lack of covering power, an inability to be extended by dilution, and a reluctance to flow evenly from a brush.

Cennino indicated that the binder for the aqueous white lead medium was gum arabic, although Vasari referred to this material—as did so many other writers—merely as "gum."[49] Gum arabic was such a familiar material of common use in all sorts of art processes that most authors either failed to describe its preparation into gum arabic water, or described the procedure with very general directions. A typical recipe was that contained in a fifteenth-century Bolognese manuscript: "Take clear water in a glass cup with gum arabic in powder and make it rather warm over the fire until it is well liquefied, and then keep it in a phial and use it."[50]

There were scattered references to the preference for clean, white gum arabic rather than the yellow, that the gum should be tied up in a piece of linen cloth and suspended in a vessel of water, or, if haste was necessary, that one could work up the gum and water with a finger.[51] Also, there were references to the use of other water-soluble gums for artistic purposes, which included the gums of cherry, plum, and apple trees, but the written evidence indicates that gum arabic was considered the best and the most versatile—a judgment which is still justifiable today.

Ingredients and recipes for making whites

Gum arabic, an exudation of the acacia tree, is frequently labeled *gum acacia* by druggists or pharmaceutical firms. Although one may obtain it in powdered form, it is usually purchased in pieces or lumps of varying sizes which are called "tears." A binding medium of gum arabic water is easily made. One crushes or grinds the tears, places the small grains or powder in a cloth bag, or ties it up in several layers of cheesecloth. This prevents the wood fibers and other foreign bodies, which are often embedded in the tears, from entering the solution. The bag is suspended in

a jar by means of a string in order to let the water penetrate from all sides. The following day the bag is squeezed to force any remaining dissolved gum into the water. To make a basic solution one may take an ounce of crushed gum arabic to one-half pint of water. If one intends to keep the mixture for more than a few weeks it is advisable to add a preservative. For this purpose one should add either of the following:

one-eighth teaspoon of sodium benzoate (1 per cent solution) for each ounce of gum arabic

5 drops of concentrated solution of zephiran chloride for each ounce of gum arabic

Without a preservative the gum arabic water tends to sour and acquires both an unpleasant odor and mold.

The basic solution above will probably be more viscous and stronger in its binding properties than is necessary. As one takes a small portion for use it should be diluted with at least an equal portion of water. Too thick a gum water will make the white pigments flow from the brush with a sluggishness, may produce strokes which shine, and in extreme cases may cause cracking or peeling. On the other hand a very dilute solution will not be strong enough to bind the particles of pigment together, or to the colored ground.

To mix the semiopaque or completely opaque washes, one places a tiny mound of zinc or titanium white dry pigment, a few drops of gum arabic water, and some clear water in separate compartments of a mixing dish or ceramic mixing slant. With a fine sable brush, the mixture is made to the desired intensity of tint required for the particular portion of the heightening, and the most favorable fluidity for precise application.

The delicacy of tints and the skill in application are more easily achieved with a fine brush than with a pen. Although the latter is usable, it does not permit the artist to modify his tints as readily and cannot be used in the very commendable semidry manner which Cennino recommended. Those who are unfamiliar with heightening with white will find it advantageous to begin with very pale "white" strokes. They will not only be more contrasting with the tinted grounds than one might suppose, but one will initially avoid the introduction of bold lights which may ruin both the sequence of modeling and a harmonious relationship with the metalpoint portions of the images.

One may find that commercial counterparts such as zinc or titanium whites in the form of tube watercolors, gouache whites in tubes, or the finest quality tempera whites in jars, are quite satisfactory when they are well diluted. Although the currently popular casein (gouache) whites may be used for heightening, at the present time their coarser texture makes them less desirable than the other commercial aqueous whites mentioned above.

Chiaroscuro drawings

The usual drawing method of the artist was to apply dark strokes over light colored papers. In chiaroscuro drawings this basic procedure was reversed. This type of drawing had two notable features: a rather deeply colored halftone which served as a dark background, and an emphasis upon white strokes in the delineation of contours or in the modeling of the figures.[1]

The term "chiaroscuro" has been appropriated by art historians from the Italian of Vasari and others in order to identify a manner of creating figures by light values over a dark halftone or to suggest the partial emergence of figures from a deeply shadowed background into atmospheric light. Consequently, chiaroscuro drawing is usually associated with those studies which have similar relationships of dark tonal backgrounds and figures largely defined by prominent, applied, lights.

Tools and materials

The tools and materials used to produce chiaroscuro drawings were basically those employed for more common types of studies. It was the distinct tonal and color characteristics, the unusual visual effects, and the reversal of the customary drawing procedures which made chiaroscuro sketches atypical.

Instructions which described chiaroscuro drawing practices are very difficult to find in technical literature. One suspects that this type of drawing was gradually developed as a modification of the procedures for heightening metalpoint drawings, of the artists' methods of monochromatic underpainting as a preliminary stage in the execution of easel paintings, or of grisaille painting. Certainly there is no evidence that the procedures were considered sufficiently unusual to warrant detailed directions either before

"Warrior" by Robert Burkert.—*Owned by the Author.* Brush, carbon black water color and heightening with titanium white mixed with gum arabic, on a blue-gray prepared ground.

or during the period when chiaroscuro drawing had its greatest flourishing in the early years of the sixteenth century. Although some comments by Leonardo and Dürer may have been offhand references to such drawing methods, their notations were very casual and inconclusive.[2] Not until 1564 do we find an acceptable statement of the technique in the writings of Raffaello Borghini, who described drawing in "chiaro oscuro sopra fogli tinti, che fanno un mezzo." Over this halftone the dark strokes were to be made with pen and ink, shadows with diluted ink, and the lights laid on with a fine brush dipped in white lead tempered with gum water.[3]

Chiaroscuro drawings are striking in their contrasts of lights against halftones or deep darks, especially when compared with either the delicate gray strokes and pastel-colored grounds of metalpoint drawings, or simple pen-and-ink studies on white papers. Moreover, the chromatic properties of chiaroscuro papers and grounds, composed of tones of dark green, blue, gray, red, or brown, set them apart from most old master drawings.

These dark and colored backgrounds reduced the black or gray strokes to a secondary role while at the same time they placed the principal burden of defining the figures upon the whites. Nevertheless, each of the elements, whether dark, halftone, or light, had a necessary function in the full modeling of the three-dimensional figures. And the color tone, more often than not, served simultaneously as the background and the intermediate tone for modeling the figures.

The rather capricious manner with which the old masters chose the colors for the backgrounds bore little relationship to colors associated with atmospheric space in nature, and as a consequence, much of the spatial illusionism common to many other types of drawings was eliminated. Furthermore, the insistent whites which defined the important features of the figures, often produced decorative effects in chiaroscuro drawings. In some instances, the inclination of the artist toward an ornamental calligraphy, such as Altdorfer delighted in, produced chiaroscuro works of unequivocal decorative appearance.

In many chiaroscuro drawings the colored tones of papers, grounds or washes were so dark that the portions of the figures described by the light strokes seemed to emerge from an enshrouding and undefinable background. This visual subtlety of chiaroscuro interrelationships between the figures and backgrounds had its attractions for artists of diverse periods and styles. Doubtless, its unusual aesthetic effects were sought by Dürer and other earlier artists, or Henry Moore for the creation of the ghostly bodies in a number of his drawings, including "Tube Shelter Perspective."

"Madonna and Child" by Henry Moore.—*Courtesy of the Cleveland Museum of Art (The Hinman B. Hurlbut Collection).* Gray wash background, greasy crayon, pen and carbon ink, heightening with whites.

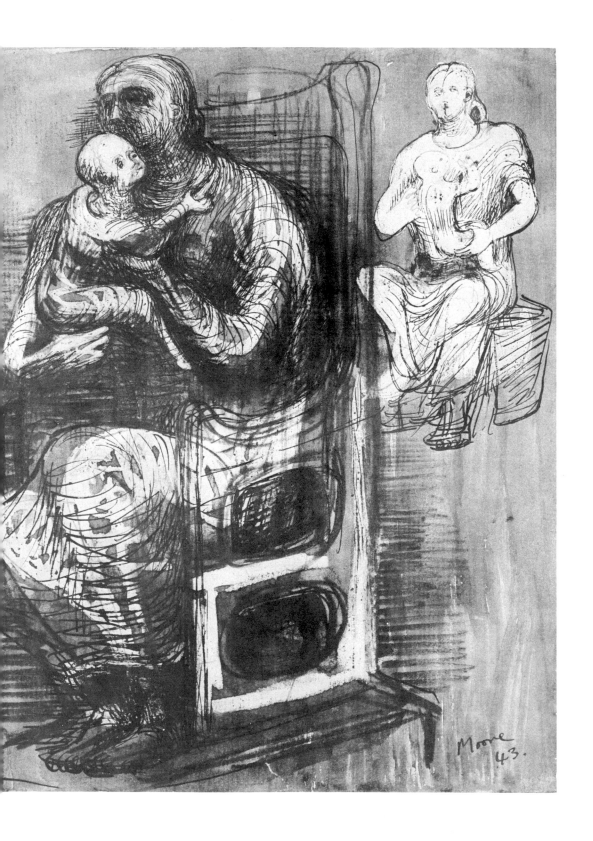

Moore
43.

Although drawings with chiaroscuro characteristics were produced by artists of Europe in many different centuries, the group which most commonly receives the designation is composed of drawings from the workshops of northern masters of the early sixteenth century. The epitome of this form of drawing was found in the works of Dürer, Altdorfer, Hans Baldung, Hans Leu the Younger, and numerous contemporaries. Fine examples in American collections include the carefully composed "Pietà" of Hans Leu and Altdorfer's freely conceived and decorative "Salome with the Head of St. John the Baptist."

One finds many drawings produced by masters of various centuries or countries in which the choice of opaque or semiopaque whites, either precisely or freely laid over dark-colored surfaces display the elements of the chiaroscuro technique. The "Rest on the Flight into Egypt," drawn upon a blue-green paper by Paolo Veronese, the broadly treated "Herdsmen Rounding Up a Herd of Bulls" executed by Gericault on brown paper, the "Mounted Jockey" which Degas created with striking patterns of white against a brown paper, or the loosely drawn "Madonna and Child" of Henry Moore, will indicate that drawings conceived with chiaroscuro intent appeared at random times and places.

Drawings by the leading masters of the chiaroscuro method in the sixteenth century indicate that a sharply pointed quill pen and a fine pointed brush were the drawing instruments ordinarily used. Although either could be used exclusively, in many drawings both were employed. These tools were handled in a manner which would produce delicately linear strokes. Indeed, the pointed brush was used with such control that at times its strokes rivaled or outstripped those of the pen in fineness of line. When broader and more limpid half-darks or half-lights were desired these tones were applied as gray washes or diluted whites. But these latter effects, produced with a broader brush, were usually introduced with great restraint and rarely competed with the linear elements of the drawing.

Usually the dark modeling in chiaroscuro drawings was produced with a solution of carbon black and gum arabic, which, depending upon its dilution and the particular manner in which it was used, could be called either an ink or a wash. The lights, or whites, were undoubtedly made with white lead pigment mixed into a gum water. Those authors who described heightening with white in drawing, such as Cennino, Vasari, and Borghini, all mention the use of this pigment. Among the available whites of those earlier centuries, white lead was the most impalpable, the greatest in covering power, and most maneuverable and even-flowing in the act of drawing with brush or pen. Consequently, it was the finest white for creating chiaroscuro effects.

"Mounted Jockey" by Edgar Degas.—*Courtesy of The Isabella Stewart Gardner Museum.* Black and white brush drawing on brown paper.

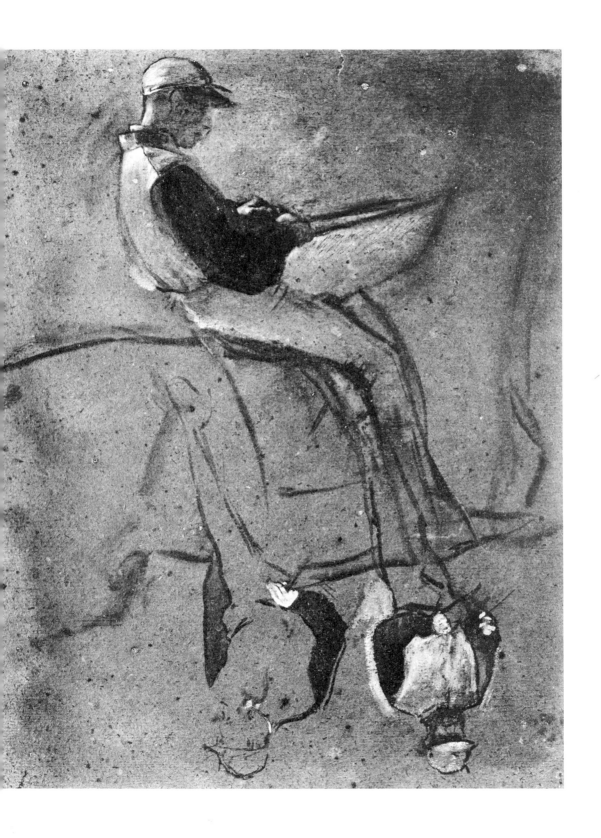

The colored backgrounds were provided either by papers in which the color was impregnated during manufacture, or the application of colored washes or grounds over the papers by the artist.

WORKSHOP PROCEDURES

Chiaroscuro drawings, which are to be executed with fine linear pen or brush work, are most easily executed on surfaces which possess a limited absorbency. A soft ground or absorbent paper will cause the strokes to bleed. Moreover, the pigment particles of a soft ground will clog the pen, or their color will adulterate the white strokes as they are applied in liquid form. Therefore, it is advisable to prepare grounds with a greater content of glue than would be desirable for grounds which serve metalpoint drawing.

The drawing surfaces Three types of surfaces may be mentioned. For a very free handling of the drawing one may prefer to apply a relatively deep colored water-color wash over a fine textured but stout water-color paper.

For either a freely or a precisely executed drawing one may select a color-impregnated paper of heavy stock. Such papers are more frequently found at printing establishments than at art stores. Charcoal papers, although available in many colors, are usually so light in weight that they will buckle from the use of a liquid medium.

A third surface for chiaroscuro drawing, and one which may be prepared to taste, is a ground applied over a heavy paper.

1. Stretch a sheet of smooth, but not slick, paper in the manner described for metalpoint grounds (see p. 28).
2. In order to reduce absorbency of the ground and toughen the surface, a stronger glue size than that used for metalpoint grounds is desirable. This may be prepared as follows:
 a. Place 16 ounces of water (by weight) in a vessel, and heat it over a hot plate until it almost boils.
 b. Remove the water from the hot plate and add ¾ ounce of gelatin glue (e.g., "silver label" sheet gelatin), and stir continuously until dissolved.
 c. In a can or other vessel, add to one measure of the glue size, *while it is hot,* about ⅓ measure of the dry colors preferred. The amount of dry color may be varied depending upon the inherent covering power of the given pigments and the relative strength of the glue size necessary to bind the pigments. For example, Venetian red requires more binding strength in the glue than does ultramarine blue, but as the

"Pietà" by Hans Leu the Younger.—*Courtesy of The Fogg Art Museum, Harvard University (Gift of Mr. and Mrs. Robert Woods Bliss).* Quill pen and brush, carbon black ink, and heightening with whites on an olive-green ground.

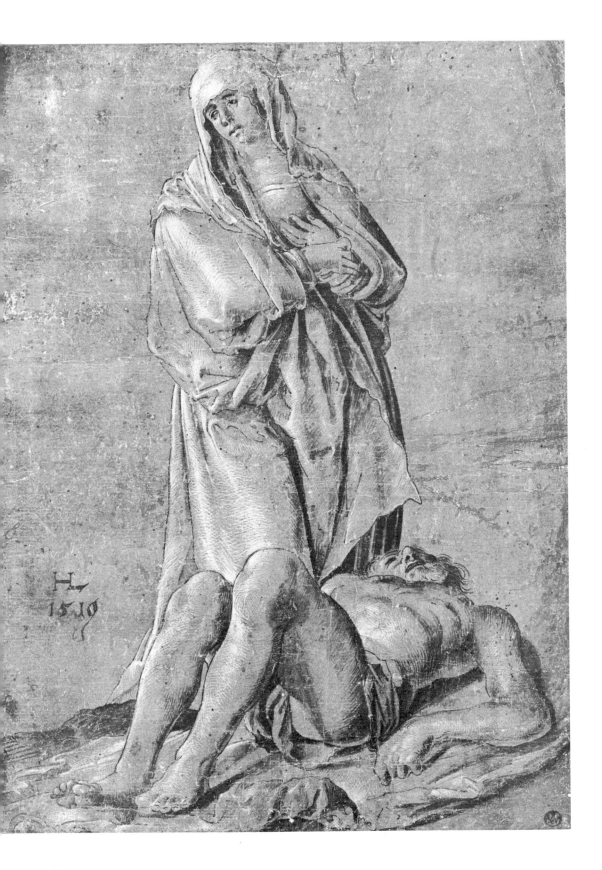

former possesses greater covering power, less of it is needed in the mixture.

d. While the mixture is still hot, brush it over the paper letting each coat set before the following one is applied. Depending upon the opacity of the pigments two or more coats are usually necessary to obtain an evenly toned ground.

e. After the several coats of the ground have thoroughly dried and the paper is again flat and taut, the surface may feel slightly rough or horny. To burnish it, a folded, moist (not wet) cloth may be drawn over it four or five times with an interval of a few minutes between each application of the cloth. This will smooth the surface, darken the color, and will increase the nonabsorbency of the ground.

One rarely finds old chiaroscuro grounds prepared with pigments of full chromatic strength. The graying or muting of these colors by the old masters was a desirable practice because unmixed pigments not only tend to appear raw but the untempered power of their colors will overwhelm the light and dark portions of the chiaroscuro drawing.

The preparation of the whites and blacks for drawing

More frequently than not one will prefer to use thinned whites and deep grays for the majority of the strokes or washes; undiluted blacks or whites are saved for accents. One should emphasize that these grays and off-whites should *not* be made by mixing the white and black media. Instead, in order to retain freshness of effect and easier control of light-dark modeling the artist will make the grays and off-whites by the simple method of diluting the black or white media with water.

The materials for the semiopaque lights or white may be any of the following: Titanium or zinc white dry colors mixed with gum arabic water as described for the heightening of metalpoint drawings; titanium or zinc white water-colors in tubes; gouache white in tubes; or tempera white of a good quality sold in jars.

The materials for the grays or blacks may be any of the following: Ivory black dry color mixed with gum arabic water; a carbon black ink made with lampblack and glue water (see recipe on page 86); ivory black water-color in either tubes or pans; or a commercial Chinese ink stick, rubbed up with water in a slate ink saucer or porcelain dish.

A chiaroscuro drawing made without any preliminary sketch lines is attractive in its purity. If a few outlines are necessary, however, one may lightly draw them in with a medium-soft graphite pencil. A metalpoint stylus may be used for the purpose, but often the chiaroscuro ground is too smooth or tough to allow the tool to leave a metallic stroke. Moreover, if a ground is very dark, the metalpoint lines can only be seen as glistening reflections.

The final drawing may be made with either a pen or a brush. A quill will have less tendency to score the ground than a steel pen, but either type must have a very fine point. A very small sable brush will produce

delicate linear strokes and with experience the artist can execute finer lines than he can obtain with a pen.

Chiaroscuro drawings cannot be erased without creating an unpleasant spottiness. However, if a drawing which has been started on a ground prepared with glue size proves unsatisfactory, one may remove it and use the ground again. This is done by rubbing a wet cloth over the ground with even, sweeping strokes until the faulty drawing and the gum or glue binders of the black and white strokes which have penetrated into the upper surface are obliterated.

Pen drawing

Among the generic groups of drawing instruments of the past six centuries, there was none more important or popular than pens. Although some artists, such as Grünewald, Rubens, and Watteau had obvious preferences for other drawing media, it is difficult to find well-known masters whose extant drawings do not include studies produced with pen and ink. The great numbers of pen drawings suggest that there was probably no other instrument with which more old-master drawings were produced. Undoubtedly this popularity of pens was due to their adaptability in creating forms which met the varied stylistic requirements of every art epoch and of almost every master, whether used as the only instrument in drawings or employed in conjunction with many other media.

The artist used three basic types of pens. Quill pens were cut from the wing feathers of fowls and birds. Reed pens were prepared from the stems of bamboo-like grasses. And metal pens, not being of natural origins like the other two types, were fabricated from various metals.

Quill pens The quill pen was the principal instrument for making the precisely hand-printed lettering and ornamental designs, or the delicate, linear pen-and-ink illustrations of medieval manuscripts. The use of quill pens for these purposes may be identified in the calligraphy of the manuscripts and by the numerous medieval representations of the quills in the hands of saints or scribes. On the other hand, references to quill pens in medieval literature occurred infrequently, and comments on their use, like those of St. Isadore of Seville or the monk Theophilus, were not common. The substitution of a quill-type pen for the older reed pen and the first clearly stated distinction between these two were suggested by Isadore in the seventh century.[1] The first specific reference to a suitable type of quill for writing, that of the goose, does not seem to have been made until several centuries later by Theophilus.[2]

"Group of Female Figures Seated on a Cloud" by Giovanni Battista Tiepolo. —*Courtesy of The Pierpont Morgan Library.* Quill pen, iron-gall ink, gray carbon ink wash, preliminary strokes with graphite.

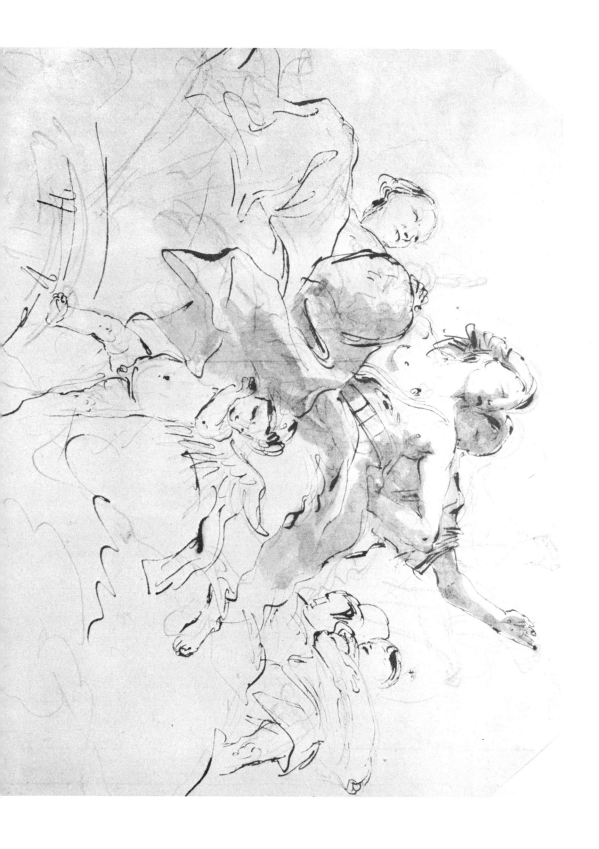

Microphotographic enlargement showing differences in ragged edges of strokes made with various pens. *Top to bottom:* (1–2) steel pen (Esterbrook Extrafine Elastic 128), medium pressure; (3–4) steel pen (Esterbrook Fine Firm 773), strong pressure; (5–6) goose quill, light pressure; (7–8) reed with narrow nibs, medium pressure; (9–10) reed with broad nibs, strong pressure.

From the fifteenth century on, innumerable treatises on the arts carefully identified the types of quills and described their relative virtues, although many other works simply referred to the quill to be used for drawing as the "pen." The four kinds of quills which were recommended were those of goose, swan, and raven or crow. The references below, chronologically arranged, will show that the various types were used interchangeably for drawing from the fifteenth through the eighteenth centuries.

GOOSE QUILLS
Late fourteenth or early fifteenth century, Cennino (Thompson, *The Craftsman's Handbook,* p. 8).
1678, Hoogstraeten, p. 31.
1765, *Encyclopédie ou dictionnaire raisonné des sciences, des arts, et des metiers,* XII, 800.

SWAN QUILLS
1678, Hoogstraeten, p. 31.
1754, Buchotte, p. 16.
1765, *Encyclopédie ou dictionnaire raisonné des sciences, des arts, et des metiers,* XII, 800.

Quills. *Left to right:* Goose quill; crow quill; wild swan quill.

RAVEN OR CROW QUILLS
1635, Le Brun (Merrifield, II, 792, 793).
1648/50, Norgate (Norgate, ed. Hardie, p. 81).
1658, Sanderson, pp. 30, 31.
1685, Salmon, p. 3.
1688, *The Excellency of the Pen and Pencil,* p. 11.
1754, Buchotte, p. 16.
1765, *Encyclopédie ou dictionnaire raisonné des sciences, des arts, et des metiers,*
 XII, 800.
1779, *The Art of Drawing and Painting in Water-Colours,* p. 7.

The goose quill seems to have been the pen commonly used and was the type depicted again and again in paintings representing artists drawing in their studios. The swan quill was considered an excellent substitute for the goose quill, but pens cut from the quills of ravens or crows were chosen when the finest and most delicate strokes were required. Quills from other birds were ignored in the handbooks of art, and our experimental efforts to draw with other kinds of pens had results which sug-

Microphotographic enlargement of a detail from "A Triumphant General" by an anonymous seventeenth-century master of the Venetian School.—*Courtesy of The Fogg Art Museum, Harvard University (The Meta and Paul J. Sachs Collection)*. Quill pen and bistre ink on a white paper.

gested that their inferiority caused the omission of references to them in the treatises on drawing.[3]

The most satisfactory pens are made from the feathers which rest toward the leading edge of the wing. The large, primary flight feathers of a goose, particularly the second to the fourth or fifth, provide quills whose pointed nibs hold their shape well and have less tendency to splay. However, they are less flexible than those from farther back on the wing, whose barrels have thinner walls.[4] Buchotte wrote that "one should always choose the clearest and least hard, because the clearest split more neatly and the softest ones, being thinner, are easier to trim for making fine lines. Since it is said that the oldest are the best, if they have been kept in a dry place, it would be desirable to keep a supply of two or three hundred of them."[5]

The quill, when drawn from the wing of the bird, bears a membrane which must be scraped away before the pen is cut, slit, and the nibs trimmed. In the eighteenth and nineteenth centuries the commercial preparation and sale of quills seems to have encouraged special processing in order to improve the quality of the pens. To shrivel the outer membranes and to harden the barrels and make them more transparent, they were sometimes plunged into hot ashes or into sand heated to about 144° F. During this processing the natural moisture and grease were driven off.[6] For a time, this procedure seems to have been a trade secret of the Dutch,[7]

48

Microphotographic enlargement of a detail from "Three Studies of a Child and One of an Old Woman" by Rembrandt.—*Courtesy of The Fogg Art Museum, Harvard University (The Meta and Paul J. Sachs Collection).* Quill pen strokes.

and such commercially processed quills were identified as *préparées à la maniere d'hollande, Plume hollandée* or "Dutch pens." [8]

In addition to the ready availability of quills, which could be obtained at the markets or, by the eighteenth century, at stationers' shops, it was the versatility of these pens which appealed to artists. Depending upon the artistic needs of their individual users, quills could be pared to blunt, medium, or fine points, or cut crosswise to form a broad, chisel-like pair of nibs. Moreover, their greatest virtue was the facility with which they responded to the very personal and autographic characteristics of any artist's draughtsmanship.

This versatility and adaptability made the quill pen a medium which

often reflected, more clearly than most other drawing instruments, the individualistic tastes and styles of the old masters. Furthermore, it obediently adapted itself to the general stylistic changes which occurred over the centuries. Whether the requirements were those of the short, precisely hatched strokes of so many fifteenth-century drawings, the fluidity of Raphael's graceful contourisms or the restless vigor of Dürer's linearisms, the quill pen met each demand placed upon it without effort. It made possible the obvious display of pen virtuosity, such as may be found in the works of Guercino or Franco, where the pen lines often existed as flourishes for their own sake. And the spontaneity with which Rembrandt, by means of a few rapidly executed strokes, created the suggestions of figures bathed in brilliant atmospheric lights was achieved with the helpful assistance of the quill pen.

For the contemporary artist who is familiar with only modern steel pens, the responsiveness of the quill to various manipulations of the draughtsman's hand provides novel sensations. The manner in which a quill pen glides over the surface of the paper eliminates the dragging friction, or actual scoring, common to metal pen strokes.[9] Therefore, the act of drawing consists in gently guiding the movement of the floating quill point. Pressure is not required except a light flexing of the nibs for an increased width of line or points of accent. The great maneuverability and gliding movement of the pen often presents a minor hazard for the inexperienced draughtsman, because the freedom and swiftness with which the quill moves often outraces the control of the untrained hand. But once the artist has learned to adjust himself to these factors the quill allows him to play with lines in a way more frequently seen in old-master drawings than in those of our contemporaries. Although this responsiveness of the pen can be utilized admirably for liveliness in personal draughtsmanship, it may be overindulged, creating technical mannerisms of penmanship such as one finds in some works by sixteenth- and seventeenth-century masters.

The effortless gliding of a well cut pen is due to the physical characteristics of the quill's structure. And the frequently observed gentleness of its lines is a result of the somewhat eccentric manner in which it deposits ink upon the paper. In appearance and texture the quill barrel is not unlike the human fingernail in that it possesses a strong hornlike but moderately soft structure which is in contrast to the resistant hardness of steel. And as the quill nibs ride the surface crests of the paper they leave ink lines with more scalloped edges than is the case in strokes made with a pen of steel. Although these eccentric contours of the quill line may be most clearly seen through a microscope, the irregularities will

"Nathan Admonishing David" by Rembrandt.—*Courtesy of the Metropolitan Museum of Art.* Reed and quill pens, brush, bistre ink, and a few tones created by smudging the wet ink strokes with the finger. Bistre grayed where drawn over semiopaque white strokes (e.g., Nathan's beard, both sides of David's chair). Drawn on a tan paper.

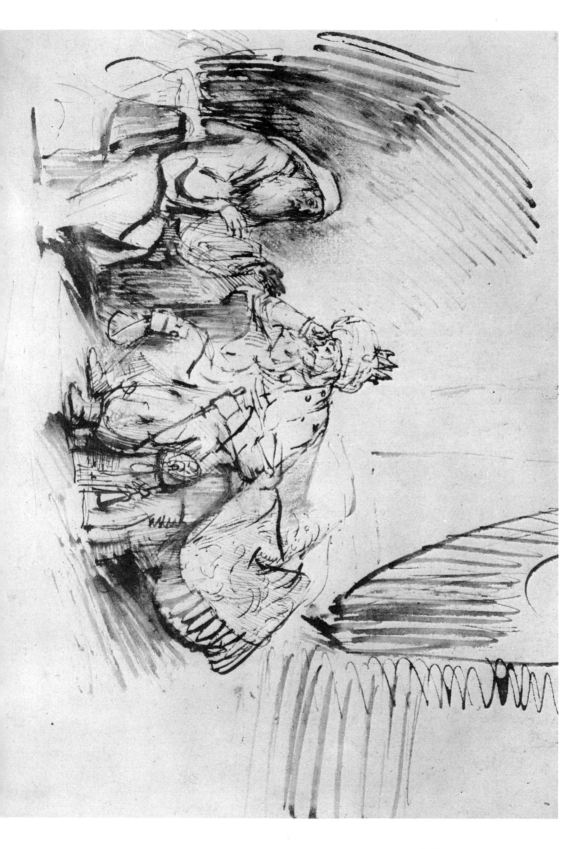

be sensed by the naked eye, and an impression is gained of softer and less mechanically produced strokes.

These effects are most noticeable in drawings where soft, moderately textured, handmade papers were used, because the random patterning of the deposits of ink from the light quill strokes is, in part, accentuated by the irregular grain of the old papers. More than one may realize at first, this unmechanical quality of the lines was the by-product of the happy combination of the quill pens and handmade papers of earlier centuries. Indeed, some of the old papers on which quill drawings were produced were so soft and uneven that one doubts that a modern steel pen could have been used without the surface being torn or the point becoming ensnarled in the fibers.

The attractive attributes of quill lines on soft surfaces, the free movement and easily executed flourishes, the very personal expression in the calligraphy, and the sensation—rarely felt with a steel pen—that the instrument is a responsive extension of the artist's hand rather than a tool interposing itself between his manipulating hand and the emerging image, are possible only if the artist provides the quill with optimum conditions. Receptive papers, quite fluid inks, and above all, well-cut quill points are necessities. To cut quills which assist rather than hinder the draughtsman requires the use of a very keen-edged knife and some patient practice. But the learning is worth the effort if the artist finds the resourcefulness of quill pens a necessary contribution to the artistic qualities which his taste in drawing requires.

> In times begone, when each man cut his quill,
> 　　　　With little Perryian skill;
> What horrid, awkward, bungling tools of trade
> Appeared the writing instruments, home made!
>
> What pens were sliced, hewed, hacked, and haggled out,
> Slit or unslit, with many a various snout,
> Aquiline, Roman, crooked, square, and snubby,
> 　　　　Humpy and stubby;
>
> Some capable of ladye-billets neat,
> Some only fit for ledger-keeping clerk,
> And some to grub down Peter Stubbs, his mark,
> Or smudge through some illegible receipt.[10]

Reed pens　　Ancient writing pens of reed or cane antedated the use of the quill. Although the reed was never completely abandoned for writing in the western world during the middle ages, it was not suitable for the delicate draughtsmanship or ornamental configurations of fine medieval manuscripts. The writings of the fifteenth century indicate that the scholars of

"Crouching Nude" by Henri Matisse.—*Courtesy of the Art Institute of Chicago.*
Reed pen and carbon black ink.

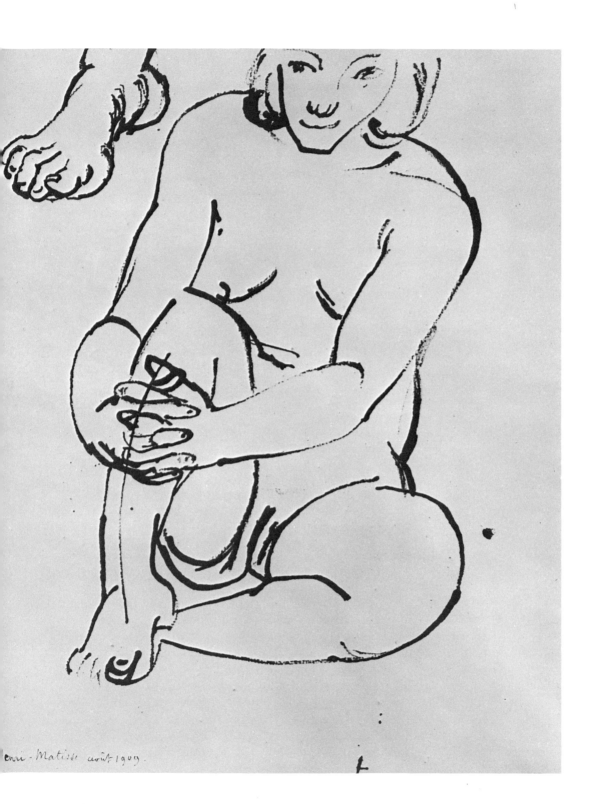

Henri-Matisse août 1909.

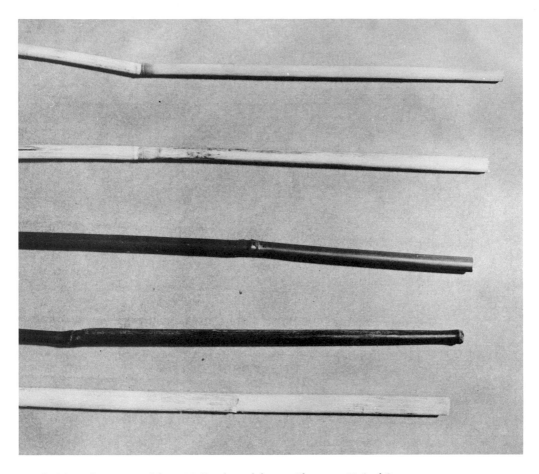

Reeds. *Top to bottom:* Reed from Holland; reed from midwestern United States; reed from Japan; reed from Near East; reed from India.

the Renaissance knew that the reed had been the pen of the ancients. It has been mentioned that in 1460 the printed colophon of the "Catholicon" of Johannes Balbus stated that the tools of writing were the reed as well as the quill and stylus.[11] About 1472, Guillaume Fichet, master of the college of the Sorbonne, wrote of Gutenberg and the radical differences between handscript methods and printing with movable type. His statement identified the reed as the pen of antiquity and the quill as that of his contemporaries.[12] Moreover, some of the humanists of the early sixteenth century affected an antiquarianism by using the reed for writing, among them Erasmus of Rotterdam. In his letters he mentioned the acceptance of the reed by distinguished colleagues.[13] And the master portraitist of the time, Hans Holbein the Younger, painted Erasmus writing with such a pen, faithfully reproducing the shape, color, and even the rounded joint at the end opposite the writing point.

"Tree in a Meadow" by Vincent van Gogh.—*Courtesy of The Art Institute of Chicago.* Reed pen strokes in iron-gall ink which is beginning to turn from black to brown.

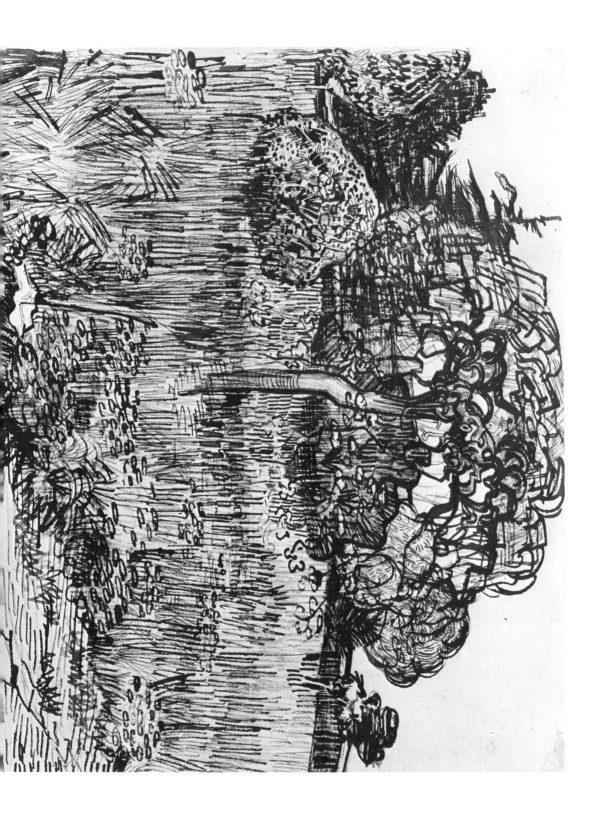

The reed was less adaptable than the quill to the requirements of graceful calligraphy, especially as a cursive script became more and more an accepted style. Likewise in drawing it was too limited an instrument to equal the quill's adaptability to the innumerable individualistic differences in styles. Consequently, one finds few drawings in which the reed was used, and there are only scattered references to it in treatises on art. Malvasia, in his *Felsina Pittrice* of 1678, mentioned its use by both Odoardo Fialetti and Marco Boschini for creating large and vigorous drawings,[14] while during the same year, but in Holland, Hoogstraeten noted that a pen for drawing could be cut from a dry reed.[15] An anonymous German volume of the eighteenth century not only cited the functions of reed pens in drawing but identified them as having been made from the reeds that grew along the banks of streams and that also were used for thatching the roofs of peasants' huts.[16] In the following century, Vincent van Gogh, while in France, wrote that he had already tried drawing with reeds in Holland and that he was adopting the medium again because of the excellent ones to be found in France.[17]

Drawing with the reed pen continues in our time, and although it is not an instrument chosen frequently, there are distinguished artists who have found it particularly effective for simple and bold pen drawings. Among them, during the earlier part of the century, were Henri Matisse and his friend Albert Marquet, who were fond of drawing with the reeds which they gathered in the south of France.[18] Perhaps the most continuous practitioner is George Grosz, who has produced innumerable drawings with the reed pen or with combinations of reed and brush, and reed and steel pen.[19]

Although this type of pen drawing includes the use of various bamboos or canes, undoubtedly the common reed (*Phragmites communis*) was the hollow-barreled grass used by artists of Europe. This reed grows throughout temperate climates. One cannot unequivocally state that the reeds used by the masters of Europe were always gathered from the local countryside, because it was possible that some reeds were imported from the Near East or northern Africa.[20] But because the common reed grows in every country of western Europe, one may suppose that in most cases the artists of Italy, Germany, France, and Holland used native sources. In the United States it is possible to obtain satisfactory reeds from many lakes and streams, and it has been the custom of the author to harvest them along the banks of local brooks which are similar to hundreds of streams in the Midwest. These reeds grow in large clusters, six to nine feet in height, and a single cluster will furnish enough stout stems to last an artist for several years. In the upper Midwest the reeds reach maturity about the end of July —a desirable time to gather them. Afterward, they should be set aside for a month or two until they are well dried and suitable for cutting into pens.

"The Survivor" by George Grosz.—*Courtesy of The Art Institute of Chicago.*
Reed and steel pens, and black carbon ink.

The physical characteristics of reeds differ, some because of their botanical variety, others through the nature of their habitats or the particular growing conditions of a given year. They may have large or small barrels, thick or thin walls, large or inconspicuous interior hollows, and more or less pith. Some obtained from the Near East have stout barrels of dark brown or brownish-black color. These coloristic and physical characteristics are similar to those of Persian pens described by Chardin after his return from a voyage to the Orient in the late seventeenth century. Those reeds were buried under manure for six months after which they became hard, turned yellow-black in color and could be brought to a high polish.[21] Reeds native to the United States are green in color when cut in the late summer and have a pronounced hollow in their barrels. In this latter aspect, and in their yellow-tan color when dry, they resemble reeds from Holland[22] and appear to be similar to the reeds for writing described in an eighteenth-century French *Encyclopédie*.[23]

The reed pen may be cut in a manner similar to that followed for the quill, insofar as the sides of the barrel are pared away and a slit made up the back of the point. The nibs, although they may be cut into a square, stublike end or to a somewhat pointed shape, will not satisfactorily retain a very fine point. This is because the wall of the barrel is thick, sometimes exceptionally so, and will not allow the cutting of a delicate tip; or if one attempts to diminish this thickness by shaving down the wall to the thinness of a quill, the fibrous structure tends to break down. This fibrous feature of the reed induces a rapid absorption of ink, and a delicately trimmed pen whose point is reduced to a few fibers becomes saturated with the fluid, soon loses its structural strength, and is transformed into a pulplike nub.

The reed produces a blunter stroke than the quill because of its fibrous structure, the thickness and width of the point, and the inflexibility of the barrel. It should not be considered a criticism to say that the reed responds, in the hand of the artist, not unlike a stick, although its hollow form and more fibrous texture are qualitative assets which distinguish it from a slip of wood. Although it lacks the ability to provide an inherent liveliness of linearism when compared to the quill, it has compensating virtues. One of these is the reed pen's effectiveness in producing powerful and sometimes coarse strokes when it is cut to a broad point. Rembrandt exploited both the broad reed and the fine quill with supreme resourcefulness. In "Nathan Admonishing David," as in many other drawings, Rembrandt used the reed to create powerful articulating strokes in the shadows which, at once, provided rich contrasts with the quill-pen details in the light areas of the sketches, and gave an organization to the tonal washes which contributed so much to the atmospheric illusionism typical of his studies.

A reed pen will move across the surface of the paper without the dragging or scoring of a steel pen, although it does not float like the quill because of the reticence of the fibrous point to move easily. Because it tends to ride the crests of the paper's grain, its strokes produce liquid bands of ink when the reed is full, or semidry and mottled trails as the ink runs out.

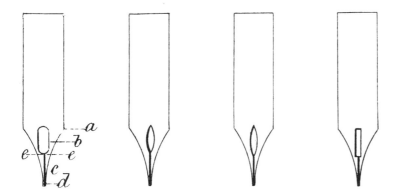

Drawing of Perry's steel pens used in connection with the British patent of 1830.

Consequently, it creates effects which fall between the precise linearism of quill and steel pens and the broad sweeps of brush strokes.

In some old-master drawings it is not immediately apparent whether a quill or a reed was used, although in others the reed or quill strokes are clearly distinguishable. The difficulty in determining which pen was employed occurs when the quill has been cut laterally across the nibs to produce a broad point or when the reed has been trimmed to a modest narrowness in its point. In such drawings one can only watch for the telltale features of the quill-pen lines—the greater variations of width in the line which are caused by the changes in pressure on the pen or the contrast between the dark concentrations of ink along both edges of the stroke and the light center of the line as the quill pen begins to run dry.[24]

There is a tendency for the reed pen to shed ink more swiftly than other types of pens, and this increases in proportion to the width of the nibs. As a consequence, one does not expect the reed to produce lines which are very long and which twist uninterruptedly or meander across the paper. Moreover, because of this feature of the reed, the draughtsman, rather than being induced into a playful manipulation, will usually employ it for lines of modest length, for short, blunt accents, or wide and ragged strokes.

Metal pens

From antiquity to the end of the eighteenth century scattered efforts were made to produce good metal pens with the desire, one may suppose, of fabricating an instrument which would be reasonably permanent, would sustain its point after continuous writing, and would avoid the necessity of frequent cutting and mending. In the last decades of the eighteenth century and the early years of the nineteenth, the incidence of these efforts was accelerated through the repeated attempts of European inventors to devise means of producing metal pens from steel in great quantities.

Although there are historical references here and there to pens made of silver, bronze, brass, and gold alloys, and even the plating of quills with metals, these records almost exclusively referred to instruments for writ-

59

ing. The mention of metal pens in sources concerned with the art of draw-
ing occurred so rarely that one can dismiss the metal pen as of little con-
sequence to the artist until the last century. Norgate, in his seventeenth-
century treatise on art, included a most casual statement: "This statue [of
Hercules] was excellently drawne [copied] with a silver pen upon a large
peece of Table-booke leafe. . . ."[25] And Sir Roger Pratt, architect, in writ-
ing of the methods of architectural drawing, informed the seventeenth-
century draughtsman of "two sorts of pens, either of quills, which must
not be too far slit, for fear of too hastily shedding the ink, or of brass,
which generally are so sharp that they somewhat cut the paper."[26]

The mass production of metal pens was not possible until methods for
stamping, bending, and grinding steel blanks were developed in the early
nineteenth century. Like so many technological successes of recent times,
the manufacture of good pens of steel rested upon a series of progressive
developments by several men. Among them was James Perry, who, in the
third decade of the century, patented and produced a steel pen which had
an aperture at the head of the slit and could be slipped into a holder.[27]
These features, in addition to processes for mass-producing the pens in
many shapes and sizes, gave great impetus to the industry, which had
its center at Birmingham.

Unlike the ready acceptance of the steel pen for writing, artists must
have adopted it with some reluctance since so many drawings of the lat-
ter half of the century were still produced with quills. Nevertheless, the
improvements, which included a diversity of points, greater flexibility to
the steel, and uniform quality, ultimately caused the quill to lose favor
and become nearly obsolete. Undoubtedly, the longevity of the steel point,
which needed no skill for cutting and mending, appeared as a further ad-
vantage and convenience. Today the steel pen is so common that artists
rarely consider other types or are unaware of the wider range of resources
in pen-and-ink drawing achievable by the additions of quill and reed to
their selection of drawing media.

The steel pen became the most satisfactory one for producing the crisp
and uncompromising lines so desirable for reproduction without loss of
effect in books, magazines, and newspapers—a factor which has helped
to fortify its position as the common pen of contemporary artists. Fur-
thermore, modern pen-and-ink papers were developed which provided the
proper surfaces for such pens. Their smooth and uniform surfaces elim-
inated any fibrous particles on which the steel point would catch and
were hard enough to withstand the incising action of the nibs. Moreover,
they were given a brilliant whiteness in order to provide the greatest con-
trast with the preferred jet-black ink. Drawings produced with these mate-
rials usually display an unequivocal image, in some ways similar to those
produced in copper engraved prints: both are seemingly superimposed

"A Reclining Female Nude" by Pablo Picasso.— *Courtesy of The Fogg Art Mu-
seum, Harvard University (The Meta and Paul J. Sachs Collection).* Metal pen
and carbon black ink.

upon the surface in a manner which insures a complete separation of the drawn or engraved image from the background furnished by the white paper.

The steel pen, in conjunction with modern jet-black inks, is an admirable instrument for the creation of drawings with crisply articulated and wiry lines of sharp, staccato-like strokes. It is less suitable for achieving the subtle interrelationships, found in so many old-master drawings, between line and paper which the quill or the reed will produce when used on soft, moderately textured papers.

WORKSHOP PROCEDURES

Steel pens Steel pens of every type, ranging from a stub to a tit-quill point, are available at art supply shops and do not warrant comment relative to workshop procedures since their processing is complete when purchased. However, before using a new pen point one may wish to pass it back and forth immediately above the flame of a match in order to counteract the surface slickness, especially if it has been varnished, and to assure an even flow of ink.

Quill pens Goose quills may be obtained from commercial sources or from poultry or produce companies which dress geese for the markets. Other types of quills are more difficult to obtain. The swan quill is a rare acquisition since the domesticated birds are not raised in great numbers, and wild swans are usually protected by law. For crow quills one must depend upon the hunter. If one has the opportunity to select quills, the largest and stoutest ones near the leading edges of the wings are to be preferred. About ten very good quills may be taken from each wing of a goose, although those of lesser size and strength may be used.

Methods of preparing quills are similar regardless of the type.

1. The vane may be removed easily from part or all of the barrel simply by grasping it between the fingers and pulling downward toward the heavy end of the quill.
2. The membrane covering the outside of the barrel should be scraped off with a knife (also see 5a). If one should elect both to remove the membrane and harden the barrel by heating, a number of quills should be processed at one time. A pot of sand is warmed, and stirred until it is uniformly heated to about 130° to 150° F. (A "low" position on an electric hot plate will provide adequate heat.) The quills are inserted into the sand at an oblique angle or so that the ends will not touch the hot bottom of the pot, for if they are overheated, quills will collapse, turn yellow-orange, and become warped into eccentric shapes. After leaving the quills in the sand for five minutes they should be withdrawn and rubbed briskly with a cloth which will remove the membrane in the form of light flakes.
3. To soften old and somewhat brittle quills, so that they can be cut and

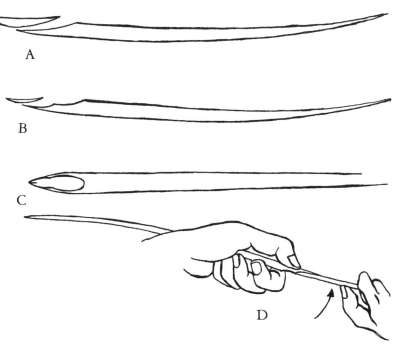

pared with greater ease, the ends should be soaked in warm water for
five or ten minutes.

4. The quills should be cut with the sharpest knife available, and one
 which has a stout blade although not necessarily a thick one. A good
 penknife or an artist's mat knife, honed to a keen edge are preferable
 to a razor blade since they are more maneuverable in the hand during
 the careful paring of the nibs.

5. To cut the shoulders and pare the nibs:[28]

 a. Scrape off the scurf of the membrane, or flakelike scales, with a knife
 so that the outside of the quill barrel will be clean.

 b. Turn the belly of the barrel up. With the blade of the knife make a
 steady but quick cut which slopes toward the end at which the point
 is to be formed. (See A.)

 c. About one-half inch from the end make another sloping cut but at a
 more oblique angle only to about the middle of the barrel. (See B.)

 d. With the knife blade make a short cut up the center of the back of
 the barrel, not more than one-fourth inch in length, in order to form
 the beginning of the slit. (See C.)

 e. Hold the quill tightly in your left hand with the belly of the barrel
 down. Place the thumb nail hard against the back at the point where
 you wish the slit to end. With your other thumb, another quill, or
 the handle of a small brush, force the formation of the slit with a
 sudden upward movement which will split the back of the barrel
 from the beginning of the slit, which you made with the knife, to
 the point where your left thumb is pressed. (See D.)

 f. Pare the shoulders and nibs to form a fine point. If the point is to
 be broader, a chisel-like cut may be made by placing the point upon
 a hard surface and making a beveled cut across the end. (See
 E and F.)

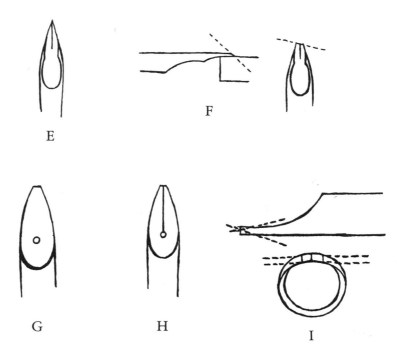

6. Very fine emery paper or sandpaper may be helpful in producing delicate points, the sides of the nibs being drawn lightly over the abrasive surface, first on one side and then on the other. This may also help to rid the tips of any tiny, hair-thin bits of the barrel or assist in making the nibs come to an even point at the end of the slit.

7. The pen should be tested with ink and tried on the paper with the lightest of pressure. If the ink flows unevenly or the nature of the line produced is not the desired one, the pen may be mended by again paring the point. If the point splays with the nibs spreading at the slit, either upon cutting or after some use, it may be turned on its back and flexed until the edges of the slit are joined again.

Reed pens It has been mentioned that native reeds may be obtained throughout the temperate climates of the world and that they are very common in the United States. Once a source is located along the bank of a neighboring lake or stream, enough reeds may be harvested within a few minutes to last for a year or more. Japanese reeds, which are imported for florists or garden supply firms, for supporting plants to which they are tied, make good reed pens. Their price is very modest, and although they are painted green, the color has no effect on their usefulness when cut into pens. Reeds from other foreign sources may be purchased only at some inconvenience through import or foreign export firms. In addition, bamboo pens, expressly prepared as such, have been obtainable at many art supply shops in recent years.

Pens may be made from reeds in the following manner.

1. The reed stem is cut into sections of convenient length; the length of an ordinary graphite pencil is satisfactory. If the joints are far enough apart, the shaft of the pen may be cut between a pair of them so that a point may be shaped for each end. This will permit wide nibs at one end and narrower ones at the other for interchangeable use.
2. After cutting the shaft, remove any pith which remains in the hollow of the barrel.
3. The subsequent procedures for cutting the point are similar to those followed for the quill with these exceptions:
 a. After the initial cutting of the shoulders, but before making a slit, one may drill a hole of moderate size to form a "reservoir" for the ink. (See G.)
 b. The slit is cut entirely with the point of the knife, rather than being finally split by the use of the thumb, quill, or brush handle. It should extend from the drilled hole to the end of the nibs. (See H.)
 c. If the reed has thick walls to the barrel, the inside and outside of the wall, toward the end of the point, may be advantageously shaved with the knife. This will straighten out the curve of the barrel so that a flat surface will be formed by the nibs, and will insure a more uniform transfer of ink to the paper. (See I.)

As in the case of the quill pen, testing by drawing will determine the preferred shape of the nibs, and at the pleasure of the draughtsman the reed may be cut and recut to form new points.

Inks for drawing

It is the custom of contemporary artists to use two commercially prepared types of inks for their drawings: the "waterproof" carbon black, commonly called drafting or "India ink," and a brown ink which is sometimes referred to as "sepia." These are the modern descendants of several old inks of black and brown colors.

The inks used most frequently by the old masters were of four basic types: the black carbon ink, which was usually not subject to color change; the iron-gall "black," which underwent pronounced color and value transformations during and after its preparation; bistre, an ink which was a chromatically strong but very transparent brown; and sepia, a more opaque brown ink, employed principally as a wash. In addition, artists used with less frequency "inks" of a variety of compositions and colors—especially of red, blue, and brown—for both pen and wash work. These "inks" were, in fact, counterparts of watercolors, both in their preparation and in their pigments, which were derived from mineral colors or vegetable and chemical dyes.

Regardless of their compositions or colors, all inks of good quality had to possess certain physical characteristics in order to be useful for pen or brush drawing, or if diluted with water, for wash drawing. Above all, an ink had to flow evenly in order to assure the artist of uninterrupted lines or strokes. Therefore, inks were prepared either from those artist's pigments which had extremely fine texture and solubility in water, or from "bodiless" dyes. Many of the old mineral pigments of the painter would not make satisfactory inks, especially those whose granular particles would settle out of suspension when prepared in a very liquid state, or those which clogged the points of pens. In addition, only mineral pigments and dyes which possessed, in a highly dilute state, either great tinting or value strength, were acceptable. In the case of good black inks it was the dark value which attracted the draughtsmen; in brown or other colored inks it was the combination of chromatic and value strength which made them serviceable.

Medieval treatises on the arts contained numerous recipes for inks, especially those of the iron-gall type, although it was unusual to find instances in which the authors stated that a given ink was to be used for drawing. And the handbooks on art published during and after the Renaissance, which frequently included directions for drawing with pens, more often than not pointedly ignored identification of the inks to be used. It is possible that the artist, from the time of the Renaissance on, often obtained his inks from ink-makers or ink-sellers. Surely this was a current practice by the eighteenth century—a period in which ink-makers such as Ribaucourt and Eisler were building reputations for their products. And Buchotte, in 1754, describes the prices as well as the qualities of "Chinese ink" sticks which were ready-made.[1] Consequently, to form a satisfactory continuity of ink recipes over several centuries, it is often necessary to supplement the references from manuals on art with information found in treatises on writing materials.

The origins of old inks are obscure, but it is known that black carbon inks were prepared by the ancient Egyptians and Chinese,[2] and that during the seventeenth century the standards for fine black carbon ink sticks in the western world were established through their comparison with the inks imported from the Orient. The fundamental basis of preparation was the incorporation of a black carbon pigment into an aqueous binding medium. And in Europe carbon particles from many sources and of varying quality were obtained from the soot of burning oils, resins or resinous woods, or the charcoal of wood, twigs, bones, ivory and the seeds or stones of various plants and fruits. These black particles were ground to a fine powder and combined with binding media made with water and any one of a number of gums or glues.

Black carbon inks

Sometime before the twelfth century, Eraclius, in his *De Coloribus et Artibus Romanorum,* presented a set of directions for making several types of carbon inks including one—somewhat similar to the inks of China—made with the soot produced by burning resin and others prepared with wood charcoal or from charred twigs or peach stones.[3]

Simple, even crude methods of preparing these carbon inks were published in the sixteenth century, although they were proposed not as fine inks but as quickly produced inks which would serve as substitutes for those of the iron-gall type. From a German book of ink recipes, printed in 1531, come the following simple directions: "Take a wax candle, light it and hold it under a clean basin until the soot hangs to it; then pour a little warm gum water into it and temper the two together—and then that's ink."[4] An English volume on handwriting of 1581, presented two recipes for carbon inks:

To make inke in haste.

In hast, for a shift when ye have a great neede,
Take woll, or wollen to stand you in steede,
Which burnt in the fyre, the powder beate small:
With vineger, or water make Inke withall.

To make speciall blacke Incke.

If that common Incke be not to your minde,
Some lampblacke thereto with gumme-water grinde. . . .[5]

By the seventeenth century the carbon ink sticks from the Orient were beginning to be mentioned in the manuals on art. These molded, dried sticks, known as either "Chinese ink" or "Indian ink," were held in high esteem. Their basic ingredients were known even though the sources of fine soots from resins and oils and the perfection of their processing were obscure. Also during this century directions for preparing their counterparts, both good and mediocre, were included in some treatises. Baldinucci described the preparation of ink from soot (*nero di fumo*) and gum arabic water for use in drawing figures and little landscapes.[6] Alexander Browne advised the artist to: "Draw with Indian Ink after the manner of washing, or instead of Indian Ink take Lamp-black or Bread burnt, temper . . . with fair water in a shell. . . ."[7] And another source of black carbon was added by *The Laboratory or School of Arts* which noted: "To Make Indian Ink. Take dry'd black horse-beans, burn them to a powder, mix them up with gum arabic water; and bring them to a mass, which press in a mould. . . ."[8]

In 1764 Dossie revealed the current ambiguity of terminology when he stated that "Indian Ink is a black pigment brought hither from China, which, on being rubbed with water dissolves, and forms a substance resembling ink."[9] Moreover, he complained that no author had described —presumably to his satisfaction—the ingredients of Indian ink. Consequently, he published his own recipe for a counterpart which was composed of isinglass size, Spanish licorice, and ivory black.[10] This differed from formulas of other writers of the West, notably in his use of a glue size instead of the customary gum arabic.

The reputation of the ink sticks from the East not only led to their mention in manuals where no recipes were provided, but also to the application of the terms "Indian ink" and "Chinese ink" to black carbon inks generally.[11] The association of the idea of quality further induced a commercial production of ink sticks in Europe which were counterfeited as coming from the Orient.[12]

Most often these black carbon inks were used alone when they were selected for drawing, and they adequately provided clean black strokes or exceptionally fine gray washes. On the other hand, for more varied effects, black carbon ink washes were sometimes introduced even though the pen work was executed with another type of ink, as is especially noticeable where the pen lines which accompany these gray washes are of a chromatically strong brown hue. Whether the pen strokes were made of bistre or an iron-gall ink which subsequently underwent its customary chemical change and the resulting transformation from "black" to brown is not always easily determined. However, Canaletto in "A Circular Church" and "The Church of the Redentore" chose pen work and tones of warm colored bistre for their contrasts with the cool gray carbon washes of shadows.[13]

And Rembrandt combined bistre and carbon ink washes in drawings such as "Achilles and Briseis."

Although one would ordinarily describe gray washes in drawings as having been made with a diluted ink, it is of no consequence whether they are thought of as a thinned carbon ink or a gray water-color wash, because water colors with their black pigments and gum binders were either analogous or identical to the composition of the old carbon inks. If a given study has no pen work but is drawn with a brush only, one tends to consider the medium to be gray-black water color, but washes made with those materials and the washes prepared from a Chinese ink stick were so similar in their carbon particles that there is no substantial difference.

Black carbon inks were prepared in liquid form for immediate use although the advantage of having the basic materials in a solid state, which minimized both thickening and souring, undoubtedly led to the preferences for the Chinese ink sticks or locally manufactured counterparts. The stick was rubbed with a little water or spittle on a stone, shell, or similar vessel in the same way that we rub up modern ink sticks in porcelain dishes or in the ink saucers of slate made expressly for the purpose. The intensity of the black for pen or brush lines, or the gray of washes, was controlled by the amount of rubbing and the relative proportions of water.

In addition to their permanency, the virtues of black carbon inks were found in the crispness of black lines which could be made with pen and brush, or the smooth flow and even distribution they allowed in laying washes. Although they appeared in drawings of many periods and countries, and seem to have been preferred to other inks for the pen and chiaroscuro drawings of northern Europe in the fifteenth and sixteenth centuries, nevertheless, until the late nineteenth and twentieth centuries they were used by artists to a lesser degree than were iron-gall inks.[14]

The virtues of the old carbon inks are duplicated in their modern counterparts, and contemporary artists select them almost to the exclusion of any other inks principally because of their potentialities for unequivocal linear delineations, jet-black masses, or limpid gray washes. For washes, the modern Chinese ink sticks, the lesser known soluble and liquid carbon inks, and cake or tube water-color blacks are used. The carbon ink most frequently chosen is the "waterproof" drafting or "India" ink. This modern ink is basically the same as the old black carbon inks, but in addition it possesses a water-resistant characteristic due to the addition of shellac or rosin dissolved in borax.[15] Although it is excellent for linear drawings or for setting in masses of heavy black, it is less suitable for the laying of washes than are the above-mentioned inks or water colors.

There is no certainty as to when iron-gall inks became an important *Iron-gall ink* medium of writing or drawing in western Europe. That they had been used for both purposes long before the art of drawing studies and sketches became a significant and even independent artistic activity may be seen in the handscript and ornamentations of medieval manuscripts. The fact that

69

they were primarily writing inks probably explains why the treatises on arts and crafts of the late fourteenth and fifteenth centuries contained recipes for their preparation but neglected to identify them specifically as inks which were to be used for drawing.

Despite innumerable Renaissance drawings produced with iron-gall inks, it was not until the time of Leonardo that we find a reference in the literature of art which associates such inks with old-master drawings. But even Leonardo's note was an indirect association and did not offer a definitive direction for making an acceptable and liquid iron-gall ink although he mentioned the two most important ingredients. Instead, he described an oddity of technical and drawing procedure, which, by its bizarreness, must have amused him: "Take dust of oak-apple and vitriol and reduce it to a fine powder and spread this over the paper after the manner of varnish; then write on it with a pen dipped in saliva and it will become as black as ink."[16]

In a few late seventeenth- and eighteenth-century treatises on art, one at last finds references to drawing with an iron-gall ink, or as it was then designated "common ink."[17] But it was not always of the finest quality, and the authors of the *Traité de la peinture au pastel,* in describing the differences between inks made with Chinese ink sticks and "l'encre ordinaire," made a point of the fact that the commercial iron-gall inks were mediocre.[18]

Meanwhile, as had been the case in the late middle ages, these iron-gall inks were also considered the principal inks for writing. The emphasis placed upon their use was indicated by the numerous recipes included in single volumes, as was the case in at least two editions of *Artliche kunste mancherley weyse Dinten und aller hand farben zubereyten.*[19] Their widespread use was implied, and their identification as "common inks" was stated, by Canepario and in a recipe of de Beau Chesne and Baildon:

> To make common inke of wine take a quart,
> Two ounces of gumme, let that be a part,
> Five ounces of galles, of copres take thre,
> Long standing doth make it better to be:
> If wine ye do want, raine water is best,
> and then as much stuffe as above at the least.
> If inke be to thicke, put veneger in,
> For water doeth make the colour more dymme.[20]

Moreover, the evidence of their employment in old handscript documents, in addition to the extensive efforts to develop improved formulas by the eighteenth-century ink-makers such as Lewis, Eisler, Ribaucourt, and others, testified to their frequent use.

The popularity of iron-gall inks must have been due in part to their fluidity and the practical feature that they could be prepared in large quantities with less effort than other inks required. Furthermore, their widespread availability, because of their use as writing or "common" inks must have encouraged their use by artists while at the same time it discouraged their preparation in the studio.

70

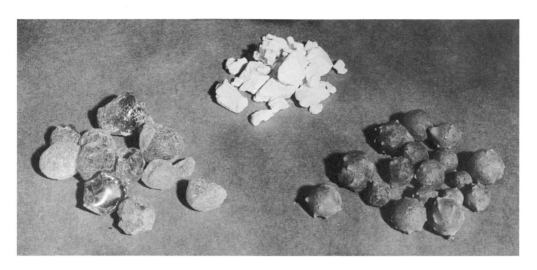

Basic ingredients of iron-gall inks. *Left to right:* Gum arabic tears; iron sulphate lumps; gall nuts.

The principal ingredients of these inks were galls and ferrous sulphate. Unlike most inks used for drawing, their color and value strengths were produced by chemical reaction. Galls of various sorts were found—and still may be—in many countries, although they were not all equally good for ink-making. Those which were considered among the best were imported from the Adriatic, Mediterranean, and Near East regions. The most famous were the *Aleppo* galls. Others were designated as *Turkey, Levant, Smyrna, Tripoly,* and *Istrian* galls. They occurred in nature where the gall-wasps, or similar insects, punctured the branches, twigs, or leaves of oak trees and layed their eggs in the tissues. The resulting irritation caused the tree to form "gall nuts," "gall apples," or "oak apples," in which the larvae developed. As the gall nuts grew, concentrations of tannic and gallic acids were drawn into them. These chemical substances, important for ink-making, were easily extracted by soaking pounded fragments of galls in water. Substitutes for gall nuts were the bark or buds of trees, aloes, or the rind of the pomegranate berry; but references to their use are limited.

The old recipes were simple prototypes of the formulas used for the commercial manufacture of iron-gall inks in the nineteenth century. Galls were crushed then soaked or boiled in water or wine sometimes for as long as six to eight days. After the extract was strained or clarified, ferrous sulphate (Roman vitriol, copperas) was added. The preparation was usually concluded by adding gum arabic although some old recipes proposed the introduction of additional materials.[21]

Iron-gall inks are not as black as concentrated carbon inks, neither at the time of their preparation nor after long exposure to the air. When "fresh," they have a violet-gray or purple-gray color—a characteristic especially noticeable during the ink-making process. The extract of galls soaked in water is a pale ochre color, but this liquid immediately changes to a weak violet-gray or purple-gray upon the addition of the ferrous sulphate. Almost all of the old recipes recommended exposing the finished inks to the air—for as long as eight days—with frequent stirrings so that the inks

TABLE II

Variations in iron-gall inks prepared from old recipes

Source of Recipe*	Ingredients	Appearance after twelve years
De Beau Chesne and Baildon (1581)	1 qt. wine; 5 oz. galls; 3 oz. ferrous sulphate; 2 oz. gum arabic	Slight brown in strokes. Brown corona around edges of drop of ink. Reverse side of paper showed strong brown stains.
Elizabethan Ink	1 qt. rain water, claret or red vinegar (distilled water used); 5 oz. galls; 4 oz. ferrous sulphate 3; oz. gum arabic.	Very slight brownish cast in fine strokes. Black in the heavy accents and in drop of ink.
Eisler (1770)	1 qt. rain water (distilled water used); 4 oz. galls; 2 oz. ferrous sulphate; 1 oz. gum arabic.	Black strokes; black drop of ink. Reverse side of paper showed a very slight tint of brown.
Eisler, "Celebrated Black Dresden Ink" (1770)	2 qts. rain water (distilled water used); 2 lbs. galls; ½ lb. ferrous sulphate; 6 oz. gum arabic; 2 oz. alum; 1 oz. verdigris; 1 oz. salt.	Black strokes. Black drop of ink.
Ribaucourt (1792)	12 lbs. water; 8 oz. galls; 4 oz. logwood; 4 oz. ferrous sulphate; 1 oz. copper sulphate; 1 oz. sugar candy; 3 oz. gum arabic.	Black strokes. Black drop of ink.

* De Beau Chesne and Baildon, page unnumbered; Elizabethan ink, *Arcana Fairfaxiana Manuscripta*, p. 4; Eisler, "Celebrated Black Dresden Ink"; Eisler as quoted in Mitchell and Hepworth, pp. 93, 94; Ribaucourt, *Dissertation sur l'encre ordinaire á écrire, par Ribaucourt*, Annales de Chimie, 1st ser., XV, 151, 152.

would darken as much as possible before use. The advantage of this process of exposure or aeration can be observed by making a few pen strokes with fresh iron-gall ink. The pale lines gradually darken, and if a good recipe is followed, within an hour or so they will appear nearly black in the areas where the ink has concentrated. The necessity of exposing iron-gall inks for several days was eliminated by ink-makers of the late eighteenth century through the addition of "provisional" colors. These dyelike substances included indigo, the purplish and reddish extracts of logwood and Brazil wood imported from the Americas, and at a later time aniline dyes. They were added to give the inks temporary color strength until the iron-gall darkened as the pen strokes lay exposed upon the paper.[22] Apparently these commercially made iron-gall inks with provisional colorations were commonly used by artists of the time, because the authors of the *Traité de la peinture au pastel* informed their readers that if they should care to prepare an ink themselves, and exposed it to the air for five or six days, it was not necessary to include the logwood or Brazil wood of the commercial inks.

Although there is no way of determining how quickly old iron-gall ink drawings changed from "black" to brown, this color transformation

occurs after a number of years and is a phenomenon known to every one acquainted with old handwriting. The variations in time necessary for iron-gall inks to turn brown may be recognized from the results obtained by preparing inks from several old recipes (Table II).

In many old-master drawings this color transformation is complete; in others the change is still in progress. Van Gogh's "Tree in a Meadow," a vigorous drawing originally made with powerful black strokes, now has numerous pen lines which have become so brown that the contrast with the black strokes is clearly observable. A less striking example, because the brown is just beginning to be perceptible in a few of the pen lines, is Corot's "View of Mt. Soracte from Città Castellana." This transformation in iron-gall inks not only caused a changed color sensation; it also made the strokes of the drawings lighter in value and reduced their contrast with the papers. Consequently, many of these drawings present effects which are quite different from those which existed when the drawings left the hands of the artists.

Some of these old inks changed color more quickly than others depending upon the particular recipe used and the unpredictable potency of the galls or ferrous sulphate on hand at the time the inks were made. Ordinarily, one expects to see the first evidences of brown in the thinner and more delicate strokes because of the limited concentration of the ink, but in comparing drawings such as the van Gogh and Corot mentioned above, it will be seen that the thinner strokes of the Corot have changed less than those in the van Gogh drawing even though the former was produced a number of years earlier.

In some instances the old iron-gall inks were destructive of drawings, although these were exceptions rather than the rule. An extreme acidity, and possibly the formation of iron oxide, caused a corrosive action which ate through the paper fibers.[23] An example is "Three Figures" by Luca Cambiaso, in which curving gaps, where the paper has been eaten away, trace the former positions of some of the pen and ink lines.

At times one may find the familiar variations from black to brown within single strokes of old-master drawings. At other times, the transformation of the iron-gall ink lines has proceeded so far that the brown coloration approximates that of some bistre inks; especially in those cases where a bistre exhibits a "dirtiness" from inadequate filtering. Generally, the brown state of old iron-gall strokes is more opaque than that of bistre and often, in spots where the inks formed concentrated accents or drops, it is very little darker in its value than it is in the thinner strokes.[24] This is in contrast to the effects in bistre, because bistre, although never very dark, usually retains distinct variations in value between the transparent light strokes and the deep resonant brown of the accents.

The probabilities that an iron-gall ink will serve the artist well, as with any other artistic medium, depend upon the existence of proper conditions. In a very fluid state it works well with the quill and reed if the drawing is executed on a soft-surfaced paper. To use it with the exceedingly nonabsorbent, hot pressed papers so popular for commercial drawings of our day

exaggerates its slow drying properties and accentuates its tendency, when in a "fresh" state, toward transparency. Under such conditions it will present a somewhat watery appearance and possibly offend the impatient draughtsman who wishes to crosshatch his strokes without delay. In these physical characteristics the old iron-gall inks are not dissimilar to contemporary commercial writing inks, a resemblance which once again recalls to mind that they were the prototypes of modern writing and fountain-pen inks.

Bistre ink A third ink used in old-master drawings was bistre. This brown ink was prepared by extracting soluble tars from wood soot. Apparently bistre had little or no use in writing, and therefore it is not surprising that references to it occurred principally in manuals on art. In 1431, Jehan le Begue included in his Table of Synonyms a reference to bistre-like substances under the headings *caligo* and *fuligo*. Of the first he wrote: "Caligo is a color, namely that dark yellow matter which the smoke of fire produces in fireplaces under which there is a continuous cooking fire"; and he described *fuligo* as a substance of "black or blackish color which tends toward yellow. It gathers in a fireplace and is otherwise called caligo." Neither description suggested that *caligo* or *fuligo* was to be used for the preparation of an ink; and le Begue's reference to the latter also included the very different carbon black produced by candles and lamps.[25] However, his mention of fireplace soot and the yellowish color, coupled with the fact that his terminologies were antecedents of those used by the Italians of a later time, suggests a close association with bistre. In 1585 Lomazzo included *caligine* among the brown pigments which served for water colors, and clearly distinguished this soot from lampblack.[26] And Baldinucci, in 1681, although he did not indicate that a brown color was made from his *fuliggine* and *fuligine,* wrote of the black soot of the fireplace as its source and of its use in water-color drawing.[27] Meanwhile, Hoogstraeten referred to it as *schoornsteenroet,* and Salmon called it "wood soot."[28]

The French term "bistre" is of unknown origin. According to Bloch it appeared in the sixteenth century, but the first use of the term in a treatise on art with which the author is acquainted was that of de Mayerne in the seventeenth century, where it was included in a simple list of colors.[29] However, by the end of the seventeenth century, bistre was the accepted term for this brown pigment dissolved in water, whether used as an ink, a wash, or as water color.[30]

Old recipes indicated that the bistre was extracted from wood soot in various ways, such as soaking or boiling the soot in water, grinding the soot with wine then diluting with water,[31] or as one recipe directed, dissolving out the bistre with child's urine.[32] The most elaborate set of instructions was provided by Buchotte:

"Three Figures" by Luca Cambiaso.—*Courtesy of The Art Institute of Chicago.* The eating away of the paper along many of the lines, indicating the use of an unusually strong iron-gall ink, may be found in this drawing.

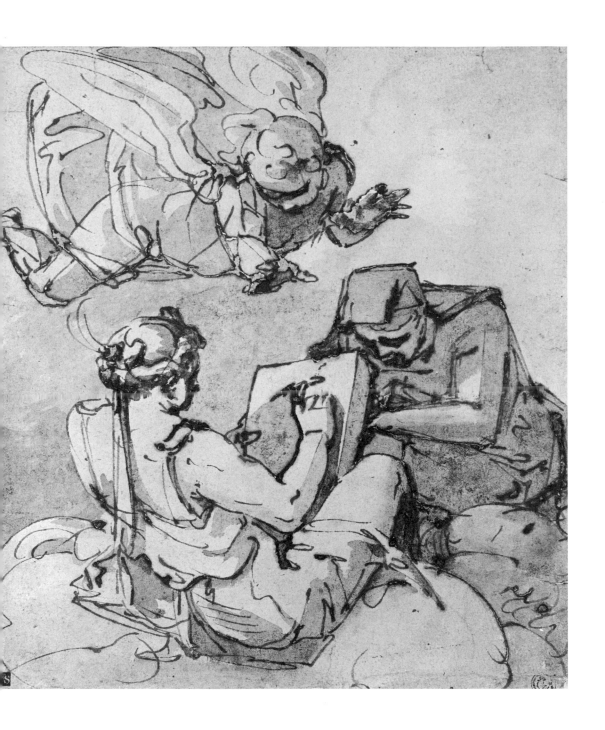

Take the shiniest possible chimney soot, crush it, and steep it in water on hot ashes until the liquid becomes strong enough in color, and filter it, as we have mentioned, to clarify its color.

When one wishes to have dry bistre, dry it in shells in the sunshine, or in the oven in winter when the bread is removed, refilling the shell as the liquid dries; and if it is in the oven, one must be careful not to let this liquid burn. One recognizes that it is dry when it is of the consistency of soft wax, or honey, and not like stone; because in that case the gum of the bistre, being too dried out, will not distemper itself.

Note 1. The liquids must be cold when they are filtered; because if they are hot, the heat will open the pores of the paper too much and a fine sediment will pass through with the liquid, destroying the beauty of the color.

Note 2. In case one has no glass funnel, he can make one with a common drinking glass of conical shape, but not with a glass shaped *en culotte de Suisse,* by cutting off the stem, so that it can be pierced; this is easy to do by putting a thick string covered with sulphur around the narrowest part of the glass; a flame is then applied, and when the string is burning all around, the stem of the glass is dipped in cold water up to the sulphured string, where it will break off cleanly, which is what is wanted; or else one could have it cut by a glazier.

Note 3. And finally, contrary to what we said above, it is not absolutely necessary that the chimney soot be shiny.[33]

The comment of Buchotte that one should not let the bistre dry out completely because the natural binding properties would be destroyed is a feature which we have not observed despite the thorough drying of bistre in evaporating dishes. It is true that dry bistre does not work up into a wash or ink easily, but then one may grind it to a powder which is readily soluble and produces an ink or wash of good binding properties. This grinding procedure was used, along with the addition of gum arabic, when bistre was formed into little cakes to be sold to artists.[34]

Any fireplace wood seems to produce a satisfactory soot, although there is no way of predicting exactly the color of the bistre extract. In the upper Midwest, where so much oak is burned, the color will vary from a brown to a golden brown. Bistre made from the soot of birch logs will produce a yellow-brown of strong chromatic intensity but of a light value, even when it is highly concentrated. Most of the old manuals neglected to mention the wood preferred although several recommended bistre made from the soot of beech wood.[35]

In order to make a clear and transparent bistre it is necessary to strain or filter the coarse carbon residue from the liquid, although this step in processing was rarely mentioned in old recipes. After the transparent brown solution is concentrated by boiling or evaporation, one may increase its lustre by adding gum arabic, although this too was infrequently suggested in old manuals.[36] The omission of the gum, which seems to have been common, was possible because in most instances bistre possesses sufficient binding

"Lady Hamilton as Ariadne" by George Romney.—*Courtesy of The Art Institute of Chicago.* Brush and bistre.

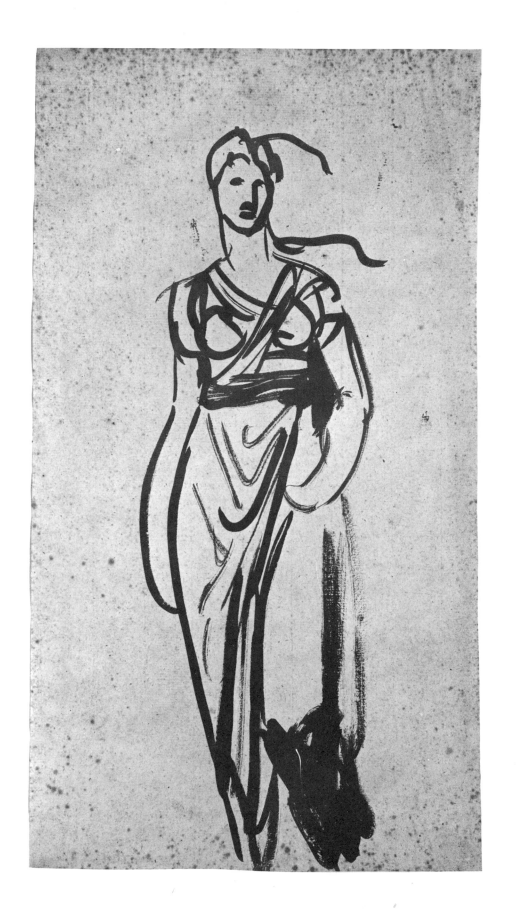

properties within itself. The addition of a gum binder has its greatest advantage when a very absorbent drawing paper is used, because it helps to hold much of the ink above the surface and minimizes the possibility that the bistre may be drawn into the fibres—a condition which can cause its brown color to change to a dull gray.

When evaporated to a solid, bistre will become coarse and crystalline in its structure. And if it is not carefully reground a granular texture may occur in the ink or wash which is made from this dry bistre and water. This "horny" effect, as well as a chipping or flaking of the dark brown lines, may be seen in old drawings, among them the "Deposition from the Cross" tentatively attributed to Salvator Rosa.

It has been mentioned that bistre made without gum arabic will soak into absorbent papers with deadening results, the warm brown color being transformed into an innocuous gray or grayish-brown stain. This may be noticed most frequently in areas of drawings where a drop, or a heavy pen accent, has sunk into the soft paper leaving a dull, opaque gray within the center of the dark bistre concentration. This is clearly observable in Rembrandt's "Two Studies of a Woman Reading," and to a lesser degree in "Two Female Figures" by Tiepolo. Often these fortuitous effects created contradictions in modeling because where the artists intended the deepest darks to occur there appeared light gray spots ringed by dark brown.[37]

Other unusual effects occur when the luminous transparency and chromatic clarity of bistre are minimized by coarse, black wood-soot particles due to incomplete filtering or straining. This type of black residue appears in many old drawings including Tiepolo's "Two Figures and Amorini" and Rembrandt's "Noah's Ark." On the other hand, these masters, and innumerable others, produced works with beautiful golden or yellow brown bistre as did Romney when he made his brush drawing of "Lady Hamilton as Ariadne."

The prime attractions of good bistre ink are its transparency and its glowing, and at times almost radiant, color. Because the darkest concentrations of it never approach black, its potential value range is limited. Nevertheless, it has the ability to create striking light, dark, and coloristic contrasts which the artist may find to be handsome resources for drawings requiring warm and resonant pictorial illusions. In order to enjoy these effects which a good bistre may provide, the artist must prepare his own ink since true bistre is not available commercially.[38]

Sepia ink Although sepia cannot be considered one of the principal inks of the draughtsmen, its use for drawings and especially washes in the nineteenth century, and the widespread use of the term "sepia" to designate brown inks or colors, have given it some importance. The original sepia was made from the dark brownish-black liquid which cuttlefish and squid dis-

"An Artilleryman Leading His Horses into the Field" by Théodore Gericault.
—*Courtesy of The Fogg Art Museum, Harvard University (The Meta and Paul J. Sachs Collection).* Graphite sketch, brush and sepia.

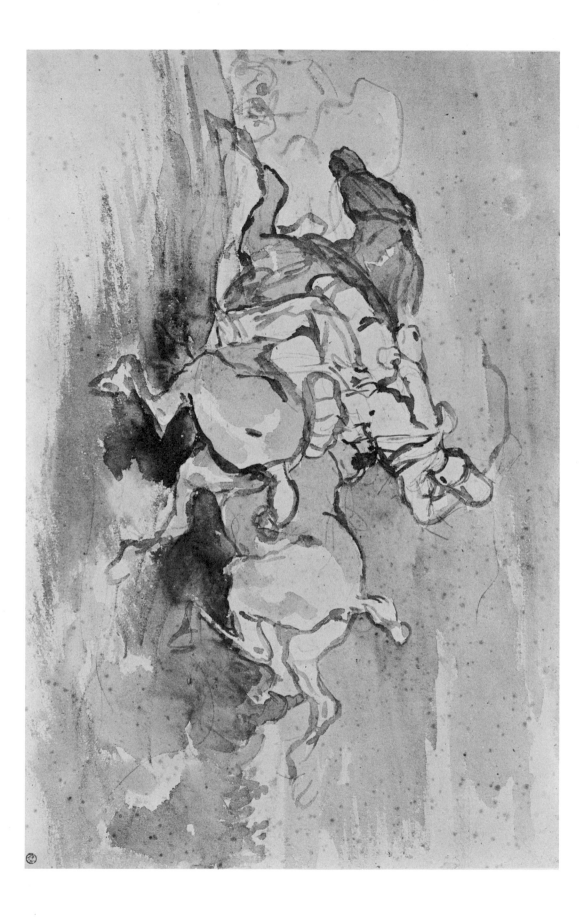

charged from their ink sacs in order to provide self-protection by beclouding the surrounding water.[39] Both of these marine animals, native to the Mediterranean and Atlantic, were sources although the inky liquid from the sacs of the cuttlefish was preferred.

Joseph Meder has pointed out that, considering the written evidence, it is difficult to accept the frequent assignment of sepia ink as the medium chosen for many old-master drawings which were created before the nineteenth century.[40] This widespread and often undiscriminating identification of sepia with so many drawings of earlier centuries seems to have arisen in the nineteenth century when the term was broadly applied to almost any aqueous, brown, artists' color.

Upon examination of the older manuals on art which list or discuss media of ink and wash drawing, one notices the obvious omissions of sepia. Even the *Encyclopédie ou dictionnaire raisonné* of the mid-eighteenth century gave no hint of its use as an ink for pen drawing, considering it sufficient to note its source and the erroneous claim of the Dutch naturalist Jan Swammerdam that the "Indeins" made "Chinese ink" from it.[41] And when, in the nineteenth century, sepia was included in some of the instructional manuals, it was associated with wash or water-color drawing rather than being specifically identified as an ink for pen work. Such is the case in the instructions for working *à la sépia* by Constant-Viguier and de Longueville who also gave extensive directions for its preparation:

Many [cuttlefish] are found in the Mediterranean, the Adriatic Sea, the Atlantic Ocean, and in the English Channel.

The bladder of this fish, filled with liquid, is dried in the sun, and a sort of cluster is made of a large number of these bladders, which is sold to color manufacturers. . . .

To prepare the color contained in the bladder, one begins by pounding a large number of these bladders and putting the dry color which they contain to soak in a glazed vessel full of pure, boiling water. One dilutes this color well, and should be sure to stir it five or six times, then let it stand.

The water is decanted four different times, and the sediments which are floated off serve to make cakes of high quality. The residue makes a color of second quality.

When the different sediments are very dry, they are separately ground on porphyry, mixing them with a solution of gum arabic with a small addition of sugar candy. Then the mixture is scraped together with a knife of horn or ivory, in order to put it into moulds and make cakes of it.[42]

The difficulty in finding drawings which without question were produced in sepia is complicated by three factors. First, sepia is rather similar in color and covering power to several other brown pigments. Sec-

"L'Invocation à l'Amour" by Jean-Honoré Fragonard.—*Courtesy of the Cleveland Museum of Art (Purchase from the Grace Rainey Rogers Fund).* Brush with brown water color heightened with white.

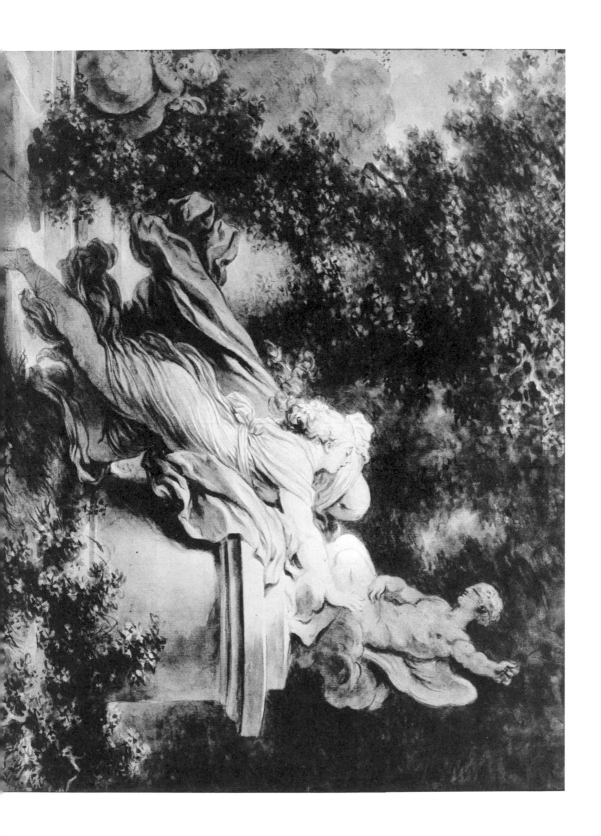

ond, written descriptions of the medium express a diversity of opinion as to its hue. And third, in the preparation of washes it seems to have been mixed with many different pigments—a feature which would tend to obscure its true characteristics.

As to the first factor, we know that earth colors such as Cologne earth, Cassel earth, Vandyke brown and Mars brown, although less transparent than sepia in light tints, were, nevertheless, similar in color and character and were used for washes and water colors. As for the description of the color of sepia, de Longueville indicated that it was a "russet brown," Field as a "dusky brown," Church as "of a redder or warmer brown hue than bister, but . . . not so reddish as Vandyke brown," and Lemoine and du Manoir as "blackish brown."[43] Our own experiments with genuine sepia and commercially prepared colors made from genuine sepia reveal that it was closer to the "dusky brown" of Field than to the other descriptions. Certainly it is not warmer than a clear bistre, as Church mentioned, and it possesses a coolness which is contrary to de Longueville's statement that "elle est chaude d'effect."[44] The mixing of sepia with other pigments in order to obtain washes of varied coloration seems to have been practiced frequently. De Longueville, in his description of the preparation of sepia into little cakes, stated that "some color manufacturers mix it with bistre, or Cassel earth, or madder lake."[45] In his table of color mixtures he listed gomme-gutte and sepia, carmine and sepia, chicory and sepia, and Chinese ink and sepia—mixtures whose hues ranged from yellowish and reddish browns to brownish black.[46] In addition to pure sepia, Field noted two prepared mixtures which were identified by titles. These were "Roman Sepia" to which yellow pigment had been added, and "Warm Sepia" produced by mixtures of sepia and reddish browns; both being designations which are now applied to water-color mixtures. Moreover, as water colors, Field described fifteen distinct mixtures of sepia and other pigments which could be used for landscape rendering.[47]

Therefore, the lack of references to sepia before the nineteenth century and the complex conditions surrounding its ultimate use would justify a reticence to accept the widespread attribution of sepia as the medium of innumerable old-master drawings, and especially pen drawings. One cannot exclude arbitrarily the possibility of the use of sepia in earlier periods, for there are drawings whose washes closely approximate it, as for example those in Giovanni Paolo Pannini's "Ruins of Roman Arches." However, in most drawings produced before the nineteenth century the warm washes, when obviously not executed with bistre, or an iron-gall wash which has become brown, appear to be made with simple or mixed water-color pigments. This must have been the choice of media in drawings by Poussin where the dark brown or reddish washes are clearly not bistre, in such works of Claude Gellée as the "Landscape with Centaur," or Fragonard's "L'Invocation à l'amour."

Once sepia is mixed with other pigments the modification of the color compounds the difficulties which attend any assignment of the medium to given drawings. However, one finds nineteenth-century studies which pre-

sent the characteristic dusky brown and smooth, fluid tones which one comes to expect from genuine sepia; among them are "An Artilleryman Leading His Horses into the Field" by Gericault, or Auguste Raffet's "Sketch for 'La Caricature.' "

Other brownish pigments for ink and wash

In addition to the combinations of sepia with other pigments, the nineteenth-century manuals on art noted that many of the artists' pigments were used in their own right for wash drawings. For example, brown washes were made with Cassel earth, Cologne earth, burnt umber, sienna earth, Mars brown, Vandyke brown, bistre, and chicory. And artists of earlier centuries, in addition to preparing washes with some of the above, used brown ochre, burnt ochre and terra Japonica.[48]

On occasion artists modified Chinese ink in order to obtain a brown or reddish color. Hoogstraeten observed that the draughtsman might use an ink to which natural red chalk dust or bistre was added.[49] The *Encyclopédie ou dictionnaire raisonné,* in the section on drawing and washes, stated that Chinese ink was sometimes diluted with a little bistre or "sanguine" (natural red chalk),[50] and de Longueville wrote of combining Chinese ink and carmine.[51] Because these references clearly indicated the readiness of artists to modify inks in order to obtain desired tints, it would be impossible to do more than speculate on which old-master drawings were produced with any one of these mixtures.

Colored inks and washes

Artists always demonstrated a preference for monochromatic pen and wash drawings in either black or brown. Nevertheless, colored inks or washes were selected with sufficient frequency that they warrant discussion. The extremes in the uses of chromatic inks and washes were, on the one hand, pen drawings composed with a single colored ink, and on the other, drawings which required an array of colored washes. An example of the former is the detailed figure composition, "Tartars at Prayer" by Auguste Raffet, a drawing in quill pen and a magenta-red ink. A more varied, but still modest, range of colors may be seen in Georg Pecham's "Acteon," created with fine black pen lines and washes of pale gray, blue and brown. Representative of studies which display an unrestrained use of many colored washes, often so extensive that the works tend to invite judgments by standards applied to water colors, are drawings such as Jordaens' "Assembly of the Gods." This florid drawing was sketched in natural black chalk, accented with natural red chalk, and the figures composed with brush and washes of ochre, pink, light blue, blue-gray, brown, and green.

From the old manuals one can assemble an impressive list of substances which furnished ingredients of colored inks and washes over several centuries. However, the great number and the similarity of many of them in their chromatic characteristics, make it extremely difficult to try assigning them to given drawings. Meder with his vast knowledge of drawings, presented an informative discussion of the distribution, historically, of colored ink and wash drawings in various countries and centuries. However, it is

TABLE III

Pigments and dyes available to draughtsmen

Color	Substance	Use
	The Fourteenth Century and Before	
Red	Ivy sap	Writing[E]
	Brazil wood	Writing,[A] Drawing[A]
Yellow	Saffron	Writing[St]
Green	Juice of nightshade leaves	Pen[E]
	Indigo + orpiment	Writing[A]
	Ultramarine + orpiment	Writing[A]
	Verdigris + juice of French flamma (gladiola)	Writing[A]
	Brass powder + vinegar or wine	Writing[St]
	Honeysuckle berries + iron rust	Ink[St]
	Fifteenth Century	
Red	Brazil wood	Writing[J, B]
Yellow	Saffron	Writing,[J] Drawing[B]
Blue	Azure	Pen,[B] Writing[B]
Green	Brass filings + salt + sal ammoniac + vinegar	Ink[J]
	Juice of rue or parsley + verdigris + saffron	Writing[J]
	Juice of dark blue iris	Drawing[B]
	Verdigris	Writing[B]
	Sixteenth Century	
Red	Brazil wood	Ink,[K] Writing[M]
Purple	Turnsole	Wash[L]
	Whortle berries	Ink[K]
Yellow	Saffron	Ink,[K] Wash[L]
Blue	Indigo	Ink[K]
Brown	Fish or ox gall	Ink[K]
Green	Buckthorn berries	Wash[L]
	Seventeenth Century	
Red	Brazil wood	Ink[S]
Purple	Turnsole	Wash[P]
Yellow	Yellowberries	Wash[S]
	Buckthorn berries	Writing[P]
	Saffron	Wash[P]
	Gamboge	Wash[P]
Blue	Indigo	Ink,[P] Wash[S, G, Pr]
Green	Juice of rue	Wash[P]
	Juice of blue iris	Wash[P]
	Verdigris + juice of rue + saffron	Writing,[P] Wash[P]
	Verdigris + litharge + quicksilver	Writing[P]

TABLE III—*Continued*

Color	Substance	Use
Green	Verdigris	Writing[P]
	Juice of black nightshade	Writing[P]
Yellow-green	Saftfarben (sap color)	Wash[G]

Eighteenth Century

Color	Substance	Use
Red	Cochineal (carmine)	Wash[T, D]
	Madder	Wash[T]
	Campeachy (logwood)	Wash[T]
	Brazil wood (Fernambouc)	Wash[T, D]
	Vermilion	Wash[D]
Purple-violet	Archal moss	Wash[D]
	Logwood	Wash[D]
	Blackberries + alum	Wash[T]
	Mulberries + alum	Wash[T]
	Bloodwort berries	Wash[T]
	Phytolacca berries + alum	Wash[T]
	Elder berries + alum	Wash[T]
	Currant berries + alum	Wash[T]
	Raspberries + alum	Wash[T]
	Black currant berries + alum	Wash[T]
	Black cherries + alum	Wash[T]
	Fruit of black mulberry tree	Wash[T]
Yellow	Tumeric root	Wash[D]
	Gamboge	Wash[T, D]
	French berries*	Wash[D]
	Zedoary root	Wash[D]
	Bile or gall stones	Wash[D]
Fawn	Tormentil root	Wash[T]
Blue	Indigo	Wash[T, D, Da]
	Litmus (archal moss + purified urine)	Wash[D]
	Prussian blue	Wash[T, D]
	Bloodwort berries + alum	Wash[T]
Green	Petals of blue iris	Wash[T]
	Verdigris	Wash[T]
	Buckthorn berries	Wash[D]

*Bancroft wrote that "the unripe berries of the *rhamnus infectorius* of Linnaeus, are called French berries, and chiefly employed for preparing a lively, but very fugitive, yellow for topical application in calico printing."—Bancroft, II, 106–7.

REFERENCES for Table III

A. Alcerius (A Treatise Upon Colours of Various Kinds), in Merrifield, I, 270, 272, 282, 286.
B. Bolognese MS (Secrets for Colours), in Merrifield, II, 408, 410, 442, 430, 440, 450, 480, 500.
D. Dossie, I, 178 ff.
Da. D'Argenville, p. xvii.
E. Eraclius (On the Colours and Arts of the Romans), in Merrifield, I, 192, 194, 200.
G. Goerce, in Berger, IV, 432.
J. Jehan le Begue (Manuscripts of Jehan le Begue), in Merrifield, I, 54, 58, 66, 310, 312.

K. *Artliche kunste mancherley weyse Dinten und aller hand farben zubereyten,* pp. 9, 10, 11, 14.
L. Lomazzo, p. 192.
M. Marciana MS (Divers Secrets), in Merrifield, II, 612.
P. Paduan MS (Recipes for All Kinds of Colours), in Merrifield, II, 648, 650, 652, 658, 662, 666, 668, 676, 678, 682, 684.
Pr. *Les Premier elemens de la peinture pratique,* p. 13.
S. Salmon pp. 104, 213.
St. Petrus de S. Audemar (Book of Master Peter of St. Audemar, on Making Colours), in Merrifield, I, 122, 131, 158.
T. *Traité de la peinture au pastel,* pp. 174 ff.

clear that the number of color substances which he suggested for the inks and washes of these drawings was far too limited.[52] The tremendous diversity of pigments and dyes available to earlier draughtsmen may be inferred from the accompanying table (Table III), although these lists cannot be assumed to be a definitive inventory of color sources. The number has been limited by excluding inks and wash colors discussed in preceding sections, and chemical pigments and dyes such as the aniline and coal tar colors of the latter half of the nineteenth century.[53] Moreover, many colors were omitted because they were not specifically recommended for inks or washes in the manuals on art. Despite these restrictions the number and the variety of ingredients recommended for colored drawings are impressive.

WORKSHOP PROCEDURES

Black carbon inks

For inks or washes the artist may choose from many commercial products including Chinese ink sticks, water-proof drafting ink, liquid black carbon ink, or ivory black water color in tubes or pans.

If he wishes to prepare a counterpart of Chinese ink, which when diluted produces fine washes, it may be done cheaply and easily in the studio or workshop:

1. Take 8 ounces of water and heat it almost to the boiling point.
2. Remove it from hotplate and add 1 ounce of rabbit-skin glue, stirring until the glue is completely dissolved.
3. Into a mortar place 1 level tablespoon of lamp-black dry color of good quality, such as one may purchase from suppliers of artist's pigments.
4. Add 2 teaspoons of the hot glue size and work the lamp black into the glue with a pestle. Although the two ingredients do not seem miscible at first, vigorous, circular grinding will produce a smooth paste within one or two minutes.
5. Continue the grinding until the mixture is well worked, then add 1 teaspoon of the hot glue size, and work it into the paste.
6. One may then follow one of two procedures in forming the stick or cake of ink:
 a. Pour the mixture into a shallow porcelain or glass receptacle to dry. Although it will not affect the quality of the ink, the stick or cake will crack or warp during the drying process.
 b. Instead, one may pour the cream-thick ink into a receptacle, stirring and working it as the moisture evaporates until it may be pressed into a semi-solid stick form. It is then covered, or wrapped in wax paper, and slowly dried throughout.
7. As in the case of Chinese ink sticks, the liquid ink may be easily prepared to the proper consistency and intensity by rubbing the sticks with a proper amount of water, in a porcelain dish or a slate ink-saucer.

Iron-gall ink

For an iron-gall ink one may follow a recipe such as that of Ribaucourt. Reduced in quantity, it may be prepared as follows:

86

1. Take 3 pounds of water, 2 ounces of gall nuts (which may be crushed with a hammer after wrapping the galls in a cloth or cloth bag), and 1 ounce of logwood shavings.
2. Boil the above for an hour or until the liquid is reduced by half.
3. Strain the liquor through several layers of cheesecloth until the coarse particles are removed.
4. Add 1 ounce of ferrous sulphate, ¾ ounce of powdered gum arabic, ¼ ounce of copper sulphate, and ¼ ounce of powdered sugar.
5. Stir this from time to time so that the ingredients become thoroughly dissolved, especially the gum arabic.
6. Let the ink stand for 24 hours, and decant the clear ink carefully so that the sediment will not be disturbed.
7. If the ink is not sufficiently dark, one may place it in a shallow vessel and agitate or stir it from time to time in order to expose it to the air.
8. Pour into bottle with screw-on cap.

An iron-gall ink of fewer ingredients may be prepared by following the recipe of Eisler. Reduced in its quantity it may be made as follows:

1. Take 1 pint of water, 2 ounces of crushed gall nuts and boil as above or soak overnight.
2. Strain the liquor, then add 1 ounce of ferrous sulphate, ½ ounce of powdered gum arabic and stir until thoroughly dissolved.
3. Let the ink stand for 24 hours and decant the clear ink. It, too, may be poured into a shallow vessel and stirred in order to darken, as described above.
4. Pour into bottle with screw-on cap.

Bistre

For bistre only wood soot may be used. Because the density of soot varies greatly, not only between fireplaces but according to its location in a given fireplace, there are no fixed proportions of soot to water which may be recommended. The soot can be gathered easily by laying an open newspaper on the hearth onto which the soot will fall when scraped off of the walls with a piece of cardboard or blunt knife.

1. Take the soot and place it in a porcelain or glass pan, or part of a double boiler. Add water until it more than covers the soot or the soot seems to float in the water.
2. Boil the wood soot and water about 45 minutes; then strain it through several layers of cheesecloth. At this stage the liquor will be dominated by fine black particles, but good soot will begin to display a brownish cast if held to light in a glass vessel.
3. Continue boiling for another hour or so; remove and let cool.
4. When cooled, filter the liquor through a funnel and filter paper as many times as it is necessary to produce a clear brown liquor without any fine particles of black residue.
5. Test with a pen for darkness. If the bistre is too light in value, the water must be reduced either by boiling or evaporation until the bistre is a rich, dark brown color.

6. When the bistre has become dark brown it is preferable to bottle it (adding a few drops of sodium benzoate, 1 per cent solution) rather than to permit it to evaporate completely. If it becomes dry, it assumes a somewhat crystalline character and must be regenerated into a fluid ink by grinding with water.

7. A few drops of the dark bistre may be diluted with a little water in order to obtain a lighter value for washes or even light strokes with the pen. The dark bistre is useful for accents or pen work of rich contrasts.

8. Because bistre possesses natural binding properties it is not necessary to add gum arabic in most instances. However, if it is to be used on absorbent paper the addition of gum arabic water will tend to hold the bistre on the surface and prevent a dull, grayish brown appearance. If one prefers more brilliant darks, gum arabic will tend to give the bistre more resonance. But too much gum arabic should not be added or the bistre will become thick, and heavy strokes or accents will run the risk of peeling or cracking—a condition common to any aqueous medium too heavily loaded with gum arabic.

Sepia Although sepia ink may be prepared in the studio, the difficulties and expense associated with obtaining genuine sepia and the patience required for processing it may discourage the artist. Therefore, one may prefer to purchase the little cakes or pans of water color as long as it is certain that they have been prepared from *genuine* sepia, as is the case with some color manufacturers. These cakes or pans may be softened with water and the pigment diluted to any desired strength.

Genuine sepia imported from Italy may be acquired in the form of chips as long as a half-inch to an inch, or as coarse particles. These latter have the appearance of short splinters, very dark in color, and have a powerful fishy odor. They are very hard and considerable grinding with a ground glass slab and muller is necessary to reduce them to a fine powder. Because sepia is insoluble in water, the pigment must be ground to this extremely fine state; but even then, with an addition of gum arabic water it is difficult to keep the sepia pigment in a good state of suspension for long. Therefore, if one should wish to prepare sepia, it is desirable to make little cakes by mixing the sepia powder with gum arabic water, letting them dry out, and rubbing them up with water as one needs an ink or wash.

The broad drawing media

Chalks, pastels, and crayons

Charcoal and graphite

Chalks, pastels, and crayons

The references to chalks, pastels, and crayons in the historical literature of art had many ambiguities, and the distinctions among these drawing media have often been obscured by the use of undiscriminating terminology. For example, the words "crayon," "craion," or "crion" were used by French and English writers in referring to such diverse drawing instruments as chalks, pastels, sticks of colors prepared with fatty binders, graphite sticks, graphite pencils, and even metallic styluses.

To some extent, this confusion in terminology still exists, and consequently, a discussion of chalks, pastels, and crayons requires a definition of some simple categories. First, there were the natural chalks, or those mineral substances which were mined from the earth, fashioned into sticks with saw and knife, and without further processing, used for drawing. A second category included the fabricated chalks and pastels, which were prepared into pastes by mixing water-soluble binding media with dry pigments and sometimes with additional substances such as inert clays. These colored pastes were then rolled, or pressed, into sticks and dried. A third group was composed of crayons which were made with powdered pigments, and occasional additions of other dry materials, but mixed into pastes with either binders of an oleaginous or fatty nature or with binding media which combined fatty and water-soluble substances.

Natural chalks

The old natural chalks were made from a few colored earths, which in their natural state satisfied the requirements of a good drawing instrument. The pigmentation of these earths had to have enough density to produce strong black, white, or colored lines. Moreover, this pigmentation had to be consistent in color and well enough distributed throughout the mass to insure uniformity in both the color and the value of the drawing strokes. Although a natural cohesiveness was necessary in order that these earths might be sawed, and be shaped with a knife without splitting or crumbling, they also had to be friable and of fine texture so that the stick would mark the paper easily. Finally, these earths had to possess a combination of these characteristics in such agreeable propor-

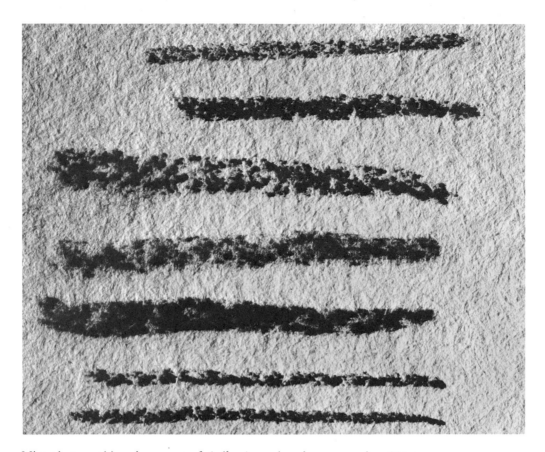

Microphotographic enlargement of chalk, charcoal, and crayon strokes. *Top to bottom:* Natural black chalk; natural black chalk, moistened; fabricated black chalk prepared with methylcellulose solution; willow charcoal (Weber 1-A-50); charcoal made from willow slips in laboratory; soft lithographic crayon (Korn No. 1); hard lithographic crayon (Korn No. 5, "copal"). Strokes drawn on paper with slight grain.

tions that they were responsive to the hand of the artist during the act of drawing.

The substances from which natural red and black chalks could be made were not "pure" minerals but amorphous compositions in which clay was an important ingredient that contributed to their softness and fine texture. The deposits of the earths, which were the sources of natural red and black chalks, occurred here and there in Europe. Despite the old references to countries and local place names which suggested the general location of these deposits, attempts to establish the present existence of these sources has been unsuccessful—a circumstance which indicates that either the lodes were mined out or knowledge of them was lost.

Natural red chalk The frequent use of natural red chalk verifies that it was one of the most important of these earth substances for drawing purposes. In addition to

92

Microphotographic enlargement of chalk and crayon strokes. *Top to bottom:* Natural red chalk; fabricated red chalk prepared with methylcellulose solution; red crayon prepared with wax, tallow, and spermaceti; commercial "sanguine" Conté crayon; commercial fabricated chalk, formula unknown; natural brown-black chalk (manganese ore).

its excellent physical properties, the warmth and vitality of its color contributed to its popularity with artists for about four hundred years.

Because this type of chalk is partially composed of iron oxide, it possesses great chromatic strength; but in the form of the mineral hematite, this iron oxide has to be diffused with clay in order to be soft enough to serve as a chalk. This latter feature distinguishes it from the many hard, brittle hematites which are of excellent color, but are useless for drawing. Mineralogically this earth is described as a "red ochre variety of hematite" (Dana 232), and in some deposits, such as those near Negaunee, in peninsular Michigan, it possesses the necessary blending of substances to make it an excellent drawing chalk.

Quite probably this type of chalk was one of those articles of art craftsmanship which made its way so casually into the hands of early draughtsmen that no author before the seventeenth century considered a satisfactory description of its mineralogical character necessary. Although numer-

ous treatises of the late middle ages and Renaissance indicated that the hematites provided red earth pigments for painting media, it was not until the time of Baldinucci that a general connection with the hematites was established for natural red chalk. When giving the terms *matita rossa* and *amatita della rossa* to a "stone" for drawing, he mentioned that the name came from the Greek for hematite and that the substance was the color of blood.[1] In the latter half of the eighteenth century the French provided several descriptions suggestive of its composition, stating that it was "la sanguine ou hématite";[2] a very clayish kind of ochre of iron;[3] or a muddy iron oxide, containing a mixture of natural clays to which one gave the name hematite.[4] And the *Encyclopaedia Perthensis,* in the early nineteenth century, described the chalk as an indurated clayish red ochre.[5]

References to the geographical location of deposits or sources of supply appeared as early as the sixteenth century with Vasari's statement that natural red chalk came from Germany. But authors of succeeding centuries noted that there were deposits in Italy, Spain, Flanders, and France, in addition to Germany.[6]

Despite the paucity of references commenting on its mineralogical composition and the sources from which it was obtained during four centuries, there were countless notices of the use of natural red chalk and a variety of colloquial terms identifying it:

"Matita rossa" (1584).—Borghini, p. 115.

"pietra rossa detta *apisso*" (1585).—Lomazzo, p. 192.

"crayon rouge" (1620–40).—De Mayerne, in Berger, IV, 160.

"Red-Oaker," "Red-Chalke" (1658).—Sanderson, pp. 31, 78, 79.

"rötel" (1675).—Sandrart, p. 62.

"root krijt" (1678).—Hoogstraeten, p. 31.

"lapis rosso" (1678).—Malvasia, I, 312.

"matita rossa," "Amatita . . . della rossa" (1681).—Baldinucci, pp. 9, 92.

"sanguine" (1684).—*Les Premiers elemens de la peinture pratique,* p. 10.

"de pierre rouge appellée sanguine" (1745).—D'Argenville, p. xvi.

"Red chalk" (1773).—Russell, pp. 8, 9.

"sanguine" (1830).—Constant-Viguier and de Longueville, p. 7.

Vasari seems to have been the first to make a distinction between natural red drawing chalk and the red earths which provided pigments for painting although he did so after the chalk had been used for several decades by distinguished Renaissance draughtsmen. The circumstances associated with the artists' acceptance of natural red chalk in the late fifteenth century, Leonardo's studies in red chalk, the adoption of the medium by other Renaissance draughtsmen, and the spreading of its use into other countries have been presented in detail by Joseph Meder.[7]

Because this drawing instrument lacked the great value range of charcoal or of black chalks, the modeling of figures had to be achieved without the benefit of deep darks. Although the natural red chalk offered broad, soft effects when compared to metalpoints or pen and ink, it was not as friable as charcoal nor as soft as fabricated chalks and therefore would not readily cover paper with unbroken tones. These characteristics

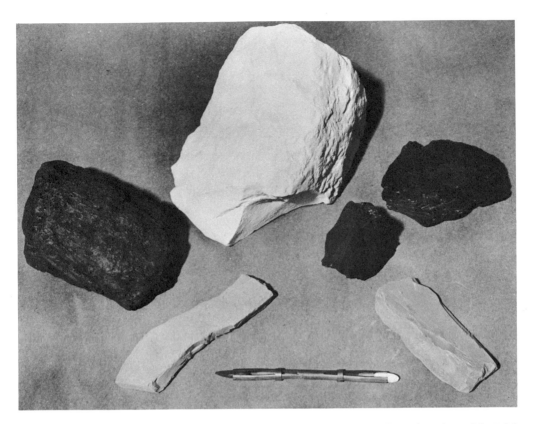

Earths from which natural chalks may be cut. *Clockwise from lower left:* Brick clay (natural gray chalk); red ochre variety of hematite (natural red chalk); chalk variety of calcite (natural white chalk); carbonaceous shale (natural black chalk); brick clay (natural ochre-gray chalk). *Center:* Manganese ore (natural brownish-black chalk). *Below:* Chalk-holder with natural red and natural white chalk pieces.

made this red chalk more suitable for drawings of modest scale and limited modeling, and it is interesting to find how many of the old drawings were of moderate dimensions and shading. No better example of a masterful use of the medium could be mentioned than the well-known study by Michelangelo for the "Libyan Sibyl" of the Sistine ceiling. Although monumental in its conception, this drawing is modeled with a judicious use of limited light-darks, treated in a basically draughtsman-like manner, and is very modest in scale (8⅜" × 11⅜")—all features suggesting Michelangelo's perceptive understanding of the resources and limitations inherent in the medium.

In many drawings natural red chalk was used alone. In others, black and white chalks were combined with it to give greater color and light-dark range to the subjects portrayed. These chromatic and light-dark effects were further extended when the chalks were applied over papers tinted blue, tan, gray, or off-white. The simplest of these combinations occurred when natural red and natural black chalks were used to suggest color distinctions associated with faces, hair, costumes, and other details, or as simple intermixtures of red and black strokes to simulate the brown

of hair or beards as François Clouet chose to do in his "Portrait of an Un-known Man."

The supreme master of red, black, and white chalk combinations was Watteau. Unlike some of his predecessors, who would intermix strokes of the three chalks in some areas of shading, Watteau usually let each stroke of the chalk remain autonomous and assigned each color to a par-ticular portion of the body or costume. Thus each chalk was unadulter-ated in color, and the drawing ensemble was scintillating in its freshness of color contrasts. Although Watteau seems always to have used a nat-ural chalk for the reds, his "Study of Two Women" and "Head of Luigi Riccoboni" clearly indicate that he occasionally selected a lush, black, fab-ricated chalk as a substitute for a natural black chalk.

The natural red chalks varied in hue. Usually they possessed a warm blood-red color, but one can find drawings in which was used a darker and cooler colored chalk similar in hue to our Indian-red pigment. These modulations of red were caused by differences in the natural compositions of the red ochre variety of hematites as they were found in one deposit or another. Moreover, as we have learned by experience, earths with varia-tions in their red hues can appear in the very same deposit. In masses mined from the same source we have obtained blood red, cool red, and brownish red earths, all of them excellent as substances from which chalks were made. By comparing natural red chalk drawings one can observe not only these color variations but also natural red chalks of different hues within a single drawing, as is the case in Watteau's "Sheet of Studies of Women."

These chromatic differences in natural red chalks, which may be seen when they are applied in a dry state, should not be confused with the variation in color which occurs when a blood-red chalk is moistened in order to introduce stronger accents in the figures. Licking the chalk or dipping it in water immediately before making the accenting strokes pro-duces a cooler color and a darker and more solid line, an effect of which earlier draughtsmen were well aware. Watteau used this technical manipu-lation of natural red chalk on numerous occasions, most noticeably for ac-cents around the eyes, noses and mouths of the maidens in "Six Studies of Heads." Another technical modification of the chalk by the artist created a a very different effect by increasing the chromatic warmth through an orange-red appearance. This occurred in Guercino's "Mother and Child" and countless other drawings where the natural red chalk was rubbed lightly, or smudged.

One cannot describe the many instances in which natural red chalks were used in minor or atypical roles, but a few of the manifold variations may be suggested. Rembrandt, within the complex array of drawing media he used to compose his "Mummers," introduced natural red chalk strokes into the plume of a hat and applied moistened red chalk to the boots and

"Study for the Libyan Sibyl" by Michelangelo.—*Courtesy of the Metropolitan Mu-seum of Art.* Natural red chalk.

along the slits in one of the costumes while the remainder of the drawing was completed with quill pen and bistre ink, bistre washes, yellow ochre fabricated chalk, and semiopaque whites applied with a brush. In the drawing "Virgin, Child and Worshiper," possibly by Bouchardon, the figures were delineated initially with the chalk; over these the artist superimposed a wash made with crushed natural red chalk, and then returned to the use of the chalk stick for the final accents. Jordaens' "Assembly of the Gods" has been mentioned as an example in which the composition was sketched with natural red chalk preparatory to its completion with other media. Although this study displayed a use of natural red chalk as a preliminary sketching device, the red chalk was chosen for this function less frequently than was natural black chalk for the obvious reason that its chromatic power adulterated other media too readily—a feature about which Taylor warned the artist when he wrote that the chalk was "very far from cleanly in its nature, and is apt to smear, and stain, whatever it touches."[8]

Toward the end of the eighteenth and the beginning of the nineteenth centuries, natural red chalk was used less and less. All the causes for this cannot be determined with exactness, but a deterioration in quality was certainly the important factor. The earths from which natural red chalks were made varied according to the accidents of their formation and blending in nature, and a supply of satisfactory earths was not always available. In a letter of the early eighteenth century, attributed to Watteau, poor quality was already lamented. The artist complained that his natural red chalk was too hard and that others of good quality were unobtainable.[9] Moreover, inferior earths produced chalks which had unwelcome pockets or pellets of gritty material. These deficiencies seem to have given further impetus to the development in the late eighteenth century of fabricated chalks and crayons—color sticks which could be controlled in their quality. In 1799, Lomet, who was experimenting with the manufacture of substitutes for natural red chalk, wrote: "One encounters many difficulties in procuring chalks [*crayons*] of good quality in most of the schools of drawing, and principally in places distant from the capital [Paris]. The sawed natural red chalk [*pierre sanguine*] which one customarily used, is almost always hard, gritty, and uneven in consistency. . . ."[10]

The experiments of the nineteenth century finally succeeded in producing fabricated drawing sticks whose characteristics were somewhat similar to those of natural red chalk. Today, the commercial product which most closely resembles the old chalk is the so-called sanguine Conté crayon. Orange-red in color and consistent in quality, it possesses a slight greasiness which makes it less friable than a soft natural chalk and more apt to produce a spottiness when smudged. Drawings by contemporary artists, and most of those of the nineteenth century masters, which are usually re-

"Sheet of Studies of Women" by Antoine Watteau.—*Courtesy of The Metropolitan Museum of Art.* This drawing was produced with two different hues of natural red chalks.

ferred to as studies in "sanguine" were undoubtedly produced with a mildly fatty crayon similar to this modern type.

Natural black chalk The history of natural black chalk has many parallels to that of natural red chalk. It, too, seems to have enjoyed its first popularity of any consequence in the period of the late fifteenth and early sixteenth centuries. This was a time when, generally, paintings were being enlarged in scale and created to display broader atmospheric and illusionistic treatments. As a result, the artists often sought to produce drawings which suggested similar features, effects which chalks could more readily provide than metalpoints.

Natural black chalk has carbon and clay as its principal ingredients, and mineralogically is considered a carbonaceous shale.[11] Although the descriptions of its composition were as rare as those for natural red chalk, the old treatises were more informative about the locations of the deposits from which it was obtained. For several centuries it was referred to as a black "stone" used in drawing (and for blackening iron-gall inks). And it was not until 1774 that it was described as a kind of *ampelitis*—a soft, black, stonelike schist;[12] a few years later it was called *ampélite* and described as a schist produced by a clayish mixture of mud.[13] In the nineteenth century this black earth was called both ampelite and bituminous slate and was mined in pieces from two to ten feet long and four to twenty inches broad.

Natural black chalk, as a medium of drawing, was mentioned in treatises on art, or in encyclopedias, from the time of Cennino to the nineteenth century. Among these comments were numerous references to countries and geographic place names which indicated that deposits occurred throughout western Europe:

Piedmont (Italy), late fourteenth or early fifteenth century.—(Cennino) Thompson, *The Craftsman's Handbook,* p. 20.
France, *ca.* 1568.—(Vasari) Maclehose, p. 212.
Spain, France, 1681.—Baldinucci, p. 92.
Ferriere-Bechet in Normandy, Bacharab (Germany), 1774.—*Encyclopédie ou dictionnaire universel,* XXXIII, 554.
Italy, 1797.—Taylor, p. 27.
Spain, Italy, Seer in the department of Orne, the environs of Cherbourg, 1819.—*Cyclopaedia: or Universal Dictionary of the Arts, Sciences, and Literature,* XXXIII, *s.v.* Slate.
Italy, 1830.—Constant-Viguier and de Longueville, p. 218.
France, Spain, Italy, Isle of Isla (Hebrides), 1831.—Tingry, p. 67.
Portugal, Caernarvonshire (Wales), Isle of Isla, Spain, France, Italy, 1865.—*A Dictionary of Science, Literature and Art,* I, 279.

"Study for the Figure of a Young Man" by Andrea del Sarto.—*Courtesy of The Pierpont Morgan Library.* Natural black chalk.

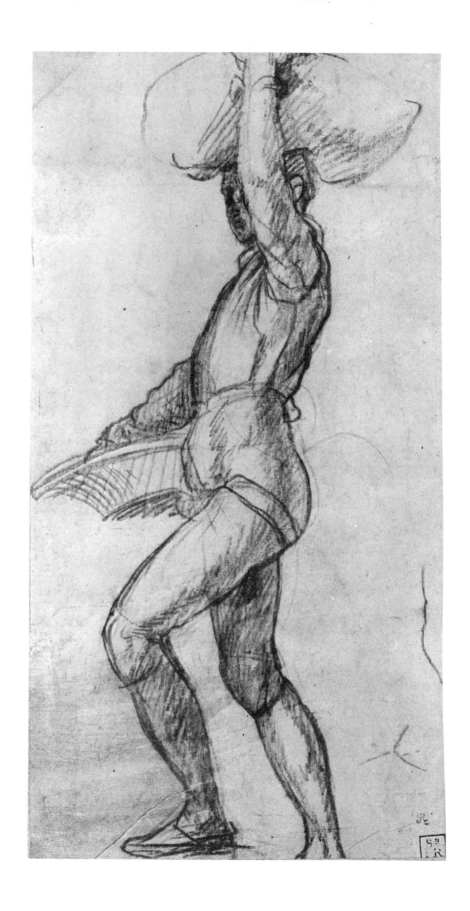

Microphotographic enlargement of detail of "Six Studies of Heads" by Watteau. This detail shows the dark accents produced by licking or dipping the natural red chalk in water (e.g., eyes, nose, and mouth).

"Six Studies of Heads" by Antoine Watteau.—*Courtesy of The Fogg Art Museum, Harvard University (The Meta and Paul J. Sachs Collection).* Natural red chalk with darker accents produced by wetting the chalk, fabricated black chalk, heightening with white chalk on a tan paper.

102

Microphotographic enlargement of detail from "Head of an Unknown Man" by Clouet. Natural black chalk strokes from a relatively hard piece of chalk, with some lines very precise and others exhibiting only limited density of pigment particles.

Bretagne, Maine, Normandy, 1866–70.—*Grand dictionnaire universel du xix^e siècle*, V, 458.

Bantry (Ireland), Wales, Italy, 1869.—Field, p. 404.

Like its red counterpart, natural black chalk varied in quality. The inferior grades were used by masons, carpenters, stonecutters, and other tradesmen, and the very best was sold to artists.[15] Although its blackness or its smoothness of texture rarely duplicates those of the relatively pure carbon particles used in fabricated chalks, it is incorrect to assume that its strokes were usually grayish-black or gritty as Meder implied[16] because examples we have used and many natural chalk drawings, such as Andrea del Sarto's "Study of the Figure of a Young Man" for one of his Florentine frescoes, display softness and blackness.

The black earth has alternately hard, crusty layers and soft, black bands. If the latter are composed of fine black blendings of carbon and clay, draw-

"Head of an Unknown Man" by François Clouet.—*Courtesy of The Fogg Art Museum, Harvard University (The Meta and Paul J. Sachs Collection)*. Natural red and black chalks. This drawing also illustrates the intermixing of red and black strokes to produce a brownish color in hair and beard.

104

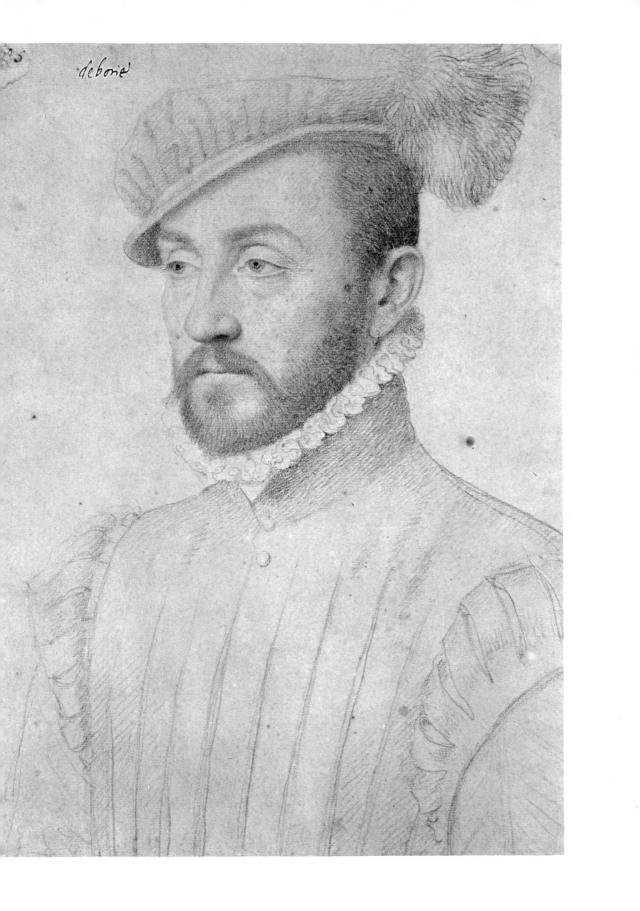
deboie

ing chalks of a very smooth texture and excellent pigmentation can be obtained. The strokes produced with natural black chalk tend to be neatly linear because of the compressed and cohesive structure of the material. Consequently, these strokes present an appearance quite different from the loose, dusty lines made with a fabricated chalk or are in contrast to the somewhat exploded appearance of charcoal strokes.

Although Cennino presented a description of a black "stone," and described the manner of shaping it with a knife for drawing, there seem to be no extant drawings from his time to illustrate its use. However, studies in natural black chalk from the latter part of the fifteenth century have survived; for example, the "Profile Portrait of a Youth Wearing a Cap" by Perugino. In succeeding centuries this chalk was used in many ways. More often than in the case of natural red chalk, it served for the preliminary outlines which guided the artist in his drawings, or for contours in works which were completed with other media. These functions, and that of completing entire drawings, were shared with charcoal, and by the seventeenth century, with graphite. On the other hand, it was often used as an important chalk in combinations of black, red, and white chalks discussed in the preceding section, or in more complex combinations of color media, as in Holbein's "Portrait of a Leper."

As long as natural black chalk of good quality could be acquired it was used for drawings where the crumbling, powerful black of fabricated chalks, or the broad, broken lines of charcoal were too unmanageable for neatness of linear draughtsmanship. But in the late eighteenth and early nineteenth centuries the popularity of this chalk declined. The unpredictability of its quality, the introduction of fine black crayons, and most of all the controlled compositions and increased production of excellent graphite pencils—which at times had their blackness intensified with the addition of lampblack[17]—contributed to its disappearance from the studio of the artist. Although *Nicholson's British Encyclopedia* declared, in the early nineteenth century, that natural black chalk "with the white is constantly preferred in the model room of the Royal Academy, the professors of which consider it the best material for drawing from plaster figures or the life," its tenure as an important medium of drawing was certainly precarious by that time.[18]

Natural white chalks The principal function of all white chalks or crayons, including the natural white, was to heighten modeling in drawings. Two natural whites were mentioned in the old literature. One was a chalk variety of calcite (carbonate of calcium); the other, soapstone (or steatite), a variety of talc (hydrous silicate of magnesium). The first of these two whites had

"The Mummers" by Rembrandt.—*Courtesy of the Pierpont Morgan Library.* In the complex use of media in this drawing, Rembrandt introduced strokes of dry and moistened natural red chalk. The other media used in this study include quill pen and bistre ink, bistre wash, yellow ochre fabricated chalk, and semiopaque whites applied with a brush.

many uses in both commerce and art, among the latter as a source of whiting for the painter's gesso. The second white served as tailor's chalk. The association of these whites with the crafts of commerce may account for the casual way in which "white chalk" was mentioned in the instructions for artists and for the very few instances in which their physical characteristics were defined. The references to tailor's chalk appeared before the end of the seventeenth century, while those to the more common white chalk appeared from the seventeenth through the nineteenth century.

Tailor's chalk, or soapstone, was recommended by Cennino for the drawing of designs on cloth although not for drawing studies.[19] Vasari mentioned it as a medium for sketching the artist's composition on the colored imprimatura or ground which was often tinted preparatory to painting.[20] However, it was Baldinucci who clearly indicated that it was used as a heightening medium, in natural black or red chalk drawings on colored papers.[21]

Although in solid form "pure" talc is slightly bluish-white and the soapstone variety of it is a very light gray, both produce strokes which for all purposes appear white. These "stones" are very cohesive, although not hard, and feel unctuous when rubbed between the fingers. Their strokes have little body and moderate covering power. Consequently, tailor's chalk or soapstone is most adaptable to a neatness of heightening appropriate in drawings of modest size—a circumstance not incompatible with the characteristics of many Renaissance drawings.

The other natural white chalk was simply, and repeatedly, referred to as "white chalk." One must assume that these references were to the common variety of calcite.[22] Although it may vary in its physical properties, the examples we have worked with indicate that it will produce a much softer, and relatively brilliant, white stroke when compared to that made with soapstone. This softness caused d'Argenville to suggest that the white was so apt to be effaced, that the artist might prefer to mix the chalk with gum water and apply it with a brush.[23] This soft chalk, however, varied in this characteristic depending upon the source or country from which it came. Taylor, in the late eighteenth century, considered that imported from Italy to be the best, and also the most desirable for small drawings because of its fine texture and firmness. He described the natural white chalk from France as being soft and only suitable for large subjects; and he stated that that of Spain was neither as soft nor as firm as the chalks from the other two countries.[24]

The softness of natural white chalk permits it to be sawed from the large mined hunks and shaped with a knife into drawing sticks with great ease. Its crumbling stroke and fluffy texture make it very difficult to distinguish from some fabricated white chalks. Aside from the fact that it has less cov-

"Head of Luigi Riccoboni" by Antoine Watteau.—*Courtesy of The Metropolitan Museum of Art.* This drawing shows Watteau's occasional preference for a very soft, black fabricated chalk as a substitute for natural red—with a few accents produced by licking or wetting the chalk, and heightening with white chalk.

ering power than a fabricated chalk—for example, that made with white lead pigment—and becomes much less opaque when covered with a fixative, there are few clues as to the identity of one or the other in old drawings. Natural or fabricated white chalks were probably used interchangeably by many draughtsmen, and Taylor indicated their similarities when he stated that "white chalk is so readily offered by nature, that it seems perfectly adapted without receiving any labour, to be used as a crayon [fabricated chalk] of the finest order."[25]

Natural chalks of other colors Natural chalks other than red, black, and white are of minor importance in the technical history of drawing. Although it is possible that earths of other colors could have been used as chalks, if a mineral of proper physical characteristics were obtained, one must assume that the lack of a constant supply and of widespread use account for the silence of technical manuals about such natural chalks.

When Meder attributed the use of a brown earth chalk to a few artists he indicated that their drawings in this medium were exceptional; among these artists were Fra Bartolommeo, Dürer, Watteau, Boucher, Robert, and Greuze.[26] Although the use of brown (or natural chalks of other colors) would have been rare, it is possible that such earths could have come into the possession of artists, since minerals with the proper softness, texture, and varied colorations occur in nature.

In our examination of minerals which might meet the requirements of natural chalks we have become very conscious of the fortuitous conditions in nature which have caused the formation of chalklike substances —of unusual blendings of earths which indicate the possibility that earlier artists could have acquired natural chalks of various colors on one occasion or another.

A study of wad—which in some nineteenth-century references was mentioned as a source of natural black chalk—led to a very dark brown earth of excellent physical properties. This claylike brown is a variety of wad (an impure hydrous manganese dioxide) which possesses most agreeable characteristics in its extremely smooth texture and rich pigmentation.[27]

Brick clays are another source of excellent chalk substances. Obtainable in the form of flat slabs or hunks they offer a variety of color tints. For example, a clay of light maroon pigmentation has provided a fine chalk which produces strokes of light red-brown. Gray brick clays are very common and diverse in their tints, with a range of color from a cool gray to a warm ochre-gray. Often these almost neutral gray clays will produce startling changes in the coloration of their strokes depending upon the paper over which they are drawn. In some instances, a gray clay of this type will provide gray strokes on white paper, a cool steel-gray sketch on buff, and

"Portrait of a Leper (so-called)" by Hans Holbein the Younger.—*Courtesy of The Fogg Art Museum, Harvard University (The Meta and Paul J. Sachs Collection).* Natural red and black chalks, quill pen and carbon black ink, and washes of ochre and gray.

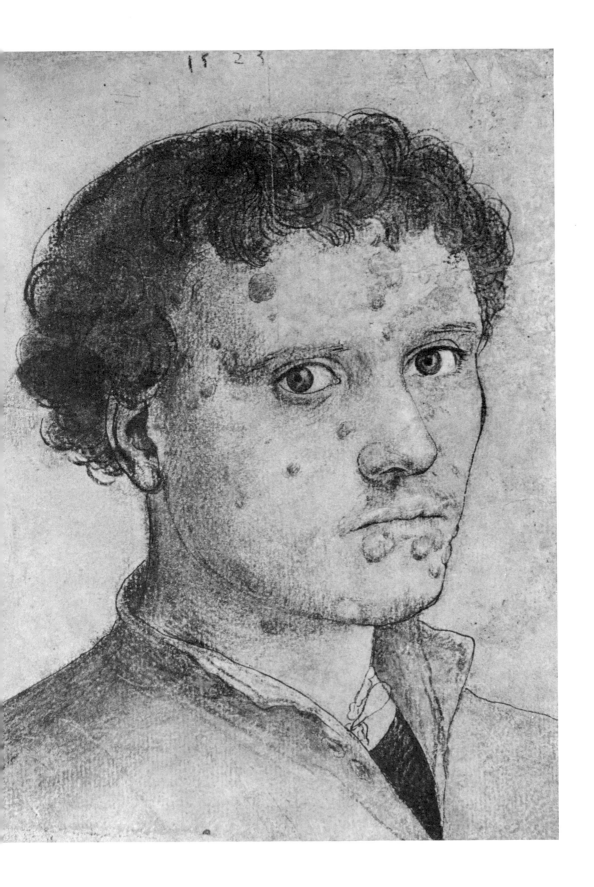

unexpectedly, pale orange lines when applied over a light blue paper; color differences which one unknowingly might assume were produced with three distinct natural chalk substances.

Fabricated chalks and pastels

Fabricated chalks or pastels are made from pastes which are prepared by mixing dry pigments with binding media. Ordinarily a paste is rolled into a colored stick of cylindrical shape and then dried.

There are several notable differences between these fabricated color sticks and natural chalks. Because most of the dry pigments of the artist may be used to prepare these chalks, the range of colors is much greater than that available in the natural chalks. Not only is there a greater variety of basic colors, but two or more pigments may be mixed to create innumerable hues. Moreover, any of these colors, or color mixtures, may be reduced in chromatic strength and lightened in value by the admixture of inert white substances in order to obtain an infinite number of tints. And individual fabricated chalks or pastels also may be made harder or softer, as the artist may wish, by varying the ingredients or proportions, or both.

The extensive variations in hue, value, texture, and hardness available in these chalks make it difficult to accept either the term "fabricated chalks" or that of "pastels" for all examples of these drawing instruments. It might be possible to accept the designation "pastels" for all fabricated chalks were it not that the term has become so closely associated with the soft, powdery effects produced in broad, coloristic drawings of the late nineteenth and the twentieth centuries. Consequently, "pastel" does not suggest the nature of the harder varieties of these chalks which were used for neat and precise drawing, or touches of color, in master works of earlier centuries.

Meder's assignment of fabricated chalks to drawings by Boltraffio and Luini suggests the introduction of this medium by the early sixteenth century, although there is no written description of the processes by which they were made until several decades later.[28] In 1585 Lomazzo wrote of a method of drawing called *a pastello*.[29] This reference, along with a description of different types of fabricated chalks by Petrus Gregorius in 1574, established their use in both the north and the south of Europe.[30] In the seventeenth and eighteenth centuries innumerable treatises included recipes for their preparation. By the latter century their use seems to have been so widespread as to warrant the manufacture of these chalks by dealers who furnished artists with their supplies.[31]

The binding media cited in the old recipes presented a wide range of substances, many of which seem very picturesque to us today. Among these binders were sugar candy, gum arabic, gum tragacanth, milk, whey, fig milk, beer, ale, ale wort, glue, stale or rotten size (glue), oatmeal (liquor), honey, starch, and plaster of Paris.[32] Because these binding media have dissimilar characteristics, earlier artists must have adjusted each recipe to the particular binding properties of each substance. Even this modest complexity in preparing the chalks was compounded by additional factors.

112

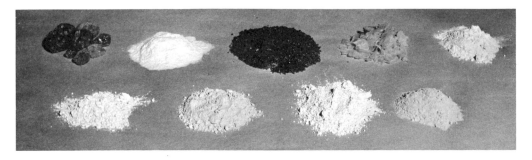

Basic materials, in their dry state, for binding media of fabricated chalks (pastels). *Left to right, upper:* Gum arabic tears; methylcellulose; rabbit-skin glue; gum tragacanth ribbons; powdered gum tragacanth. *Lower:* Plaster of Paris; ball clay No. 6; kaolin; bentonite.

For example, each pigment has inherent to it a distinct binding strength. This strength is so pronounced in some of the pigments that when mixed with water alone they produce chalks which are too hard to leave satisfactory marks on paper. Also pigments differ in their absorbencies, and where one color, when combined with a given amount of binding solution, forms a malleable paste, another remains too dry to roll into a cohesive cylinder. This dryness cannot be corrected by the simple expediency of diluting the binding solution with water, because the diminishing of the relative proportions of the binding ingredient to the given amount of pigment produces chalks which tend to fracture or crumble under the slightest pressure.

The old recipes never presented specific proportions, undoubtedly because of the factors mentioned above and because some of the binders such as beer, ale, whey, and milk had binding strengths which could not be predetermined on account of the variable nature of the products from which they might have been taken. Therefore, the old recipes were generalized directions with which the artist must have experimented in order to obtain optimum combinations of binding media and pigments.

The general characteristics of chalks prepared with the old binders, when a broad selection of common pigments are used, range from soft to very hard and crusty, and it is not surprising that combinations of binding media were sometimes recommended in an effort to take advantage of the virtues and minimize the particular deficiencies of each.[33]

One cannot clearly discern any pattern of changing preferences for binding media from the sixteenth through the eighteenth centuries. But the recipes in the old manuals do create the impression that there was a tendency, up through the eighteenth century, for artists to prefer chalks which were, for the most part, harder than our modern pastels. The greatest number of recipes called for the use of relatively strong binding media, such as glue, gum arabic, and plaster of Paris. But this did not exclude the production of more friable chalks when they were necessary for less draughtsman-like use in drawings, or for the pastel "paintings" of the eighteenth century where soft fabricated chalks were rubbed with bits of cotton, the artists' fingers, or stumps (bits of tightly rolled paper or leather).

In the nineteenth century, when drawing (and painting) with pastels experienced something of a revival reaching a high point of achievement

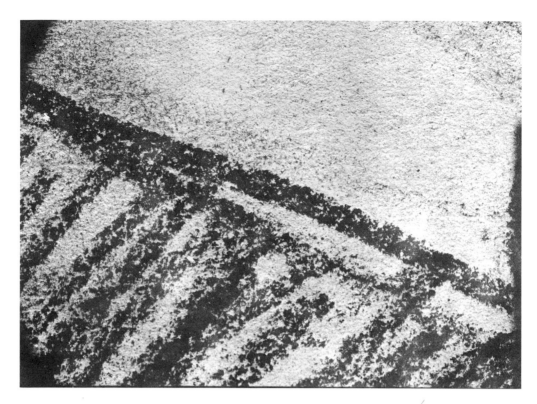

Microphotographic enlargement of a detail from "Study for a Portrait of Diego Martelli" by Degas. Fabricated black chalk. Compare the detail from the study of Martelli drawn with charcoal (p. 134).

in the broadly treated, colorful works of Degas, the most common binder was gum tragacanth (an exudation of the *astragalus gummifer*). Although gum tragacanth is now being supplanted by methylcellulose, a product of modern chemistry, as the principal binding medium for pastels, nevertheless, the extensive use of these binders during the last two centuries has not eliminated the continuing admixture of some of the substances favored in earlier centuries—substances which contribute to optimum formulas for various pigments or their tints.[34]

The preparation of white fabricated chalks and the creation of color tints by admixtures of white substances were often given special attention in the old treatises. Pure whites were made with white lead, the common white pigment of early painters, or from earth products such as whiting (calcium carbonate), plaster of Paris (calcined gypsum), or tobacco-pipe clay (a hydrous silicate of aluminum). In addition to providing a pure white fabricated chalk, plaster of Paris was also added to the pigments to serve as both a binding medium and a tinting white. But the type of white for tinting which was mentioned most frequently was tobacco-pipe clay or

"Study for a Portrait of Diego Martelli" by Edgar Degas.—*Courtesy of The Fogg Art Museum, Harvard University (The Meta and Paul J. Sachs Collection).* Fabricated black chalk (pastel) heightened with white chalk, on a gray-brown paper.

variations of it known as porcelain clay or china clay.[35] These were the antecedents of modern kaolin. As impalpable powders, their exceedingly soft texture undoubtedly contributed to these expressions of preference. Occasionally one encounters recipes which indicated that they were mixed with some dry pigments and water but without a binding medium. This suggests that the binding properties must have been supplied by clayey adulterants since modern kaolin possesses little strength of this kind; in fact, it is especially useful for softening chalks prepared with pigments having inherently strong binding properties. In given instances these adulterants must have been very strong. Alexander Browne suggested that chalks made with tobacco-pipe clay should be soaked in oil to soften them, and Dossie commented that they dried too hard for his satisfaction.[36]

Although a mild firing of some pastels is practiced by commercial manufacturers today, this additional processing seems to have been very rare. Ordinarily the fabricated chalks were set aside to dry slowly or were placed near a fireplace, with no firing during or after the initial drying. A type of firing was mentioned by Alexander Browne, who recommended that his fabricated chalk prepared with a mixture of tobacco-pipe clay and ale wort should be placed in an oven after the bread was removed; but this reference was exceptional.[37]

Until pastels were used to create works possessing the characteristics of painting, the customary carriers for fabricated chalk drawings were the papers used by the artist for various types of charcoal, pen and ink, or natural chalk drawing. Although these papers had some grain, it was modest in texture. On the other hand, the trend toward pastel painting in the eighteenth century, led to the preparation of textured grounds on carriers of various types. This grain caused the color particles to be easily transferred from the chalks to the drawing surface and also assisted in holding the soft, dusty strokes in place. The authors of the *Traité de la peinture au pastel* described carriers of blue paper, velum, taffeta, and linen. These were either roughened with pumice or covered with a coat of glue into which marble dust or pumice was sifted.[38] The surfaces for modern pastel drawing or painting are very similar. Canvasses, boards, or papers are covered with pumice, wood dust, felt wool, or other materials in order to obtain properly textured grounds.

It has been observed that the natural chalks, because of their physical characteristics, are most adaptable to drawings of modest scale. These same factors hold for the relatively hard fabricated chalks. On the other hand, the easily transferred particles of pigment from soft fabricated chalks or pastels permit the artist to execute wide strokes and suggest broad modeling which encourages and assists the making of drawings of large scale.

"After the Bath" by Edgar Degas.—*Courtesy of The Fogg Art Museum, Harvard University (The Meta and Paul J. Sachs Collection)*. The basic drawing of the figure was done with charcoal. The varied colors were introduced with fabricated chalks (pastels) and include ochre-brown, Burgundy-red, dark red, dark green, and light blue.

Crayons Ambiguities in the use of the term "crayon" occurred frequently during several centuries because the term was used to refer to a miscellany of drawing instruments. It was therefore proposed in the introductory portion of this chapter to identify crayons as color sticks made either with oily, waxy, or greasy binding media, or with combinations of water soluble and fatty binders. Such a classification has a further advantage because, in the United States, the term "crayon" is commonly associated with waxy or greasy drawing sticks.

A fatty viscousness usually distinguishes most crayons from natural or fabricated chalks. However, there are exceptions in which the limited amounts of fatty materials or the use of combinations of fatty and water-soluble binders modify the nature of crayons to such an extent that they display physical characteristics somewhat similar to those of chalks in their "dry" and rather friable strokes.

Historically, the preparation of crayons seems to have occurred in a sporadic manner, and manuscripts and manuals on art offer no chronological pattern suggesting any sustained effort to produce crayons until the late eighteenth century. An item in one of the manuscripts of Leonardo, which seems acceptable as a notation for the preparation of a crayon, was both a very early and an unusual reference to a mixing of pigments with wax in order to obtain a "true" crayon.

To make points [crayons] for colouring dry. Temper with a little wax and it will not come off, which wax dissolve with water; so that the white lead is thus tempered, the water, being distilled, may go off in vapour and the wax may remain; you will thus make good crayons; but you must know that the colours must be ground with a hot stone.[39]

No comparable recipe may be found in the sixteenth century, and manuals from the seventeenth to the late eighteenth centuries, with one exception, did not describe the direct mixing of fatty binders and pigments to form a crayon paste. Instead, the recipes of these latter two centuries proposed a modification of fabricated chalks—and charcoal—which converted them into crayon-like drawing sticks. Preformed or precut chalks or charcoals were soaked with oils or soaps, not only to lessen their hardness but to prevent the danger of smearing common to these media. In the seventeenth century, the French artist Aulmont added soapy water to fabricated chalks made with plaster of Paris,[40] and Alexander Browne indicated that chalks prepared with tobacco-pipe clay were to be brushed with a feather dipped in "Sallet Oyl."[41] The use of linseed oil was also advised: by Browne for modifying chalks made with yellow ochre, and by Volpato for soaking charcoal.[42] In the following century Dossie recommended the use of olive oil, which was probably the "Sallet Oyl" of Browne, and both Dossie and Taylor indicated that fabricated chalks were sometimes soaked with linseed oil,[43] despite the fact that it was by its nature a drying oil which would soon harden and make a chalk—or a charcoal—useless for drawing.[44]

As late as 1818, the impregnation of charcoals was still being practiced,

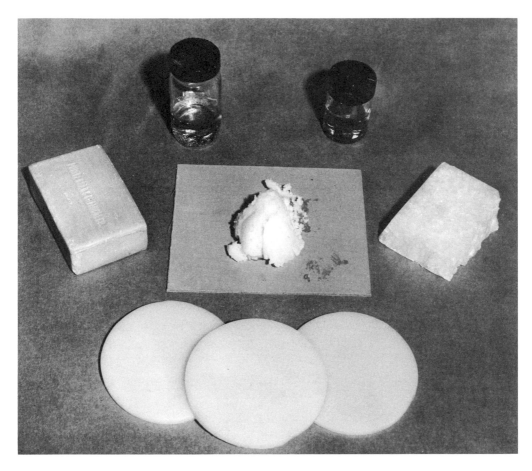

Basic materials for the binding media of crayons. *Left to right, in bottles:* Linseed oil; olive oil. *Middle:* Soap; tallow; spermaceti. *Bottom:* White beeswax.

although the effort was made to control the relative softness or hardness of the sticks by the use of fatty substances other than linseed oil. For hardness, the charcoal was soaked in melted resin and wax; for a medium charcoal, wax alone was used; and for a soft, greasy stick, the charcoal was soaked in a mixture of wax and either tallow or butter.[45]

The idea of mixing fatty ingredients with pigments during the preparation of pastes, in order to produce "true" crayons, seems to have occurred even more sporadically. After Leonardo's time one finds no reference until 1685, when Salmon presented a recipe in which the binding ingredients were new milk and either "Oyl" or wort, thereby proposing a drawing tool which, depending upon the use of the oil or the wort, would have been either a crayon or fabricated chalk.[46] Although it was not until the end of the eighteenth century that such crayon recipes recur, they then appeared with moderate frequency. Dossie mentioned wax crayons for drawing, but he still considered them of little importance compared to pastels.[47] Thomas Beckwith, an artist of the city of York, patented a method of making crayons with "dephlegmated essential oils" and "animal oleaceous substances" which were also fired and then fitted into grooved pieces of wood.[48] And Lomet, as a result of his efforts to du-

119

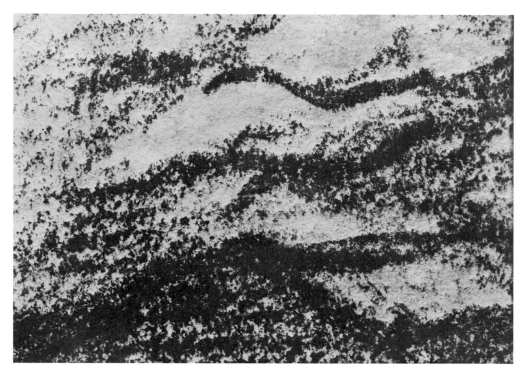

Microphotographic enlargement of a detail from "A Seated Nude Woman" by
Greuze. Red crayon.

plicate the chalks and crayons of Desmarest of Paris, published a recipe
which combined soap with gum arabic.[49]

One receives the impression that it was during the very last years of the
eighteenth and the early years of the nineteenth centuries that "modern"
crayons and the formulas for them were evolved, not only from the nature
of the recipes, but also from the apparent increase in the use of these media
as found in the works of masters during the first decades of the latter cen-
tury. In 1797, Hochheimer published his *Chemische Farben-Lehre* which in-
cluded a recipe with specific proportions of wax, tallow, and spermaceti
(the white wax from the sperm whale).[50] Meanwhile, between 1796 and
1800, Alois Senefelder, the inventor of lithography, experimented with a
great number of crayon formulas which included various combinations
and proportions of wax, tallow, spermaceti, soap and shellac.[51] It is not
unreasonable to suppose that Senefelder's invention, which was rapidly
adopted by artists of prominence in the nineteenth century, provided an
impetus to the use of crayons in drawings.

Although the literature indicates that crayons (or those analogous coun-
terparts produced by impregnating charcoal and fabricated chalks with
fatty substances) were used in the seventeenth and eighteenth centuries,
it is difficult to find examples of old-master drawings which were exe-
cuted with crayons before the nineteenth century. Among the few excep-

"A Seated Nude Woman" by Jean Baptiste Greuze.—*Courtesy of The Fogg Art
Museum, Harvard University (The Meta and Paul J. Sachs Collection).* Red crayon.

120

tions are Fragonard's "A Woman Standing with Hand on Hip" and "A Seated Nude Woman" by Greuze.

Artists of the nineteenth century not only used crayons with frequency but produced drawings which indicated the diversity of textures and colors which were available. Masters who displayed a predilection for linear draughtsmanship seem to have found crayons very sympathetic drawing means. Among them was Ingres who, in his graphite "Study for the Portrait of Madame d'Haussonville," chose the black crayon for strengthening the dark modeling in the arms and in most of the drapery of the young lady. Crayons were adaptable to drawings of large scale and varied colors as Toulouse-Lautrec demonstrated in his lively presentation with a blue crayon of "Le Carnaval au Moulin Rouge; Entrée de Cha-U-Kao" and in the characterization of the celebrated entertainer "Yvette Guilbert"— a study in black crayon.

Generally, within the area of drawing, crayons are most serviceable for linear works. Their tendency to resist smudging and their lack of friability limit their usefulness in producing broad, tonal shading of subtle gradations—effects which are so easily obtained with soft fabricated chalks. Their fatty characteristics provide both a richer body to the strokes and a deeper chromatic intensity than do their counterparts in chalks, both being effects caused by the fatty binders which envelop the particles of pigments in semi-transparent encasements or films.

Today, crayons of various viscosities and colors are obtainable commercially, or may be prepared in the artist's workshop. Whether the black lithographic crayons or the many colored types are preferred, the contemporary artist has a wide range of hardness and softness, texture, and pigmentation in the crayons at his disposal. Although they are not selected as often as graphite and pen and ink by our contemporaries, they provide additional diversity in the media of many modern artists, among them distinguished draughtsmen such as Henry Moore and Picasso.

WORKSHOP PROCEDURES

Natural chalks The workshop procedures for preparing natural chalks involve little more than the cutting and shaping of the minerals into proper drawing sticks.

1. The earths are mined in eccentric shapes and sizes as chips, slabs, or large lumps. These may be cut in usable forms of finger length with a scroll or hack saw.
2. With a sharp penknife the edges of the stick may be rounded so that the chalk will fit into a chalk holder (*porte-crayon*), quill,[52] or hollow reed. A point for drawing may then be sharpened as desired.
3. The finest and smoothest lumps of natural red chalk are usually uniform in their excellent texture. One may encounter pieces which are

"Yvette Guilbert" by Henri de Toulouse-Lautrec.—*Courtesy of The Cleveland Museum of Art (Gift of Leonard C. Hanna, Jr.).* Black crayon.

adulterated with little pockets of grit—a feature occasionally mentioned in the old literature—but these usually occur in lumps which are generally inferior to the best examples of natural red chalk.

4. In the case of natural black chalk, the earth may be composed of alternating laminations of hard gray and soft black layers. The usable black material is extracted by sawing sections parallel to the laminations.

5. Natural white chalk is so very consistent in its mass that cutting a satisfactory piece requires no process of selection.

Obviously, in both natural and fabricated chalk drawings, if heightening with white is contemplated, a colored or "off-white" paper is necessary. Many earlier artists used the papers impregnated with blue which was recommended in the manuals. At other times they tinted their sheets with washes in the manner of Alexander Browne who suggested a "complexion" made of ceruse, yellow ochre and gum arabic water, and applied with a sponge, or of de la Tour who wrote "I have also been treating blue paper with a light wash, applied with a brush, of yellow ochre diluted with water and yolk of egg."[53] Today, the many tinted papers available provide the artist with a wide selection of colors for his backgrounds. However, a desire to vary the colors, or relieve the even tones, of commercial papers may persuade the artist to produce his own tints. They may be applied with a brush or sponge using transparent or semiopaque watercolors, gouache or casein paints, or colored inks.

Fabricated chalks and pastels Any additions or subtractions in proportional mixtures of any of the binding media, inert materials or dry pigments will change the characteristics of fabricated chalks and pastels. Furthermore, different lots of similar materials may vary in their properties. For example, several lots of Venetian red, obtained from various sources, may be sufficiently different in their characteristics to require the modification of a given recipe. The unwillingness of authors to cite specific recipes indicated their awareness of this factor, and Dossie cautioned his readers of this when he wrote that "as the different parcels of each kind of substance differ greatly in proportion to their qualities, though they may agree in the general nature of them, sometimes produce good, and sometimes bad crayons, by the very same rules."[54] Therefore, in the preparation of these colored drawing sticks the factors of hue, tint, texture, hardness, softness, cohesiveness, brittleness, and fracturability must all be taken into account in establishing and then adjusting recipes.

Ingredients The limited list of ingredients below—with the exception of bentonite —presents substances similar or analogous to ones used in earlier centuries. They are classified as liquid binding media or dry materials, although some of the dry materials possess pronounced binding qualities when mixed into a paste with water alone.

Liquid binding media: Methylcellulose solution; gum tragacanth solution; gum arabic solution; hydromel (honey water); starch solution.

Dry materials: Dry pigments; whiting; kaolin; plaster of Paris; ball clay No. 6; bentonite.

Some characteristics of the various materials

Although it might be assumed that satisfactory fabricated chalks could be prepared which would display desirable differences in hardness or softness by simply using solutions of varying degrees of diluteness, such a procedure cannot always be followed in practice. It often occurs that as the solution is weakened the chalks become too susceptible to fracturing or crumbling. When these tendencies appear it is sometimes advisable to add dry materials which possess some inherent cohesiveness, for example, ball clay, plaster of Paris, or bentonite.

Some dry pigments, by their nature, are "dry" and harsh, and additions of kaolin or ball clay will improve their smoothness of texture. But these additions are not always possible when the full chromatic strength of a dry pigment is desired, since such white or off-white materials in any substantial quantities will reduce the hue to a pastel-like tint. Under these circumstances the chromatic strength can only be retained by using the transparent and nearly colorless liquid binding media, with the artist working out the best possible adjustments of the recipes.

Dry pigments possess differing binding properties. For example, terreverte, or raw umber, when formed into a paste with water alone, will dry too hard for drawing; and cadmium yellow (light) or cadmium red dry pigments, when mixed with water only, will form chalks which crumble under gentle pressure. The artist may determine the relative binding properties of each dry pigment very easily by forming little sticks in the above manner and testing them when they have dried thoroughly.

The other dry materials, when mixed with water alone, take on the following characteristics: plaster of Paris and bentonite become very cohesive (the latter producing a very hard and tough stick). Ball clay No. 6 displays moderate binding strength. Whiting and purified kaolin display no significant binding properties, and because of this may require, when added to the dry pigments, the use of a strong binding solution.

Liquid binding media

The following solutions of liquid binding media are suggested for use in the recipes presented below.

Methylcellulose: Take 12 ounces of water and place it in a wide-mouthed vessel. Add ¼ ounce of dry methylcellulose (viscosity 100 CPS). Cover the vessel and let the mixture stand overnight. Stir it well, then pour it into a jar; cap it to prevent evaporation of the water. This initial solution may be labeled M–1.

To dilute, take 6 fluid ounces of M–1 solution and to it add 12 fluid ounces of water. Label it M–2.

Dilute 6 fluid ounces of M–2 with 12 fluid ounces of water to prepare M–3.

Dilute 6 fluid ounces of M–3 with 12 fluid ounces of water to prepare M–4.

125

Dilute 6 fluid ounces of M–4 with 12 fluid ounces of water to prepare M–5.

Hydromel: Take clear, strained honey. To one part of honey add the number of parts of water necessary to prepare the desired solution; e.g., 1 honey : 3 water, or 1 honey : 6 water. Stir the mixture well and place it in a jar with a cap to prevent evaporation.

Starch: Take ¼ ounce of good laundry starch and dissolve it in 8 fluid ounces of boiling water. Stir it until the solution is smooth and clear, then place it in a jar with a cap to prevent evaporation.

Gum arabic: Take 1 ounce of powdered gum arabic. Place it in a little cloth bag. Tie a string around the neck of the bag and suspend it in a jar containing 8 fluid ounces of water. Soak it overnight, then lift the bag and squeeze it to extract the remains of the softened gum arabic. Place the solution in a jar which may be capped to prevent evaporation.

Gum tragacanth: Soak overnight ¼ ounce of powdered gum tragacanth in 6 fluid ounces of water. Stir it well and pour the solution into a jar which may be capped.

Preparing pastels and forming sticks

All dry materials should be impalpable powders. Dry pigments obtained from commercial suppliers frequently need further grinding on a ground glass slab with a muller. Any combination of dry materials called for in a given recipe should be mixed thoroughly *in a dry state* in order to insure proper distribution.

1. A single dry ingredient or a dry mixture is placed on a piece of glass or other nonabsorbent, smooth surface. To one side of the mound of dry material pour a bit of the liquid binding medium, or of water, as the recipe requires. With a palette knife place some of the dry material in the pool of liquid and work the two together. Either more dry material or more liquid should be added to form a proper paste. The paste should be of a consistency that it can be rolled into a neat ball between the palms of the hands.

2. Take a dab of this paste and form it into a rough cylinder, always keeping the paste well compressed. Place it upon a piece of cardboard or brown wrapping paper. Then take a little block of smooth wood, about 2 inches wide by 5 inches long, and *very gently* with a little pressure roll the cylinder back and forth. During this operation one runs the risk of forming a little hollow within the cylinder. Therefore, either have the original cylinder approximately the desired length and thickness so that a minimum of rolling strokes is required, or after every few strokes pinch the ends where the hollows tend to begin their formations.

3. When the colored cylinders are complete, they may be covered with a light sheet of cardboard to equalize the drying process and minimize the tendency for the ends to curl. Usually they will be dry by the following day, although those prepared with starch and honey solutions, or other thick binders, may require two or three days to dry thoroughly.

126

4. One may also use a cake-decorator's syringe to form the cylinders. The aperture may have to be enlarged or, if it is an odd shape, sawed off to provide a simple circular opening. In this case, the edge of the new opening should be filed and burnished with steel wool until it is perfectly smooth so that the burr of the metal will neither form grooves in the cylinders nor make them curl as they are forced through the opening. It is advisable to use such a syringe only if one is preparing a large supply of the same color tint.

5. During the process of drying, a crust frequently forms on the outside of the cylinders. The drawing ends of the cylinders should be gently scraped with a penknife to remove the crust and expose the soft interior.

The following simple recipes will provide a point of departure for preparing fabricated chalks and pastels. Generally, these recipes produce chalks which are neither hard nor extremely soft. *Recipes*

Yellow ochre: yellow ochre dry pigment + M–1 solution
Yellow ochre tint: 1 measure of yellow ochre dry pigment + 1 measure of ball clay No. 6 + water
Cadmium yellow (light): 1 measure cadmium yellow (light) dry pigment + 1 measure ball clay No. 6 + water; *or*
1 measure cadmium yellow (light) dry pigment + 1 measure hydromel (1 honey : 6 water)
Cadmium yellow (light) tint: 1 measure cadmium yellow (light) dry pigment + 4 measures ball clay No. 6 + water
Burnt sienna: 1 measure burnt sienna dry pigment + 1 measure kaolin + M–2 solution
Burnt sienna tint: 1 measure burnt sienna dry pigment + 2 measures ball clay No. 6 + water
Burnt umber: 1 measure burnt umber dry pigment + 1 measure whiting + water; *or*
3 measures burnt umber dry pigment + ⅛ measure bentonite + water
Burnt umber tint: 3 measures burnt umber dry pigment + 4 measures kaolin + ¼ measure bentonite + water
Cadmium red (light): 4 measures cadmium red (light) dry pigment + ¼ measure plaster of Paris + M–2 solution; *or*
cadmium red (light) dry pigment + hydromel (1 honey : 3 water); *or*
cadmium red (light) dry pigment + gum tragacanth solution (¼ ounce gum tragacanth : 6 fluid ounces water)
Cadmium red (light) tint: 1 measure cadmium red (light) dry pigment + 3 measures ball clay No. 6 + water
Ultramarine blue: 4 measures ultramarine blue dry pigment + 1 measure ball clay No. 6 + ⅛ measure bentonite + water
Ultramarine blue tint: 2 measures ultramarine blue dry pigment + 1 measure ball clay No. 6 + water
Viridian: viridian dry pigment + M–5 solution

Viridian tint: 1 measure viridian dry pigment + 2 measures kaolin + M–5 solution; *or*

1 measure viridian dry pigment + 2 measures kaolin + 3 measures ball clay No. 6 + water

Titanium white: 1 measure titanium white dry pigment + 1 measure ball clay No. 6 + water

Ivory black: 1 measure ivory black dry pigment + ¼ measure ball clay No. 6 + water; *or*

ivory black dry pigment + gum arabic solution (1 ounce gum arabic : 8 fluid ounces water); *or*

ivory black dry pigment + starch solution (¼ ounce starch to 8 fluid ounces water)

Oil-soaked fabricated chalks and charcoal

Sticks of charcoal or fabricated chalks may be placed in a jar of linseed oil or olive oil and permitted to absorb the fatty liquid overnight. Upon removal from the oil they should be carefully wiped with a cloth so that no superficial film remains on the surface.

Because linseed oil is a drying oil, charcoal or fabricated chalks impregnated with it must be used within a very few days, otherwise the drying of the oil makes the stick useless for drawing. On the other hand, those soaked in olive oil may be used for an indefinite time.

Crayons

Crayons range in characteristics from those which are "dry" and friable to those who are greasy and viscous. The recipes presented below will produce crayons of various representative types.

With the decline in the use of the old natural red chalk, comparable but fabricated substitutes were developed. A type frequently used by contemporary artists is the so-called sanguine Conté crayon. It is a finger-length, four-sided stick of warm reddish color which is rather chalky in its stroke but has some resistance to smudging. The following recipe will produce a crayon which possesses somewhat similar characteristics.

1. Mix the following ingredients while they are in a dry state:
 2 measures burnt sienna dry pigment
 ½ measure cadmium red (light) dry pigment
 ¼ measure Venetian red dry pigment
 3 measures ball clay No. 6
2. Grate ¼ ounce of good white soap with a common kitchen grater. Dissolve it in one fluid ounce of warm water, making certain that all the soap particles are well dissolved into a solution of creamy consistency.
3. Mix the dry materials and soap solution into a paste and roll cylinders of the crayon in the manner described under workshop procedures for fabricated chalks.

The following will produce a slightly more fatty crayon, but one which is not viscous.

1. Soak 1 gram of powdered gum arabic in 1 teaspoon of water.

128

2. Soak 7½ grams of grated white soap in 1 teaspoon of water.
3. Mix the liquid ingredients together and add 1 ounce of Venetian red dry pigment to form a paste. Roll into cylinders as described above.

For a crayon of fatty characteristics the following recipe may be used.

1. Melt together in a shallow vessel over low heat, 2 ounces of tallow, 1 ounce of pure white beeswax, and ¼ ounce of spermaceti. This mixture need not be used immediately but may be set aside to cool into a paste.
2. Take 1 ounce of this mixture and add 3 teaspoons of turpentine. Warm it over a low fire until it has melted and the turpentine is thoroughly incorporated.
3. Add 2 ounces of ivory black dry pigment. Mix it well and pour it into a metal or porcelain mold to harden.

The following recipe will give a crayon of greasy or unctuous characteristics.

1. Take a given weight of the above mixture of tallow, beeswax, and spermaceti, and melt it over a low heat.
2. Take an equal weight of ivory black dry pigment and mix it into the melted fatty liquid.
3. Remove it from the fire, but while the mixture is still warm and plastic, roll it into a cylindrical shape.

A similar crayon which is red may be obtained by adding to each part (by weight) of the mixture of tallow, wax, and spermaceti, 3 parts (by weight) of Venetian red dry pigment.

Charcoal and graphite

Charcoal: sources and characteristics Charcoal is a medium of such modest characteristics, simplicity of preparation, and common usage that we are apt to overlook the reliance which so many artists placed on it over the centuries. Moreover, because it was an admirable preparatory sketching medium we tend to look upon drawings in charcoal as penultimate versions of art works. This attitude persists despite many beautiful charcoal drawings which are complete artistic achievements in their own right.

The modest tinting strength of wood carbon particles prevented charcoal from being preferred as a black pigment for painting or in the preparation of fabricated chalks or inks. On the other hand, its friability, which produced scattered splinters of carbon, and its lack of covering power, made it an excellent tool for setting-in preliminary outlines which could be either removed upon completion of drawings with metalpoints or pens, or could remain unobtrusive in chalk drawings. It was these latter characteristics and virtues which originally led to its acceptance as a useful preparatory medium. Over the centuries sketching with charcoal was described in almost every manual which included a section on drawing. If pens and ink, or metalpoints, were to be used to finish drawings the commonly described procedure was to lightly sketch the tentative images with charcoal. Upon completion of such drawings, the charcoal was removed with the vane of a feather, stale bread crumbs, or, by the eighteenth century, with "gum erasers."[1]

The splintering manner in which the charcoal stick broke down under modest pressure was also recognized as a feature which could provide the broad lines necessary for delineating figures of the large scale required for mural compositions. Cennino recommended it in his instructions for lay-

"Study for a Portrait of Madame d'Haussonville" by Jean Auguste Dominique Ingres.—*Courtesy of The Fogg Art Museum, Harvard University (The Meta and Paul J. Sachs Collection).* Graphite sketch reinforced with black crayon strokes in the drapery.

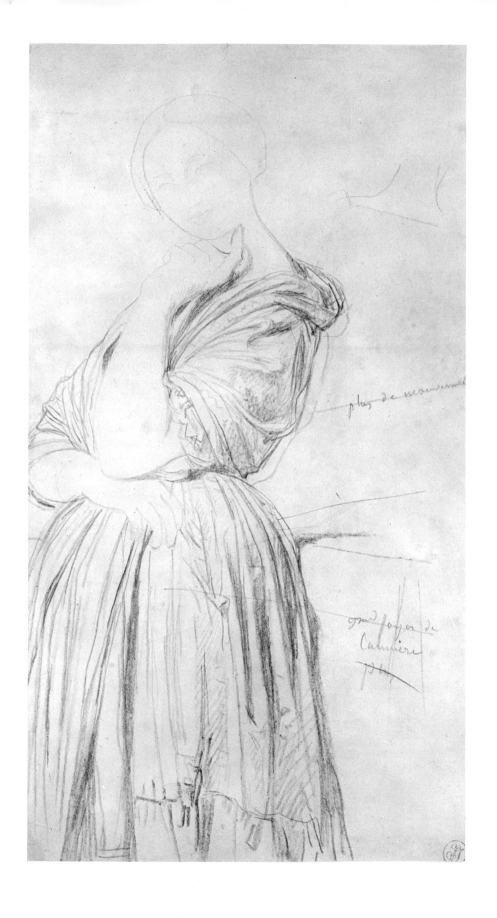

ing out the full scale designs on the rough coat of walls to be frescoed, and Vasari described how large preparatory cartoons for fresco should be drawn with charcoal.[2]

Because the artists of the sixteenth century preferred to produce many of their drawings on a larger scale than was common to their predecessors, charcoal was adopted with more and more frequency for the completion of studies. It was not only a satisfactory medium for entire figures, but also for large portrait drawings such as the nearly life-sized head of a "Bearded Man Wearing a Turban" by Hans Burgkmair, the Elder. For very large drawings charcoal had advantages over the harder and more compact natural black chalk as may be found in drawings similar in size to the "Apollo" of Guido Reni, a work approximately four feet in height. In some instances drawing with charcoal was used for works of such great scale that the carbon stick was fastened to a long rod so that it could be manipulated at more than arm's length. This method of creating large studies was recommended as early as the Renaissance by Vasari and was still being employed in our time by Matisse in designing decorations for the church at Vence.[3] Moreover, the extreme softness of some charcoals was highly effective for producing exceptionally broad, black strokes. Tintoretto, as in his "Samson and the Philistine," used thick, soft charcoal sticks and papers of little grain to create drawings in which the lines resemble wide bands of black dust.

During the seventeenth and eighteenth centuries charcoal was extensively used, although it was not necessarily preferred by many of the artists. However, as the use of natural chalks declined, and in the nineteenth century was ultimately abandoned, it became the principal medium for figure studies. And in the academies, it was the traditional tool for life drawing exercises, a preference which is still common today.

The methods of preparing charcoal were quite simple and had few variations over the several centuries during which artists produced their own drawing sticks. Although vine charcoal was used in the nineteenth and twentieth centuries, the manuals of the preceding centuries suggested that woods were the common source. The favorite wood was willow (or sallow, a species of willow), but linden, plum, "dogge-woode," and spindle wood were also recommended.[4] The charcoal was made by carbonizing the wood in heated chambers from which air was excluded in order that the sticks would not burn and be reduced to ashes. Cennino described how the artist formed bundles of willow wood slips by binding them with iron or copper wire, placed them in a casserole, the cover of which was luted with clay to make it airtight. The vessel was put into a baker's oven or under the hot ashes of a fire and left overnight to produce the carbonization.[5] Borghini, at the end of the sixteenth century, paraphrased these directions of Cennino but added a third method which made use of linden wood placed in an

"Bearded Man Wearing a Turban" by Hans Burgkmair.—*Courtesy of The Fogg Art Museum, Harvard University (Gift of Mr. and Mrs. Robert Woods Bliss).* Charcoal.

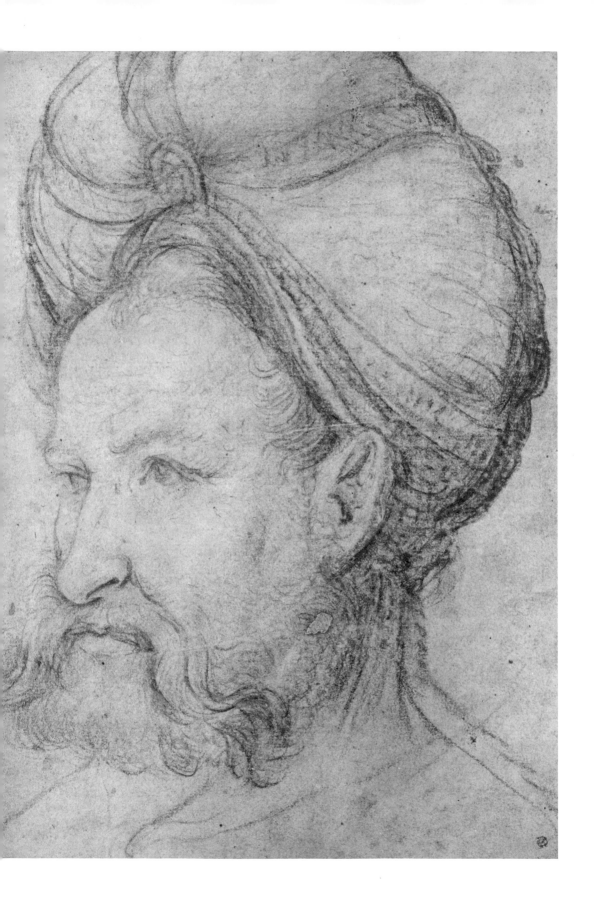

Microphotographic enlargement of a detail of "Study for a Portrait of Diego Martelli" by Degas. Charcoal strokes, illustrating the manner in which the weightless carbon particles tend to fall in the pits of the grain of the paper. Compare the enlargement of the study done with fabricated black chalk (p. 114).

"Study for the Portrait of Diego Martelli" by Edgar Degas.—*Courtesy of The Fogg Art Museum, Harvard University (The Meta and Paul J. Sachs Collection).* Charcoal, with a few touches of white chalk on the shoes, on a gray-brown paper. Compare the study of Martelli drawn with fabricated black chalk (p. 115).

134

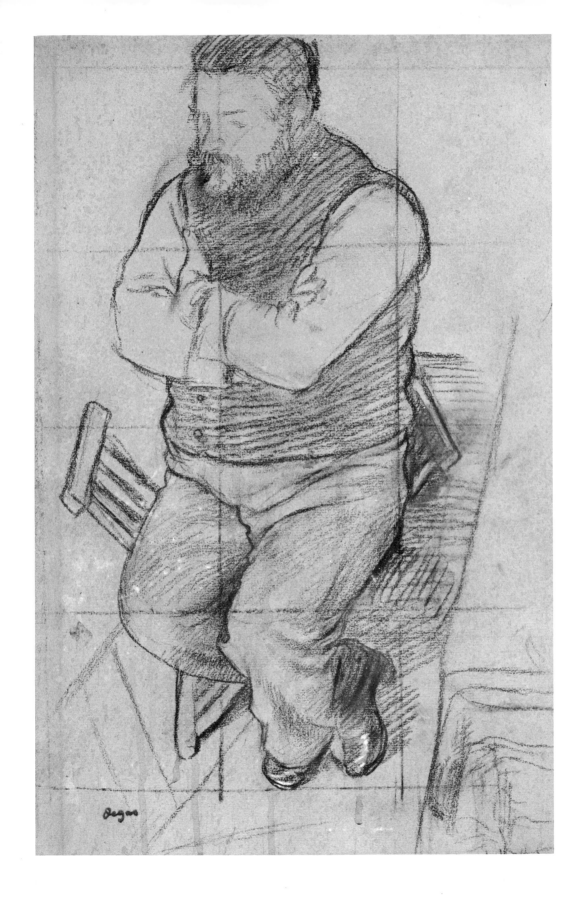

iron box whose cover and lock had to be luted before the baking took place.[6] And Volpato, in the late seventeenth century, suggested the use of an iron tube, into which plum or willow sticks were placed, the ends of the tube being carefully covered with ashes to exclude the air.[7]

During these early centuries there was no simple method by which artists could control precisely the softness or hardness of their charcoal sticks as is done in the manufacturing processes of today. But Cennino and Volpato were aware that the longer one left the wood slips within their airless chambers in the hot oven or under the ashes, the softer the charcoal became.

Most charcoals do not produce strokes which possess the intensity of blackness which is common to fabricated black chalks. The limited tinting strength and covering power which are typical of this form of carbon, and the resulting grayish cast, may be recognized whenever charcoal particles are not piled up in heavy concentrations. Moreover, this grayness of charcoal often produces a duller effect than is usual with fabricated black chalks, especially when it is broadly distributed in areas of tonal shading, or subjected to smudging with the fingers or a chamois skin or stump.

Under a microscope one may observe that charcoal particles on the paper possess sharp edges and crisply fractured planes, suggesting that during the act of drawing they have freed themselves from the stick in a splintering manner. In contrast, fabricated chalks deposit short and somewhat round pellets of black powder. In the distribution of these substances on paper, one may note that strokes from a stick of relatively hard charcoal will have its fragments deposited unevenly, sometimes leaving a transparent film of smudged pigment between points of darker concentration, with the weightless charcoal particles tending to drop into the pits of the paper's grain. Fabricated black chalks with their greater covering power, which is due to the density of their black pigments, and their weakly bound masses which crumble so readily, seem to saturate the paper and, more than charcoal, leave mounds of black on the peaks of the paper's grain.

Although these textural features and manners of distribution are not to be found in all drawings, one may find them in many studies, especially those which have not suffered from rubbing or other abuses over the centuries. Two well preserved examples which present these diverse characteristics of charcoal and fabricated black chalks are both portrait studies of Diego Martelli by Degas. An example in which a relatively hard charcoal was used and the resistant stick caused tiny charcoal fragments to "explode" over the surface of the paper is another drawing by Degas entitled "After the Bath."

Charcoal drawings by contemporary artists may have features somewhat

"Study for a Portrait of Madame d'Haussonville" by Jean Auguste Dominique Ingres.—*Courtesy of The Fogg Art Museum, Harvard University (The Meta and Paul J. Sachs Collection).* Graphite.

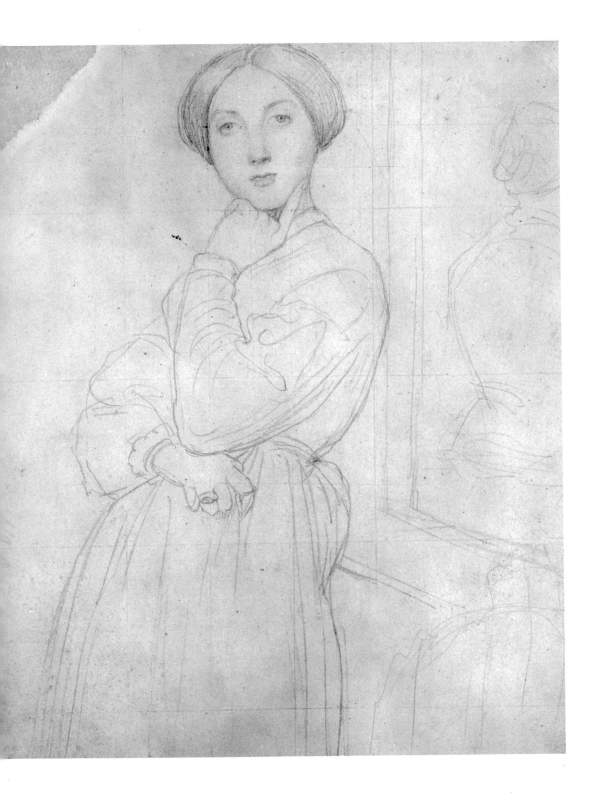

more like those of drawings produced with the old fabricated black chalks. At the present time, in addition to the traditional charcoals made from sticks of wood and vine, commercial manufacturers are developing substitutes for the artist who prefers a stroke of more concentrated blackness than the traditional charcoal will usually provide. Produced with compressed charcoal, which gives them a greater density and effect of blackness, they may be obtained either in stick form or as "pencils" with wooden sheaths.

Graphite The modern graphite pencil is such a commonplace instrument of writing and drawing that artists and students of drawings tend to overlook the particular resources which it offers the draughtsman, resources which are most clearly apparent when it is compared with the metallic stylus. Despite some differences in characteristics which these tools displayed, they produced effects of sufficient likeness that lumps or sticks of graphite, and ultimately graphite pencils, became, in the field of art, the principal successors of metalpoints. It was also because of these similarities, especially in the cases of lead and lead-alloy styluses, that the accidents of terminology occurred and persisted which have caused us to refer to the commonest of graphite instruments as a "lead pencil" in English and "Bleistift" in German.

Although the metalpoint tools were beginning to lose favor among artists during the sixteenth century, graphite did not concurrently become an important substitute. From the drawings of the period we know that artists favored pen and ink, charcoal, and chalks. And the paucity of references to graphite in the literature of the sixteenth and early seventeenth centuries also discourages any assumption that there might have been widespread use of it until the latter century.

The lode which was to furnish Europe with its finest graphite was discovered about 1560 at Burrowdale, Cumberland, England. For almost three centuries it was the most highly prized European deposit and was jealously guarded both at the source and by severe export restrictions. Shortly after its discovery, references to a substance which seems to have been graphite began to appear. Scholars compiling information on minerals, such as Conrad Gesner and Andrea Caesalpino, seem to have had knowledge of graphite, although their descriptions and terms presented some ambiguities.[8]

Although Caesalpino, and Lomazzo's English translator, Haydocke, mentioned its application to drawing, graphite does not seem to have had common use until well into the seventeenth century.[9] In 1620 Sir Roger Pratt, the architect, mentioned the use of "black lead Pencils, the blackest and least brittle whereof are the best";[10] in 1658 Sanderson clearly distinguished between black chalk and "Pensills, of Black-lead,"[11] as did the author of *The Excellency of the Pen and Pencil* in 1688.[12] In 1694, the French

"An Arab on Horseback Attacked by a Lion" by Eugène Delacroix.—*Courtesy of The Fogg Art Museum, Harvard University (The Meta and Paul J. Sachs Collection).* Soft graphite on brown paper.

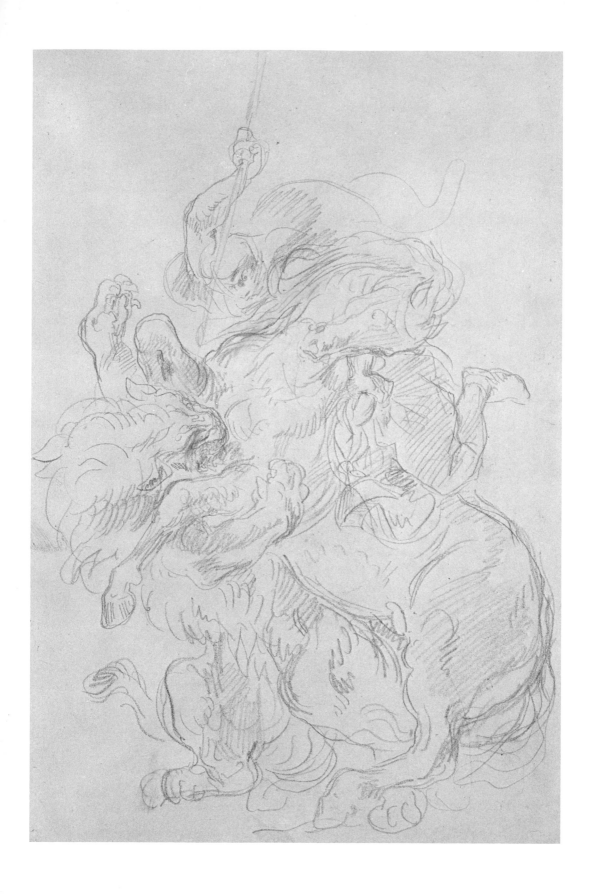

Microphotographic enlargement of a detail from "Study for The Portrait of Madame Julie Burtin" by Degas. Graphite with touches of white chalk.

"Study for the Portrait of Madame Julie Burtin" by Edgar Degas.—*Courtesy of The Fogg Art Museum, Harvard University (The Meta and Paul J. Sachs Collection).* Graphite with touches of white chalk.

140

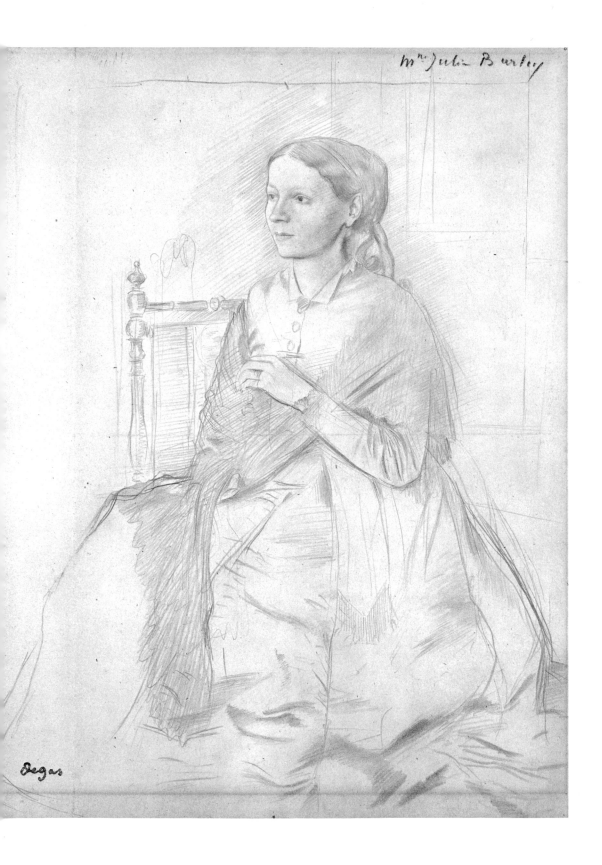

student of pharmaceuticals, Pierre Pomet, not only observed that graphite was used by architects and other draughtsmen but recommended that one choose the finest grade, which was imported from England, in preference to inferior graphite which was obtained from Holland.[13]

Natural graphite was used either as a lump or a stick set into a *porte-crayon* and pointed, or in a form more familiar to us, that of pencils with pieces cut and fitted into hollow cylinders of wood.[14] The development of manufacturing processes by which graphite pencils became the immediate prototype of our modern form seems to have been stimulated by two factors. One was the inevitable attempts to utilize inferior graphite. After crushing and purification, the powder was compressed—or mixed with binding media and compressed—into rods which could be fitted into hollow wooden sticks, usually of cedar. The second development was a result of the embargo on the shipment of graphite from Burrowdale during the difficulties between England and France in the late eighteenth century. As early as 1754 Buchotte wrote of the high price, caused by war, which was asked for fine graphite from England.[15] Subsequently, the lack of graphite pencils for commerce became so critical in France that public encouragement led the amateur artist and mechanical genius, Nicolas-Jacques Conté, to undertake experiments toward the effective use of inferior graphite from continental sources. In 1795 Conté patented his process for preparing pencils from pastelike mixtures of graphite and fine clays which were compressed into cylindrical rods, a method which was recommended for the approbation of the *Institut National* and the encouragement of the French governmnent.[16] Conté's processes permitted control of quality and type, and graphite pencils could be made texturally fine or coarse, dark or light, hard or soft by the manufacturer's choice of ingredients, their relative proportions, and the extent of firing or baking of the pastes.[17]

Although the basic mixtures of graphite pencil manufacture were established in the late eighteenth and early nineteenth centuries by Conté, Brookman, and Hardmuth, materials in addition to graphite and clay were sometimes introduced to vary the type of product. These included antimony, spermaceti and other waxes, shellac, rosin, gums, and at times, undoubtedly to produce a greater blackness, lampblack.[18] Despite subsequent discoveries of deposits in other countries, until the middle of the nineteenth century when the lodes were mined out, the graphite of Burrowdale was the most famous and considered the best. By the twentieth century modern technology had devised ways of producing graphite synthetically—a product now used in the manufacture of our graphite pencils.

The strokes from a graphite pencil, because of a similar metallic lustre and relative darkness, most closely approximate the lines produced by lead-alloy metalpoints. However, soft pencils can create strokes of a dark-

"Nude Study" by Henri Matisse.—*Courtesy of The Metropolitan Museum of Art.*
Graphite, in a pencil of a broad and very black type, with probable mixture of carbon black particles.

ness unobtainable with any metalpoint. And graphite strokes have a richness of textural effect which is noticeably greater than that of the flat, compressed strokes from a stylus. This latter difference in appearance is a result of the fact that the graphite is transferred to the paper as grains or flakes of crumbled, friable material, rather than in the form of a thin metallic layer transmitted by a wearing, rubbing action of the metal.[19]

The textural element, the greater range of light-dark value, and the slightly rougher edges of graphite strokes permit easier shading of broad tonal areas than is possible with metalpoints. Moreover, not only do they give the artist a greater latitude in the dimensions or scale of his drawings, but they produce richer effects and stronger delineations than can lead-alloy styluses regardless of whether the latter are used on papers with prepared grounds or unprepared surfaces.

The use of graphite as an acceptable medium for the finishing of drawings, contrasted with its role as a preliminary sketching tool for ink, wash, or chalk drawings, first occurred in works by masters of the seventeenth century. David Teniers the Younger, in his "Study of Figures," and Aelbert Cuyp, in the "Study of Cows and Milk Cans," produced works which revealed this new function. At other times, as in his "View of a Walled Town," Cuyp introduced gray strokes of graphite to suggest the distant portions of landscape in drawings where other media produced the elements of the foreground.

The gradual increase in the selection of graphite by masters of the following century should not lead one to suppose that by the eighteenth century it was used as frequently as natural black chalk or charcoal for either preliminary notations or finished drawings. The works of the period give the impression that these three media were used interchangeably but that graphite was the least favored. In works of outstanding draughtsmen, such as the "Two Seated Females" of Tiepolo or the "Seated Lady" of Watteau, graphite served as a means for preliminary sketching. Other masters accepted it as a proper medium for finished drawings as Gainsborough did in a series of studies, among them the "Landscape with a Decayed Willow Tree," and Romney in the "Lady Holding a Book."

In the late eighteenth and early nineteenth centuries, the difficulties of obtaining good natural black and red chalks, and the fine quality and range of graphite pencils produced by the new methods of fabrication, undoubtedly contributed to the widespread use of this medium. Artists of very diverse tastes in draughtsmanship seem to have found one type of pencil or another to their liking. Whether for the simplicity and clarity of Ingres' draughtsmanship in the "Study of Mlle Joséphine Lacroix" or the more flamboyant and unbridled linearisms of "An Arab on Horseback Attacked by a Lion" by Delacroix, graphite pencils were adaptable drawing means. Degas, as much as any artist, exploited the range provided by pencils of different blackness or grayness, softness or hardness, and on occasion used more than one type of graphite pencil, as is the case in the "Study of Mme Julie Burtin." He exhibited a remarkable sensitivity to graphite, which he never abused in an attempt to obtain effects

which were beyond the inherent capabilities of the medium to provide. Van Gogh, wishing to transmit his conceptions onto paper in blunt, powerful strokes, wrote appreciatively of the qualities he found in the thick, black graphite rod of carpenters' pencils which, at one time, he preferred to the pencils customarily used for writing and drawing.[20]

A piece of soft graphite is friable enough to use on its side for modestly broad strokes, but it is less adaptable in this manner than chalks, charcoal, or lithographic sticks. Although it is no longer a fashionable method, frequently graphite strokes were rubbed with a stump of paper or leather in order to produce light gray tonalities. These practices were most frequently followed by artists of the nineteenth century and both methods were used in the "Head of a Bearded Man" and the "Head of a Young Woman" by Adolph von Menzel. On the other hand very hard graphite pencils provided the means by which were created the delicate and uncompromisingly precise drawings of numerous nineteenth century masters, a typical example being Ludwig Richter's "Dresden: View from the Brühl Terrace toward the Hofkirche and the Augustus Bridge."

Graphite pencils are used by every artist and art student. And this recurring and common use accounts in part for a skillful employment by some but frequent abuse of the tool by others. The fact that it will draw, no matter how unwillingly, on almost any surface has caused it to be thoughtlessly assigned artistic tasks of almost every conceivable kind in drawing.

Despite the range of values and distinctions in hardness and softness which artists have had to choose from among graphite pencils, it is not uncommon to find that the medium was forced beyond the limits of its greatest resourcefulness. There are many drawings in which artists have overworked areas, have forced a hard pencil to attempt effects more easily and satisfactorily obtained with a soft pencil, or have assigned to a soft pencil tasks more sympathetically and effectively performed by chalks and crayons.

The dull, monotonous grayness of tones which result from overdrawing of shaded areas often destroy the desired form in figures and reduce suggestions of textural richness. And the shiny, mottled effects which result from endless redrawing and forced shading are common symptoms of a lack of appreciation of the graphite medium which operates handsomely in drawings of simple linearism and limited shading.

WORKSHOP PROCEDURES

Charcoal

The availability of commercially produced charcoal sticks of good quality and modest price will hardly encourage the artist to prepare his own charcoals. Nevertheless, the process is so simple that if one wishes, charcoal may be made at substantially no cost.

1. From a plumbing shop one can obtain a short length of pipe; a piece approximately 10″ long and 2″ in diameter is adequate. The ends of

the pipe should be threaded so that pipe caps can be screwed on to form an airtight chamber comparable to the old luted casseroles.

2. Slips of well-seasoned wood are shaped by sawing or cutting to the desired thicknesses and lengths. These may then be bound together with stove wire into bundles, the tighter the better. The loops of wire may be spaced every few inches, but one should be placed as close to each end of the bundle as possible. The wires will help prevent the warping of the charcoal sticks as they undergo the process of carbonization.

3. Place the bundles into the pipe, screw the caps on tightly, and bury this "chamber" under the hot coals or ashes of a fire. Be sure that it is well covered so that there will be an equal distribution of heat. If one leaves this overnight, a good set of charcoal sticks will be produced.

Appendix

References and notes

Index

I. *Commercial and noncommercial sources of materials*

Many of the materials mentioned in the text, or in the sections on workshop procedures, such as honey, olive oil, plaster of Paris, linseed oil, and soap, are so readily available through local drug, grocery, and art supply stores that they have not been listed in the sources of materials below. Other materials which are less familiar usually may be obtained through drug stores. If they are not in stock the druggist may order them from chemical, pharmaceutical, or scientific wholesalers. For each item presented below, the sources of supply have been arranged according to the convenience of obtaining it or the possibility of purchasing it in a small lot.

Ball clay No. 6
Ceramic studios
Kentucky Clay Mining Co., Mayfield, Ky.

Beeswax (genuine, white)
Art supply stores
Innis, Speiden and Co., Chicago, Ill.

Bentonite
Ceramic studios
O. Hommel Co., Pittsburgh, Pa.

Bismuth (lumps)
Chemical supply firms
Chicago Apparatus Co., Chicago, Ill.
E. H. Sargent and Co., Chicago, Ill.

Bistre (wood soot)
The artist must obtain this for himself by scraping the soot from fireplaces in which wood has been burned. Coal or oil soot is useless for making bistre.

Bone ash
Chicago Apparatus Co., Chicago, Ill.

Boxwood
J. H. Monteath Co., New York, N. Y.

Brass
Brodhead-Garrett Co., Cleveland, Ohio

Bronze
Brodhead-Garrett Co., Cleveland, Ohio

Chalk (natural black)
This carbonaceous shale is difficult to obtain in the blend necessary for a good natural black chalk. Specimens ordered as "roof rock" are too unpredictable in quality for a certain source of supply to be listed.

Chalk (natural red)
Ward's Natural Science Establishment, Rochester, N.Y. This should be ordered as "Hematite, var. ochre (Dana 232), Negaunee, Mich."

Chalk (natural white)
Ward's Natural Science Establishment, Rochester, N.Y. This should be ordered as "Calcite, var. chalk (Dana 270), Dover Cliffs."

Copper
Art supply stores, in the form of etching plates
Brodhead-Garrett Co., Cleveland, Ohio

Ferrous sulphate
Wholesale drug firms
Mallinckrodt Chemical Works, New York, N.Y.

Gall nuts
Wholesale drug firms
S. B. Pennick Co., New York, N.Y.

Glue (rabbit skin)
Art supply stores
Connecticut Glue Co., Danbury, Conn.

Glue (sheet gelatine)
Drug stores
Wholesale drug firms

Gold
Gold and gold wire may be obtained from manufacturing jewelers or jewelry repair shops which may be found in almost any city of moderate size.
Goldsmith Brothers Smelting and Refining Co., New York, N.Y.

Gum arabic (tears or powder)
Drug stores
Wholesale drug firms
J. T. Baker Chemical Co., Phillipsburg, N.J.
Mallinckrodt Chemical Works, New York, N.Y.

Gum tragacanth (ribbons or powder)
Drug stores
Wholesale drug firms
Eimer and Amend, New York, N.Y.
Fischer Scientific Co., New York, N.Y.

Kaolin
Ceramic studios
J. T. Baker Chemical Co., Phillipsburg, N.J.
Mallinckrodt Chemical Works, New York, N.Y.

Lead (granules)
Chemical supply firms
E. H. Sargent and Co., Chicago, Ill.
Merck and Co., Rahway, N.J.

Methylcellulose (100 CPS)
Chemical supply firms
Fischer Scientific Co., New York, N.Y.
Quills (goose)
Lewis Glaser, Box 123, New Haven, Conn.
Kruk and Co., Chicago, Ill.
Reeds
Floral and garden supply shops. Japanese reeds imported to be used for supporting plants.
The banks of lakes and streams in the United States
Sepia (genuine)
F. Weber Co., Philadelphia, Pa. Genuine sepia in watercolor pans
Silver
Local manufacturing jewelers or jewelry repair shops
Handy and Harman, Chicago, Ill.

Sodium benzoate (.01 solution)
Drug stores
Spermaceti
Wholesale drug firms
Innis, Speiden and Co., Chicago, Ill.
Chicago Apparatus Co., Chicago, Ill.
Tallow (mutton)
Wholesale drug firms
Fischer Scientific Co., New York, N.Y.
Tin (granules)
Chemical supply firms
J. T. Baker Chemical Co., Phillipsburg, N.J.
Whiting
Drug stores
Wholesale drug firms
Zephiran chloride (concentrated solution)
Drug stores

2. *List of masterworks cited*

Altdorfer, Albrecht. "Salome with the Head of St. John the Baptist." Quill pen and brush, carbon black ink, and heightening with white on a brownish ground. The Cleveland Museum of Art: 48.440.

Bouchardon (?), Edme. "Virgin, Child and Worshipper." Natural red chalk and a wash made with natural red chalk particles. The Pierpont Morgan Library, New York: III, 94A.

Burgkmair, Hans (the Elder). "Head of a Bearded Man Wearing a Turban." Charcoal. Fogg Art Museum, Harvard University: 1936.124. Gift of Mr. and Mrs. Robert Woods Bliss.

Burkert, Robert. "Warrior." Chiaroscuro drawing with brush on a dark blue-gray ground. Collection of the author.

Cadmus, Paul. "Seated Female Nude" (1942). Silverpoint on a white ground. Midtown Galleries, New York.

Cambiaso, Luca. "Three Figures." Pen and iron-gall ink. The Art Institute of Chicago: 22.15.

Canal, Antonio (Canaletto). "The Church of the Redentore." Quill pen, bistre ink and carbon black ink wash. Fogg Art Museum, Harvard University: 1932.325.

———. "A Circular Church." Quill pen, bistre ink and carbon black ink wash. Fogg Art Museum, Harvard University: 1932.327.

Clouet, François. "Portrait of an Unknown Man." Natural red and black chalks. Fogg Art Museum, Harvard University: 1927.624. Meta and Paul J. Sachs Collection.

Corot, Camille. "View of Mt. Soracte from Città Castellana." Quill pen and iron-gall ink. Fogg Art Mu-

seum, Harvard University: 1938.436. Meta and Paul J. Sachs Collection.

Cuyp, Aelbert. "Study of Cows and Milk Cans." Graphite and carbon black wash. The Pierpont Morgan Library, New York: I, 123.

———. "View of a Walled Town." Graphite, natural black chalk strokes both dry and through a wet wash, carbon black wash. The Pierpont Morgan Library, New York: I, 122.

Degas, Edgar. "After the Bath." Charcoal, and pastels of ochre-brown, burgundy red, dark red, dark green, and light green. Fogg Art Museum, Harvard University: 1927.723. Meta and Paul J. Sachs Collection.

———. "Mounted Jockey." Black and white brush drawing on a brown paper. The Isabella Stewart Gardner Museum, Boston (no accession number).

———. "Study for a Portrait of Diego Martelli." Charcoal, and white chalk heightening on a gray-brown paper. Fogg Art Museum, Harvard University: 1929.612. Meta and Paul J. Sachs Collection.

———. "Study for a Portrait of Diego Martelli." Fabricated black chalk with touches of white chalk on a gray-brown paper. Fogg Art Museum, Harvard University: 1929.613. Meta and Paul J. Sachs Collection.

———. "Study for the Portrait of Madame Julie Burtin" (1863). Graphite with touches of white chalk. Fogg Art Museum, Harvard University: 1928.623. Meta and Paul J. Sachs Collection.

Delacroix, Eugène. "An Arab on Horseback Attacked by a Lion" (1849). Graphite. Fogg Art Museum, Harvard University: 1927.722. Meta and Paul J. Sachs Collection.

———. "Hamlet and His Mother." Quill pen and

bistre. Fogg Art Museum, Harvard University: 1944.10.

Dix, Otto. "Head of a Child" (1935). Silverpoint on a white ground. Swetzoff Gallery, Boston.

Fragonard, Jean-Honoré. "L'Invocation à l'amour." Brush and brown water colors. The Cleveland Museum of Art: 43.657. Purchase from the Grace Rainey Rogers Fund, 1943.

———. "A Woman Standing with Hand on Hip." Red crayon. Fogg Art Museum, Harvard University: 1927.407.

Franco-Flemish, fourteenth century. A booklet of silverpoint drawings on boxwood leaves. The Pierpont Morgan Library, New York: M.346.

Gainsborough, Thomas. "Landscape with a Decayed Willow Tree." Graphite. The Pierpont Morgan Library, New York: III, 47.

Gellée, Claude (Le Lorrain). "Landscape with Centaur." Quill pen and bistre, water-color washes, and heightening with white on a brown paper. Fogg Art Museum, Harvard University: 1927.536. Meta and Paul J. Sachs Collection.

Gericault, Théodore. "An Artilleryman Leading His Horses into the Field." Graphite sketch, brush and sepia. Fogg Art Museum, Harvard University: 1929. 564. Meta and Paul J. Sachs Collection.

———. "Herdsmen Rounding up a Herd of Bulls." Heavy graphite strokes, blackish washes on brown paper, broadly treated heightening with whites. Fogg Art Museum, Harvard University: 1927.670.

Gogh, Vincent van. "Tree in a Meadow." Reed pen and iron-gall ink. The Art Institute of Chicago: 45.31.

Greuze, Jean-Baptiste. "A Seated Nude Woman." Red crayon. Fogg Art Museum, Harvard University: 1929.602. Meta and Paul J. Sachs Collection.

Grosz, George. "The Survivor" (1936). Reed and steel pens, and black carbon ink. The Art Institute of Chicago: 39.311.

Guercino (Giovanni Francesco Barbieri). "Mother and Child." Natural red chalk with warm orange-red effects where the chalk has been rubbed. The Pierpont Morgan Library, New York: IV, 168G.

Holbein, Hans (the Younger). "Portrait of a Leper (so-called)." Natural red and black chalks, quill pen and carbon black ink, and washes of ochre and gray. Fogg Art Museum, Harvard University: 1927.425. Meta and Paul J. Sachs Collection.

Ingres, Jean Auguste Dominique. "Study for a Portrait of Madame d'Haussonville." Graphite. Fogg Art Museum, Harvard University: 1927.498. Meta and Paul J. Sachs Collection.

———. "Study for the Portrait of Madame d'Haussonville." Graphite and black crayon. Fogg Art Museum, Harvard University: 1927.670. Meta and Paul J. Sachs Collection.

———. "Study of Mlle Joséphine Lacroix" (1813). Graphite. The Pierpont Morgan Library, New York: III, 124B.

Jordaens, Jacob. "Assembly of the Gods." Natural black chalk sketch, natural red chalk accents, brush and washes of ochre, pink, light blue, blue-gray, brown, and green. The Pierpont Morgan Library, New York: III, 171.

Kubota, Jean. "Young Girl." Silverpoint on a white ground. Department of Art History, University of Wisconsin.

Legros, Alphonse. "Head of a Man." Silverpoint on a white ground. The Metropolitan Museum of Art: 92.13.1.

———. "Study for a Portrait of Edward D. Adams" (1892). Goldpoint on a white ground. The Metropolitan Museum of Art: 21.33.10.

———. "Study of the Hands of Edward D. Adams." Goldpoint on a white ground. The Metropolitan Museum of Art: 21.33.11.

Leu, Hans (the Younger). "Pietà." Quill pen and brush carbon black ink, and heightening with whites on an olive-green ground. Fogg Art Museum, Harvard University: 1936.125. Gift of Mr. and Mrs. Robert Woods Bliss.

Lippi, Filippino. "Two Male Figures." Silverpoint with heightening with white on a light pink ground. The Metropolitan Museum of Art: 36.101.1.

Matisse, Henri. "Crouching Nude" (1908). Reed pen and carbon black ink. The Art Institute of Chicago: 26.1533.

———. "A Lady with a Necklace." Steel pen and carbon black ink. Fogg Art Museum, Harvard University: 1938.571. Meta and Paul J. Sachs Collection.

———. "Madame Manquin." Reed pen. Collection of Mr. T. E. Hanley, Bradford, Pennsylvania.

———. "Nude Study." Graphite, in a pencil of a broad and very black type, with probable mixture of carbon black particles. The Metropolitan Museum of Art: 10.76.3.

Menzel, Adolph von. "Head of a Bearded Man." Graphite. Fogg Art Museum, Harvard University: 1943.534.

———. "Head of a Young Woman." Graphite. Fogg Art Museum, Harvard University: 1943.532.

Michelangelo. "Study for the Libyan Sibyl." Natural red chalk. The Metropolitan Museum of Art: 24.197.2.

Moore, Henry. "Madonna and Child." Greasy crayon and black pen lines, gray wash background, heightening with white. The Cleveland Museum of Art: 47.313. The Hinman B. Hurlbut Collection, 1947.

———. "Tube Shelter Perspective" (1941). Chiaroscuro drawing. Tate Gallery, London.

Pannini, Giovanni Paolo. "Ruins of Roman Arches."

Quill pen and sepia with washes of sepia and carbon black ink. Fogg Art Museum, Harvard University: 1929.28. Meta and Paul J. Sachs Collection.

Pecham, Georg. "Acteon" (1602). Faint natural black chalk sketch, quill pen and carbon black ink, washes of brown, pale gray, and blue. The Metropolitan Museum of Art: 39.81.3.

Perlin, Bernard. "The Beggar" (1942). Silverpoint on a white ground. M. Knoedler and Company, New York.

———. "Landscape with Tree." Silverpoint on a white ground. M. Knoedler and Company, New York.

Perugino, Pietro. "A Music-Making Angel." Silverpoint on a white ground. Fogg Art Museum, Harvard University: 1936.120. Gift of Mr. and Mrs. Robert Woods Bliss.

———. "Profile Portrait of a Youth Wearing a Cap." Natural black chalk. Fogg Art Museum, Harvard University: 1936.120 verso. Gift of Mr. and Mrs. Robert Woods Bliss.

Raffet, Auguste. "Sketch for 'La Caricature'" (1831). Graphite sketch with quill pen and wash in sepia. Fogg Art Museum, Harvard University: 1927.628. Meta and Paul J. Sachs Collection.

———. "Tartars at Prayer" (1837). Quill pen and magenta-red ink. The Cleveland Museum of Art: 23.920.

Rembrandt. "Achilles and Briseis." Quill pen, reed pen, bistre, and carbon black washes. The Pierpont Morgan Library, New York: I, 184.

———. "Man Seated on Step." Quill pen and wash in bistre ink with gray areas where a semiopaque white was added. The Metropolitan Museum of Art: 29.100.935.

———. "The Mummers." Natural red chalk with darker accents produced by wetting the chalk, quill pen and bistre, bistre washes, yellow ochre fabricated chalk, and semiopaque whites applied with a brush. The Pierpont Morgan Library, New York: I, 201.

———. "Nathan Admonishing David." Reed pen, quill pen, brush, and bistre ink. The Metropolitan Museum of Art: 29.100.934.

———. "Noah's Ark." Quill pen and reed pen with bistre ink. The Art Institute of Chicago: 53.36.

———. "Two Studies of a Woman Reading." Quill pen and bistre ink. The Metropolitan Museum of Art: 29.100.932.

Reni, Guido. "Apollo." Charcoal, with touches of natural red chalk, heightened with white chalk on a grayish paper. Fogg Art Museum, Harvard University: 1920.43.

Richter, Ludwig. "Dresden: View from Brühl Terrace toward the Hofkirche and the Augustus Bridge." Graphite. Fogg Art Museum, Harvard University: 1898.82.

Romney, George. "Lady Hamilton as Ariadne." Brush and bistre. The Art Institute of Chicago: 44.580.

———. "Lady Holding a Book." Graphite. The Metropolitan Museum of Art: 11.66.4.

Rosa (?), Salvator. "The Deposition from the Cross." Quill pen and bistre ink. The Cleveland Museum of Art: 39.668.

Sarto, Andrea del. "Study for the Figure of a Young Man." Natural black chalk. The Pierpont Morgan Library, New York: I, 30.

Strang, William. "Nude Study of a Girl, Seated." Goldpoint on a pink ground. National Gallery of Canada, Ottawa: 689.

Tchelitchew, Pavel. "Portrait of Frederick Ashton" (1938). Silverpoint on a white ground. Fogg Art Museum, Harvard University: 1944.1. Meta and Paul J. Sachs Collection.

———. "Portrait of Nicolas Kopeikine" (1938). Silverpoint on a white ground with a few accents added with a graphite pencil. Fogg Art Museum, Harvard University: 1944.2. Meta and Paul J. Sachs Collection.

Teniers, David (the Younger). "Study of Figures." Graphite with a slight brown wash. The Pierpont Morgan Library, New York: I, 124A.

Tiepolo, Giovanni Battista. "Group of Female Figures Seated on a Cloud." Quill pen, iron-gall ink, gray carbon ink wash, preliminary strokes with graphite. The Pierpont Morgan Library: IV, 111.

———. "Two Female Figures." Quill pen and bistre ink. The Pierpont Morgan Library, New York: IV, 95B.

———. "Two Figures and Amorini." Quill pen and wash with bistre ink. The Pierpont Morgan Library, New York: IV, 109.

———. "Two Seated Females." Graphite, quill pen and bistre ink. The Pierpont Morgan Library, New York: IV, 122.

Tintoretto (Jacopo Robusti). "Samson and the Philistine." Charcoal on blue paper. Fogg Art Museum, Harvard University: 1933.991.

Toulouse-Lautrec, Henri de. "Le Carnaval au Moulin Rouge, Entrée de Cha-U-Kao." Blue crayon. Fogg Art Museum, Harvard University: 1950.126.

———. "Yvette Guilbert." Black crayon. The Cleveland Museum of Art: 50.455. Gift of Leonard C. Hanna, Jr., 1950.

Venetian School. "A Triumphant General" by an anonymous seventeenth-century master. Quill pen and bistre ink on a white paper. The Fogg Art Museum, Harvard University: 1936.357. Meta and Paul J. Sachs Collection.

Veronese, Paolo. "Rest on the Flight into Egypt."

Quill pen and iron-gall ink, heightened with whites laid on with a brush in a heavy manner. Fogg Art Museum, Harvard University: 1928.681. Meta and Paul J. Sachs Collection.

Watteau, Antoine. "Head of Luigi Riccoboni." Natural red chalk with darker accents produced by wetting the chalk, fabricated black chalk, traces of white chalk, on an off-white paper. The Metropolitan Museum of Art: 37.165.107.

———. "Seated Lady." Graphite, natural red chalk, fabricated black chalk and touches of white chalk. The Pierpont Morgan Library, New York: I, 278C.

———. "Sheet of Studies of Women." Two shades of natural red chalks. The Metropolitan Museum of Art: 23.280.5.

———. "Six Studies of Heads." Natural red chalk with darker accents produced by wetting the chalk, fabricated black chalk, heightening with white chalk on a tan paper. Fogg Art Museum, Harvard University: 1927.698.

———. "Study of Two Women." Natural red chalk, fabricated black chalk, heightening with white chalk on a tan paper. The Pierpont Morgan Library, New York: I, 278B.

References

The titles in the list which follows are those to which reference is made in the chapter notes. Citations in the notes are given in abbreviated forms. Works appearing in the bibliographical list are identified in the notes by authors' names alone unless an author is represented by more than one work; then the citation includes the specific title referred to. Anonymous works are cited in the notes by title.

Annales de chimie et de physique, 2nd series, Vol. X. Paris, 1818.

Arcana Fairfaxiana Manuscripta, ed. George Weddell. Newcastle-on-Tyne, 1890.

The Art of Drawing and Painting in Water-Colours, 5th ed. London, 1779.

L'Art sacré, Nos. 11–12. Paris, July-August, 1951.

Artliche künste mancherley weyse Dinten und aller hand farben zubereyten. Nuremberg, 1531.

Baldinucci, Filippo. *Vocabolario Toscano dell' arte del disegno.* Florence, 1681.

Bancroft, Edward. *Experimental Researches Concerning the Philosophy of Permanent Colours; and the Best Means of Producing Them.* London, 1813.

Berger, Ernst. *Beiträge zur Entwicklungs-geschichte der Maltechnik,* Vol. IV. Munich, 1901.

Bloch, Oscar. *Dictionnaire étymologique de la langue française.* Paris, 1932.

Blum, André. *The Origins of Printing and Engraving,* trans. H. M. Lydenberg. New York, 1940.

Bore, Henry. *The Story of the Invention of Steel Pens.* New York, 1890.

Borghini, Raffaello. *Il riposo.* Reggio, 1826.

British Patent Reports, Old Series, 1780–81. London, 1856.

British Patent Reports, Old Series, 1830. London, 1857.

British Patent Reports, Old Series, 1831. London, 1856.

Bromley, H. A., and Shore, J. *Articles of Stationery and Allied Materials: Their Chemistry and Technical Examination.* London: Grafton and Co., 1939.

Browne, Alexander. *Ars Pictoria: or an Academy Treating of Drawing, Painting, Limning, Etching,* etc., 2nd ed. London, 1675.

Buchotte, M. *Les règles du dessin et du lavis,* etc., revised ed. Paris, 1754.

Buc'Hoz, M. *Recueil de secrets sûrs et expérimentés à l'usage des artistes.* Paris, 1786.

Buchwald, August. *Bleistifte, Farbstifte, farbige Kreiden und Pastellstifte.* Vienna and Leipzig, 1904.

Butler, Pierce. *The Origin of Printing in Europe.* Chicago, 1940.

Caesalpino, Andrea. *De Metallicis Libri Tres.* Nuremberg, 1602.

Canepario, Petro Maria. *De Atramentis cujuscunque Generis.* London, 1660.

Chardin, Sir John. *Voyages du Chevalier Chardin, en Perse, et autres lieux de l'Orient,* ed. L. Langlès. Paris, 1811.

Church, A. H. *The Chemistry of Paints and Painting,* 2nd ed. London, 1892.

Constant-Viguier, S. F. *Manuel de miniature et de gouache, par Stév. F. Constant-Viguier, suivi du manuel du lavis à la sépia et de l'aquarelle, par F. P. Langlois de Longueville,* 2nd ed. Paris, 1830.

Cyclopedia: Universal Dictionary of Arts, Sciences and Literature, ed. Abraham Rees. London, 1819.

D'Argenville, Antoine-Joseph Dezallier. *Abrégé de la vie des plus fameux peintres.* Paris, 1745.

De Beau Chesne, John, and Baildon, M. John. *A Booke Containing Divers Sortes of Hands.* London, 1581.

De Grez, Bernard Dupuy. *Traité sur la peinture.* Toulouse, 1699.

A Dictionary of Science, Literature and Art, ed. W. T. Brande. London, 1865.

Dictionnaire des inventions, ed. MM. Nöel, Carpentier et Piussant fils, 4th ed. Brussels, 1839.

Dossie, Robert. *Handmaid of the Arts,* 2nd ed. London, 1764.

L'Ecole de la mignature. Brussels, 1759.

Encyclopaedia Perthensis; or Universal Dictionary of the Arts, Sciences, Literature, etc., 2nd ed. Edinburgh, 1816.

Encyclopédie ou dictionnaire raisonné des sciences, des arts, et des metiers. Paris and Neufchâtel, 1751–65.

Encyclopédie ou dictionnaire universel. Yverdon, 1774.

The Excellency of the Pen and the Pencil. London, 1688.

Field, George. *Chromatography; or A Treatise on Colours and Pigments, and their Powers in Painting,* ed. T. W. Salter. London, 1869.

Frimmel, Theodor. "Der Anonimo Morelliano," in *Quellenschriften für Kunstgeschichte,* new series, Vol. I. Vienna, 1896.

Gesner, Conrad. *De Rerum Fossilium Lapidum et Gemmarum Genere.* Zurich, 1565.

Goncourt, Edmond and Jules de. *French XVIII Century Painters,* trans. Robin Ironside. New York, 1948.

Grand dictionnaire universel du xixe siècle, ed. Pierre Larousse. Paris, 1866–70.

Gunther, R. T. *The Architecture of Sir Roger Pratt.* Oxford, 1928.

Hamerton, Philip Gilbert. *The Graphic Arts.* New York, 1882.

Haydocke, Richard. *A Tracte Containing the Artes of Curious Paintinge, Carvinge & Buildinge; Written first in Italian by Jo: Paul Lomatius painter of Milan and Englished by Richard Haydocke.* Oxford, 1598.

Hochheimer, C. F. A. *Chemische Farben-Lehre.* Leipzig, 1797.

Holmes, Urban Tigner. *Daily Living in the Twelfth Century.* Madison, Wisconsin, 1952.

Hoogstraeten, Samuel van. *Inleyding tot de Hooge Schoole der Schilderkonst.* Rotterdam, 1678.

Isidori Hispalensis Episcopi Etymologiarum Sive Originum, ed. W. M. Lindsay. London, 1911.

Jenkins, John. *The Art of Writing.* Cambridge, Mass., 1813.

Kirstein, Lincoln. *Pavel Tchelitchew Drawings.* New York, 1947.

The Laboratory or School of Arts. London, 1740.

Lemoine, Raoul, and du Manoir, Ch. *Manuel pratique de la fabrication des couleurs.* Paris, 1898.

Lettres de Vincent van Gogh à Émile Bernard, ed. Émile Bernard. Paris, 1911.

Lettres de Vincent van Gogh à son frère Théo, ed. Georges Philippart. Paris, 1937.

Li Ch'iao-p'ing, *The Chemical Arts of Old China.* Easton, Pennsylvania, 1948.

Lomazzo, G. P. *Trattato dell' arte della pittura, scoltura et architettura.* Milan, 1585.

Lomet, A. F. "Mémoire sur la fabrication des crayons de pâte de sanguine employés pour le dessin," in *Annales de chimie,* 1st ser., Vol. XXX. Paris, 1799.

Lucas, A. *Ancient Egyptian Materials.* London, 1926.

Ludwig, Heinrich. "Lionardo da Vinci. Das Buch von der Malerei," in *Quellenschriften für Kunstgeschichte,* Vol. XV. Vienna, 1882.

MacCurdy, Edward. *The Notebooks of Leonardo da Vinci.* New York: Harcourt, Brace and Co., 1938.

Maclehose, Louisa S. *Vasari on Technique.* London: J. M. Dent and Sons Ltd., 1907.

Malvasia, Carlo Cesare. *Felsina pittrice; vite de' pittori bolognesi.* Bologna, 1678.

Meder, Joseph. *Die Handzeichnung: Ihr Technik und Entwicklung,* 2nd ed. Vienna, 1923.

Merrifield, Mary P. *Original Treatises Dating from the XII to XVIII Centuries,* Vols. I and II. London, 1849.

Mitchell, C. Ainsworth. *Documents and Their Scientific Examination.* London, 1922.

Mitchell, C. Ainsworth, and Hepworth, Thomas. *Inks, Their Composition and Manufacture.* London, 1904.

Le Moyen de devenir peintre en trois heures. Paris, 1755.

Müntz, J. H. *Encaustic: or Count Caylus's Method of Painting in the Manner of the Ancients; To which is added A sure and easy Method for Fixing of Crayons.* London, 1760.

Nichols, Francis M. *The Epistles of Erasmus.* London, 1904.

Nicholson's British Encyclopedia, or Dictionary of Arts and Sciences, 3rd American ed. Philadelphia, 1819.

Norgate, Edward. *Miniatura, or the Art of Limning,* ed. Martin Hardie. London: Oxford University Press, 1919.

Parker, K. T. *The Drawings of Antoine Watteau.* London: B. T. Batsford Ltd., 1931.

Perrot, Catherine, *Traité de la mignature.* Paris, 1693.

Les Premiers élémens de la peinture pratique. Paris, 1684.

Pomet, Pierre. *Histoire général des drogues.* Paris, 1694.

Records of Journeys to Venice and the Low Countries by Albrecht Dürer, trans. Rudolph Tombo; ed. Roger Fry. Boston, 1913.

Reichel, Anton. *Die Claire-Obscur-Schnitte des XVI., XVII. und XVIII. Jahrhunderts.* Vienna, 1926.

Ribaucourt, "Dissertation sur l'encre ordinaire à écrire, par Ribaucourt," *Annales de chimie,* 1st ser., Vol. XV. Paris, 1792.

Richter, J. P. *The Literary Works of Leonardo da Vinci,* 2nd ed., J. P. and Irma A. Richter. London, 1939.

Ring, Grete. *A Century of French Painting, 1400–1500.* London, 1949.

Russell, John. *Elements of Painting with Crayons.* Dublin, 1773.

Salmon, William. *Polygraphice: or the Art of Engraving,* 5th ed. London, 1685.

Sanderson, William. *Graphice: The Use of the Pen and Pencil, or the Most Excellent Art of Painting.* London, 1658.

Sandrart, Joachim van. *Teutsche Academie der edlen Bau-Bild- und Malerey-Künste.* Nuremberg, 1675.

Secrets concernant les arts & metiers. Brussels, 1766.

Senefelder, Alois. *The Invention of Lithography,* trans. J. W. Muller. New York, 1911.

Smith, Cyril S., and Gnudi, Martha T. *The Pirotechnia*

of *Vannoccio Biringuccio.* New York: American Institute of Mining and Metallurgical Engineers, 1942.

Taylor, Charles. *A Compendium of Colors and Other Materials Used in the Arts.* London, 1797.

Theobald, Wilhelm. *Technik des Kunsthandwerks im Zehnten Jahrhundert des Theophilus Presbyter Diversarum Artium Schedula.* Berlin, 1933.

Tingry, Pierre François. *The Painter's and Colourman's Complete Guide,* 1st American ed. from the 3rd London ed. Philadelphia, 1831.

Thompson, Jr., Daniel V. *The Craftsman's Handbook.* New Haven, 1933.

———. *Il libro dell' arte.* New Haven, 1932.

Traité de la peinture au pastel. Paris, 1788.

Vasari, Giorgio. *Le vite de' più eccellenti pittori, scultori ed architettori,* ed. Gaetano Milanesi. Florence, 1881.

Notes

CHAPTER 1

1 Holmes, p. 69.
2 Cennino, in Thompson, *The Craftsman's Handbook,* p. 4.
3 De Mayerne, in Berger, IV, 153, 155; Meder, pp. 97 ff.
4 Butler, p. 92.
5 Theophilus, in Theobald, pp. 37, 169.
6 De Mayerne, in Berger, IV, 153–55, 177.
7 Perrot, pp. 8 ff.
8 Constant-Viguier, pp. 66, 198.
9 *Cyclopaedia,* Vol. XXXIX, *s.v.* "Style"; Mitchell, pp. 86, 87.
10 Mr. V. Harley, of Winsor and Newton, Ltd., stated that the earliest entry for these silverpoint kits occurred in their trade catalogue of 1892.
11 Hamerton, pp. 93 ff.
12 Kirstein, pp. 13–22.
13 Cennino, in Thompson, *The Craftsman's Handbook, p. 5.*
14 Meder, pp. 77, 82, 83.
15 Cennino, in Thompson, *The Craftsman's Handbook,* p. 7.
16 De Mayerne, in Berger, IV, 176, 177.
17 Mitchell, p. 86.
18 Meder, pp. 82, 84.
19 Alcerius, in Merrifield, I, 276.
20 Cennino, in Thompson, *The Craftsman's Handbook,* p. 4; Borghini, p. 114; Alcerius, in Merrifield, I, 274 ff.
21 Cennino, in Thompson, *The Craftsman's Handbook,* p. 5; Borghini, p. 114.
22 Alcerius, in Merrifield, I, 278.
23 De Mayerne, in Berger, IV, 153.
24 Dossie, I, 134, 135.
25 Smith and Gnudi, pp. 137, 253.
26 "Liber illuministarum pro fundamentis auri et coloribus ac consimilibus," in Thompson, *The Craftsman's Handbook,* pp. 5, 4, note 1.
27 De Mayerne, in Berger, IV, 153.
28 Dossie, I, 138.
29 *The Laboratory or School of Arts,* p. 181.
30 Cennino, in Thompson, *The Craftsman's Handbook,* p. 11; Alcerius, in Merrifield, I, 276.

31 Meder, p. 89.
32 Cennino, in Thompson, *The Craftsman's Handbook,* pp. 9, 10.
33 Alcerius, in Merrifield, I, 276, 277.
34 "Liber illuministarum pro fundamentis auri et coloribus ac consimilibus," in Thompson, *The Craftsman's Handbook,* pp. 5, 4, note 1.
35 Cennino, in Thompson, *The Craftsman's Handbook,* pp. 6, 7.
36 Dr. B. Francis Kukachka, of the United States Forest Products Laboratory, has indicated that this density of pores makes boxwood one of the finest textured of all woods.
37 Ring, p. 201; Meder, pp. 196, 197.
38 Thompson, *The Craftsman's Handbook,* p. 7; De Mayerne, in Berger, IV, 177.
39 Theophilus, in Theobald, p. 46; Smith and Gnudi, p. 211.
40 De Mayerne, in Berger, IV, 177.
41 Meder, pp. 78, 79; Buchwald, pp. 4, 5. Mitchell (pp. 86, 87) cites formulas for three alloys for these metallic writing "pencils." Arcet's [d'Arcet's]: 5 lead, 3 tin, 8 bismuth; Rose's: 1 lead, 1 tin, 2 bismuth, and sometimes 1/16 mercury; and Carlier's: 10 lead, 30 bismuth, 8 mercury.
42 Smith and Gnudi, pp. 70 ff. The brass of today, although it may frequently have proportions of about two parts copper to one of zinc, will vary in amounts, and it also may include minor portions of tin and lead.
43 *Ibid.,* pp. 299, 300.
44 *Ibid.,* pp. 208, 209.
45 Vasari (Milanesi edition, 1881), VI, 136.
46 Maclehose, p. 213.
47 Cennino, in Thompson, *The Craftsman's Handbook,* pp. 18, 19.
48 Both Cennino and Vasari indicated that white lead was the pigment used for applying these lights on the colored "half-tone" grounds or papers.—Maclehose, p. 213; Thompson, *The Craftsman's Handbook,* pp. 16 ff.
49 Cennino, in Thompson, *The Craftsman's Handbook,* p. 19.
50 "Secrets for Colours," in Merrifield, II, 502.

51 "Book of Master Peter of St. Audemar, on Making Colours," in Merrifield, I, 154; *The Excellency of the Pen and Pencil,* p. 65; Sanderson, p. 55.

CHAPTER 2

1 For chiaroscuro graphic arts Anton Reichel accepts a broader category, and graphics printed with two or more blocks or plates and with inks of various colors are placed in a chiaroscuro classification regardless of their light-dark contrasts.

2 Ludwig, in *Quellenschriften für Kunstgeschichte,* XV, 250 ff.; *Records of Journeys to Venice and the Low Countries by Albrecht Dürer,* pp. 77, 88, 89.

3 Borghini, pp. 115, 116.

CHAPTER 3

1 "Instrumenta scribae calamus et pinna. Ex his enim verba paginis infiguntur; sed calamus arboris est, pinna avis . . .," *Isidori Hispalensis Episcopi Etymologiarum sive Originum,* ed. Lindsay, I, Lib. VI, XIV.

2 Theophilus, in Theobald, p. 106. Although Theophilus was describing the use of a goose feather in an enameling process, he identified it as being the type of quill which, when pointed, was used for writing.

3 Gull and Moscovy duck quills are only moderately satisfactory as pens; duck, pheasant, owl, and domestic turkey quills are even more inferior.

4 "Quills are denominated from the order in which they are fixed in the wing; the second and third quills being best for writing, as they have the largest and roundest barrels."—*Encyclopaedia Perthensis,* XVIII, 568.

5 Buchotte, pp. 15–16.

6 Maintenant on plonge la plume dans toute la longueur du tuyau et pendant quelques instants dans un bain de sable fin chauffée à une température d'environ 50 degrés de Réaumur; puis on la frotte de suite fortement avec un morceau d'étoffe de laine. Elle sorte de cette opération blanche et transparente."—*Dictionnaire des inventions,* p. 426.

"To harden a quill that is soft, thrust the barrel into hot ashes, stirring it till it is soft, then taking it out, press it almost flat upon your knee with the back of a penknife, and afterward reduce it to a roundness with your fingers."—*Encyclopaedia Perthensis,* XVIII, 568. Another method of hardening quills was to dip them into a weak bath of boiling water and alum—*Ibid.*

7 *Dictionnaire des inventions,* p. 426.

8 "Plume Hollandée, terme de Papetier, on appelle plumes hollandées des plumes à écrire, préparées à la maniere d'Hollande, c'est-à-dire dont on a passé le tuyau sous la cendre pour l'affermir, & en faire sortir la graisse."—*Encyclopédie, ou dictionnaire raisonné des sciences, des arts, et des metiers,* XII, 800.

"Pens, *Dutch,* are those made of quills which have been passed through hot ashes, to take off the grosser fat and moisture thereof."—*Cyclopaedia, s.v.* "Pens."

9 Although the drag of a steel pen is a common experience, scoring usually occurs when the artist elects to draw on soft papers. An example of scoring may be seen in Matisse's "A Lady with a Necklace," especially where the pen ran out of ink, leaving the incised line clearly exposed.

10 From Tom Hood's "Whims and Oddities," in Bore, pp. 30–31.

11 Butler, p. 92.

12 Pierre H. J. B. Champion, *Les plus anciens monuments de la typographie parisienne* (Paris, 1904), as quoted in Blum, p. 12.

13 Erasmus to Reuchlin about the Bishop of Rochester: "I observed, that he took a great fancy to those pens from the Nile, of which you gave me three; therefore, if you have any, you could not send him a more acceptable present."—Nichols, II, 373.

14 Of Fialetti: ". . . usava molte volte in vece di penne, alcune canne tagliate." Of Boschini: "Sig. Boschini, che in disegnare in quella forma grande del naturale, con penne grosse e di canna."—Malvasia, I, 312, 313.

15 Hoogstraeten, p. 31.

16 "Dabei gilt das Schilff-Rohr, womit die Bauernhütten gedeckt werden und das überall auf den Schiffs-Zimmerstätten zu bekommen, als besonders geeignet."—*Anweisung zu der Mahler-Kunst und zur Reiss- und Zeichen- wei auch Illuminir-Kunst* (Leipzig, 1745), as quoted by Meder, p. 61.

17 "Mes dessins sont faits avec un roseau, taillé comme serait une plume d'oie. Je compte en faire une série comme cela. C'est un procédé que j'ai déjà cherché en Hollande dans le temps, mais là je n'avais pas d'aussi bons roseaux qu'ici."—*Lettres de Vincent Von Gogh à Émile Bernard,* p. 25. An example of van Gogh's reed drawing is "Tree in a Meadow."

18 Mr. Pierre Matisse was kind enough to inform me of this fact, and also suggested that their interest probably was stimulated by the mention of reed pens in the letters of van Gogh. Examples of reed pen drawings by Matisse include "Madame Manquin" and "Crouching Nude."

19 Mr. George Grosz has informed me that a number of years ago he obtained his reeds from a commercial firm in Germany and that he believes they were imported from Palestine. He has also drawn with bamboo pens and, since coming to the United States, with reeds he has gathered near lakes on Long Island.

20 In addition to those imported reeds mentioned by

Erasmus as coming from the Nile and the reeds of the Near East used by Grosz, the author has found reeds imported from Syria and India very satisfactory for drawing.

21 Chardin, pp. 273–74.

22 For samples of reeds cut near Leiden in the Netherlands I am indebted to Dr. S. J. van Ooststroom of the Rijksherbarium, Leiden.

23 "Roseau A Écrire, (Botan.) C'est une espece de canne qui ne croît que de la hauteur d'un homme, & dont les tiges n'ont que trois ou quatre lignes d'épaisseur, solides d'un noeud à l'autre, c'est-à-dire, remplies d'un bois moelleux & blanchâtre. Les gens du pays taillent les tiges de ces *roseaux pour écrire;* mais les traits qu'ils en forment sont très-grossiers, & n'approchent pas de la beauté des caracteres que nous faisons avec nos plumes."—*Encyclopédie ou dictionnaire raisonné des sciences, des arts, et des metiers,* XIV, 367.

24 A fine pointed, flexible steel pen will produce these darker concentrations of ink along the edges even more distinctly than a quill. Its tendency to incise furrows, when spread under pressure, produces tiny troughs along the boundaries of the line, into which the ink flows. In the case of the quill, it is an action in which the ink is drawn from the center of the stroke to the two paths of the widespread nibs rather than an incising of the paper with parallel furrows.

25 Norgate, p. 85.

26 Sir Roger Pratt, in Gunther, p. 20.

27 James Perry, a bookseller and stationer of Red Lion Square, Holborn, Middlesex County, received patents in 1820, 1830, and 1832, and formed the Perry Co., Ltd., a great name in nineteenth-century pen manufacture. His patent (No. 5933), approved October 11, 1830, was for slit steel pens with apertures.—*British Patent Reports,* Old Series, 1830 (London, 1857). Joseph Gillott, penmaker of Birmingham, whose name some of our contemporary pens still bear, received a patent (No. 6169) in 1831 for pens with curved barrels and thin parallel nibs, the latter to minimize the broadening of the point as it wore down.—*Ibid.,* 1831 (London, 1856).

28 Directions for the cutting of quills were fully and picturesquely described by an early nineteenth-century writing-master. See John Jenkins, *The Art of Writing,* etc., pp. 58–59.

CHAPTER 4

1 See Buchotte, pp. 193–94:
Le pain ou bâton d'encre de la Chine de deux pouces de longueur, sur environ neuf lignes de largeur, & trois d'épaisseur, faite en Hollande ou à Paris, la commune,................... 5 f.

Et la meilleure,........................10
Celle qui est véritablement de la Chine, & de même volume que nous de dire,........................1 liv. 0 f.
Et la plus belle,1 10

2 For presentations of the ingredients, manufacture, and use of ancient black carbon inks, see A. Lucas, *Ancient Egyptian Materials,* and Li Ch'iao-p'ing, *The Chemical Arts of Old China.*

3 "How atramentum of various kinds is made. The method of making ink is as follows for it is necessary, not only for use in painting, but even for every day writing. A vase is put into a hollow chamber; and a furnace is made so as to have nostrils, that is, apertures, through which the smoke can penetrate into the vase. Some tiles must be laid in the furnace, and upon these hot tiles resin must be put, so as to drive all the smoke and soot into the vase. Afterward grind the soot very fine, and you will make a very bright atramentum, with which you must mix painter's size. To accelerate the process, soft charcoal wood, or of peach-stones, ground up with glue is useful. Charred twigs also will imitate the appearance of atramentum; but the blackest twigs must be used. If good wine is poured over them, and glue be added, they will form a colour which will appear to imitate the softness of daylight."—Eraclius, in Merrifield, I, 248.

4 "Nym eyn wachß licht zünd es an und halts under ein sauber becken biß das sich der rũß dran hẽckt gieß dann ein wenig warm gumi wasser darein und temperirs durcheinander so ists auch dinten."—*Artliche kunste mancherley weyse Dinten und aller hand farben zubereyten,* pp. 6–7.

5 De Beau Chesne and Baildon, pages unnumbered.

6 "Inchiostro della China. Una qualità d'inchiostro, non liquido nè corrente, ma solido; composto di nero di fumo, infuso con gomma e risecco in panellini lunghi un dito in circa, ben formati in figura quadrangolare. A' nostri Artefici serve mirabilmente per disegnare figure, e paesetti, i quali appariscono tocchi d'acquerello; l'adoperano in questo modo. Intingono il pennello nell'acqua, e poi con esso sfregano l'inchiostro più o meno, secondo che vogliono, che il tocco o la macchia venga più chiara o più scura."—Baldinucci, p. 75.

7 Browne, pp. 95–96.

8 *The Laboratory or School of Arts,* p. 183.

9 Dossie, I, 142.

10 *Ibid.*

11 1684: "... d'encre de la Chine"—*Les Premiers elemens de la peinture pratique,* p. 13.
1685: "... then take a stick of Indian Ink ... wet one end of it with Water, or rather with your Spittle, which is better ..."—Salmon, addendum

to Lib. I, Chap. II, after Section XVIII, p. 8.
1759: "Les uns emploians avec les traits de la plume un peu de *Lavis* fait avec de l'encre de la Chine"—*L'Ecole de la mignature*, p. 158.
1830: "Encre de Chine. Couleur d'un noir grisâtre et froid. La meilleure tire sur le roux: un de ses traits fait à la plume ne doit point s'effacer quand on le lave avec le pinceau."—Constant-Viguier and de Longueville, p. 256.

12 "L'encre de la Chine est une composition en forme de pains, ou en bâtons de différentes grandeurs & figures, ornés de tous les côtés d'une impression de caracteres & de figures d'animaux du pays, dont la plûpart des caracteres, qui sont en creux, sont remplis d'une feuille d'or. . . . On en contrefait en Hollande & à Paris; mais il s'en faut beaucoup qu'elle soit ni si bonne, ni si belle que celle de la Chine; & parmi celle qui est contrefaite, il y en a qui est fort graveleuse."—Buchotte, pp. 1–2.

13 Meder suggested that in drawings by Canaletto the brown color of the ink in the pen lines was the result of the brownish transformation of iron-gall inks. However, the transparent brown of the ink in the Canaletto drawings at the Fogg Museum, the chipping off of the surface of some of the strokes—a phenomenon often occurring in bistre—and the artful distribution of warm bistre washes in the light areas and cool gray washes in the shadows make it apparent that the Venetian master intentionally combined black carbon and bistre inks.—Meder, p. 63.

14 Meder has not only indicated this preference of the northern masters but has observed, on the other hand, that the black carbon inks were rarely chosen by the draughtsmen of the Italian Renaissance.—Meder, pp. 65, 66.

15 Bromley and Shore, p. 59.

16 MacCurdy, II, 173. As a matter of curiosity, a former student, Mr. Walter Hauboldt, followed the directions of Leonardo. The smudge made by the dry, powdered galls and iron sulphate (vitriol), and the weak lines produced by the pen after being dipped in saliva, demonstrated that it was a technical trick rather than a method of practical value.

17 1685, "common Ink."—Salmon, p. 204. 1755, "l'encre ordinaire."—*Le Moyen de devenir peintre en trois heures*, p. 37. 1788, "l'encre ordinaire."—*Traité de la peinture au pastel*, pp. 177, 178.

18 *Ibid.:* "Quant à l'encre ordinaire, elle est d'un si grand usage, qu'on en trouve partout. Mais elle est presque toujours médiocre"

19 *Artliche kunste mancherley weyse Dinten und aller hand farben zubereyten*, p. 6. Also in the Tübingen edition of 1533, p. 6.

20 "Neotericorum Vulgare Atramentum Scriptorinm

[*sic*] nostro indomate dicitur Inchiostro."—Canepario, p. 262; De Beau Chesne and Baildon, page unnumbered.

21 Recipes in manuals on art from the fifteenth to the eighteenth century proposed variable combinations of the following types of ingredients:
A. Galls; blackthorn bark; mountain ash bark; walnut root bark; alder tree buds; pomegranate rind; aloes.
B. Ferrous sulphate.
C. Water; bog water; rose water; white wine; red wine; vinegar; beer.
D. Gum arabic.
E. Alum; sea salt.

22 Mitchell and Hepworth stated (pp. 92, 93) that either of the old procedures, of exposing the ink to the air or boiling the finished ink, caused the formation of black insoluble oxidized tannate which could not penetrate the paper fibers once it was formed and thus reduced the permanency of the writing.

23 "The acidity of gallotannate writing inks is usually due to sulphuric acid. . . . There is some evidence that the free acid in an iron ink, at any rate when it is sulphuric, can in time effect a certain amount of degradation in the fibre stock of a paper document, although the part played by the iron as an oxygen acceptor and catalyst is itself not entirely above suspicion."—Bromley and Shore, pp. 44–45.

24 The methods of regenerating faded or brown iron-gall inks presented by Mitchell were valuable in civil and criminal investigations of documents, but they were either so temporary or committed such violence on the inks and papers that they have little to recommend them for the restoration of fine drawings. See Mitchell, pp. 78 ff.

25 "Caligo est color, videlicet, materia illa crocea obscura, quam fumus ignis generat sub caminatis sub quibus continue fit ignis decoquendo fercula."—Le Begue, in Merrifield, I, 24. "Fuligo est color niger vel quasi niger, ad croceum tendens, et veniens a camino ignis, aliter dicta caligo, et est etiam fumus candele et lampadis nigerrimus recollectus ad scutellam vel aliud vas ferreum, vel cupreum, vel terreum."—*Ibid.*, p. 27.

26 Lomazzo, p. 192.

27 "Fuliggine ⎫ f. Quella materia nera, che lascia il fumo su pe' cammini. Lat. *Fuligo.*
e⎬ Questa serve a'nostri Artefici, per
Fuligine ⎭ macchiar disegni d' acquerello. . . ."—Baldinucci, p. 61.

28 Hoogstraeten, p. 31; Salmon, pp. 204, 209.

29 Bloch, I, 83; de Mayerne, in Berger, IV, 275.

30 Bistre became the established term by the end of the seventeenth century, and the liquid was so designated in various countries and times, as the vol-

umes below will suggest:

1684.—*Les Premiers elemens de la peinture pratique,* p. 13.

1699.—De Grez, p. 254.

1745.—D'Argenville, p. xvii.

1764.—Dossie, I, 126, 127.

1797.—Taylor, 13.

1830.—Constant-Viguier and de Longueville, p. 30.

1831.—Tingry, p. 107.

31 Taylor, p. 13.

32 *Secrets concernant les arts & metiers,* I, 125.

33 "Prenez de la suye de cheminée, la plus luisante qu'il sera possible, concassez-la, & la faites infuser dans de l'eau, sur la cendre chaude, tant que la liqueur soit assez haute en couleur, & la filtrez, comme nous l'avons dit pour la couleur d'eau.

Lorsqu'on voudra avoir le bistre sec, on le fera sécher dans des coquilles au soleil, ou au four en hyver quand le pain est tiré, en remplissant la coquille à mesure que la liqueur seche; & si c'est au four, il faut prendre garde de laisser brûler cette liqueur. On connoîtra qu'elle sera assez seche, quand elle sera d'une consistance de cire molle, ou de miel, & non comme de la pierre; car alors la gomme du bistre étant trop desséchée, il ne peut pas se détremper.

Nota 1°. Qu'il faut que ces liqueurs soient froides lorsqu'on les filtre; car si elles étoient chaudes, la chaleur ouvrant trop les pores du papier, il passeroit avec la liqueur un fin limon qui ôteroit la beauté de la couleur.

2°. Que si l'on n'avoit pas d'entonnoir de verre, on en feroit un avec un verre commun à boire, de figure conique, & non en culotte de Suisse, en lui ôtant le pied, ensorte qu'il en soit percé; ce qui est aisé à faire, en mettant un gros fil souffré autour de l'endroit le plus étroit du verre, auquel on mettra le feu, & lorsque ce fil sera enflammé tout autour, on trempera le pied du verre dans de l'eau froide jusqu'à l'endroit du fil souffré, où il ne manquera pas de se casser net, comme on le souhaite, ou bien on le fera couper par un Vitrier.

3°. Et qu'enfin il n'est point absolument nécessaire que la suye de cheminée soit luisante, comme nous l'avon dit ci-devant."—Buchotte, pp. 12–13.

34 Taylor, p. 13; Lemoine and du Manoir, p. 255.

35 Dossie, I, 127; Taylor, p. 13; Tingry, p. 107; Lemoine and du Manoir, p. 255.

36 Taylor, p. 13; Lemoine and du Manoir, p. 255.

37 These mat gray spots should not be confused with those grays which resulted when Rembrandt modified or corrected a dark area by brushing semi-opaque white over bistre strokes—a device he used in order to regain a light area in the reorganization of his composition. Such grays may be seen in his "Man Seated on Step" and in Delacroix's Rem-brandtesque drawing of "Hamlet and His Mother."

38 In recent years the preparation of true bistre has been abandoned and Mr. F. W. Weber was kind enough to inform me that the commercial "bistre" of today is a brownish carbon product. True bistre was too slow-drying and fugitive a pigment to be used as an oil color in painting, but its fugitiveness seems to have had little effect in old-master drawings.

39 For a discussion of the complex organic composition of sepia, see Mitchell and Hepworth, pp. 19 ff.

40 Meder, pp. 69, 70.

41 *Encyclopédie ou dictionnaire raisonné des sciences, des arts, et des metiers,* IV, 891; XIV, 892.

42 "On en trouve beaucoup dans la *Méditerranée,* dans la *mer Adriatique,* dans l'*Océan Atlantique* et dans le *canal de la Manche.*

On fait sécher au soleil la vessie de ce poisson, remplie de sa liqueur, et avec un grand nombre de ces vessies, on forme des espèces de grappes qu'on vend aux fabricans de couleurs. . . .

Pour préparer la couleur contenue dans la vessie, on commence par briser un grand nombre de ces vessies, et on met la couleur sèche qu'elles contiennent à tremper dans un vase vernissé rempli d'eau pure et bouillante: on délaie bien cette couleur, et on a soin de la remuer cinq ou six fois, et de la laisser reposer ensuite.

On décante l'eau à quatre reprises différentes, et les sédimens qu'elle laisse servent aux tablettes fines. Le surplus sert pour la couleur de seconde qualité.

Quand les différens sédimens sont bien secs, on le broie chacun à part sur un porphyre, en y mêlant de l'*eau de gomme* arabique avec une légère partie de *sucre candi,* et on la ramasse avec un couteau de corne ou d'ivoire, pour la mettre dans des formes et en faire des *tablettes.*"—Constant-Viguier and de Longueville, p. 261.

Commercial processes of making sepia were discussed by Mitchell and Hepworth, pp. 18–19; and by Church, p. 225.

43 ". . . brun roussâtre"—Constant-Viguier and de Longueville, p. 256; Field, p. 349; Church, p. 226; ". . . brun noirâtre"—Lemoine and du Manoir, p. 256.

44 Constant-Viguier and de Longueville, p. 256.

45 "Quelques fabricans de couleurs y mêlent ou du *bistre,* ou de la terre de *Cassel,* ou de la *laque de garance.*"—Constant-Viguier and de Longueville, p. 261.

46 "Gomme-gutte . . . couleur vegetal d'un jaune doré" (i.e., gamboge).—*Ibid.,* p. 252.

47 Sepia mixed with indigo, Prussian blue, madder lake, lampblack, aureolin, cobalt blue and brown madder, purple madder, French blue, madder red,

yellow ochre, gamboge, raw Sienna, cobalt blue and aureolin, and madder red and burnt Sienna.— Field, pp. 349 ff.

48 If all the brownish tints used for little washes in limning and miniature painting or for the washing of maps were included, the number of browns would be increased by the addition of rather unusual colors: seacole [*sic*], rinds of green walnuts, Spanish brown, licorice, walnut-tree leaves, etc.

49 Hoogstraeten, p. 31.

50 *Encyclopédie ou dictionnaire raisonné des sciences, des arts, et des metiers,* V, 634.

51 Constant-Viguier and de Longueville, p. 258.

52 Meder, pp. 57–60, 71.

53 For a discussion of inks made with aniline dyes and coal tar colors, see Mitchell and Hepworth, Chapter VI.

CHAPTER 5

1 Baldinucci, p. 92.

2 *Encyclopédie ou dictionnaire raisonné des sciences, des arts, et des metiers,* IV, 429.

3 *Traité de la peinture au pastel,* p. 113.

4 Lomet, in *Annales de chimie,* 1st ser., XXX, 284.

5 *Encyclopaedia Perthensis,* V, 204.

6 Germany: (Vasari) Maclehose, pp. 212, 213; Sandrart, p. 62; Baldinucci, p. 92; *Encyclopaedia Perthensis,* V, 204. Italy, Spain, France, Flanders: *Encyclopaedia Perthensis,* V, 204.

7 Meder, pp. 119 ff.

8 Taylor, p. 28.

9 "Archives de l'art français," III-II, 210 ff., in Parker, p. 9.

10 Lomet, in *Annales de chimie,* 1st ser., XXX, 284.

11 I am indebted to Professor Louis Cline for his help in locating satisfactory examples which serve for drawing. At times, when this formation occurs above coal deposits, it receives the designation "roof rock." Just as in the case of natural red chalk and its source among hematites, so, too, all specimens of carbonaceous shale will not provide good natural black chalks because of the lack of proper blendings.

12 *Encyclopédie ou dictionnaire universel,* XXXIII, 554.

13 *Traité de la peinture au pastel,* p. 197.

14 *Encyclopaedia Perthensis,* V, 203; *Grand dictionnaire universel du xix^e siècle,* V, 458.

15 *Cyclopaedia: Or Universal Dictionary of the Arts, Sciences, and Literature,* XXXIII, *s.v.* "Slate"; *A Dictionary of Science, Literature, and Art,* I, 279.

16 "Wir erkennen sie an dem braungrauen oder schwarzgrauen glanzlosen Strich, unter welchem oft deutlich sichtbare, von sandigen Bestandteilen herrührende Kratzer zu bemerken sind"— Meder, p. 110.

17 Buchwald, p. 9.

18 *Nicholson's British Encyclopedia, or Dictionary of Arts and Sciences,* IV, *s.v.* "Drawing."

19 Cennino, in Thompson, *The Craftsman's Handbook,* p. 104.

20 Maclehose, p. 231.

21 "Serve anche a'nostri Artefici per fare i chiari ne' disegni che fanno di matita rossa o nera, su' fogli colorati."—Baldinucci, p. 66.

22 Field (p. 79) described natural white chalk as a native (English) carbonate of lime which was sawed into sticks of convenient length both for drawing and for tracing of designs.

23 D'Argenville, p. xvi.

24 Taylor, p. 33.

25 *Ibid.*

26 Meder (pp. 116, 130) described the drawing by Fra Bartolommeo as having been done with a soft "brown-coal" (*Braunkohle*). The two drawings by Dürer included some brownish strokes which Meder associated with a substance mentioned in Dürer's diary as "stone-coal" (*Steinkohln*). The chalks used by the few eighteenth century French masters were described as "brown-stone" (Braunstein) by Meder, and he considered this substance to be a variety of natural red chalk.

27 All varieties of wad do not possess these attractive features. In the majority of samples these earths are too hard, or too gritty, to be useful as artists' chalks.

28 Meder, p. 136.

29 Lomazzo, pp. 192–93. Malvasia (I, 312) continued this terminology in writing of the methods of Fialetti.

30 Petrus Gregorius, *Syntaxeon Artis Mirabilis,* in Meder, p. 135.

31 In 1760 Müntz wrote (pp. 116–17) that "as few artists compose the crayons themselves," he turned over his own recipes to "Mr. Sandys, colour merchant, in Dirty-Lane, Longacre, of whom perfect sets may be had."

32 Petrus Gregorius, in Meder, p. 135; Norgate, p. 75; Sanderson, p. 78; Browne, p. 92 and Appendix, pp. 26, 30; Baldinucci, p. 119; Dossie, I, 202 ff.; *Secrets concernant les arts et metiers,* I, 139.

33 In our experiments the recipes using plaster of Paris or kaolin had these dry ingredients and the pigments mixed in fixed proportions, with water subsequently added to form a paste of desirable consistency. In the recipes which called for liquid binding media, the pigments were simply mixed with the solutions until a proper paste was formed. See the table, p. 162.

34 Mr. F. W. Weber was kind enough to inform me that gum tragacanth, gum arabic, whiting, china clay, gypsum, starch, and dextrin are ingredients used in various contemporary formulas.

35 Browne, p. 92, and Appendix, pp. 26, 30; Volpato, in Merrifield, II, 752; Hoogstraeten, p. 31; Salmon, p. 80, and sections VIII, IX, XIX, XX; Dossie, I, 199, 200; *Secrets concernant les arts et metiers,* I, 139; Russell, p. 19; *Traité de la peinture au pastel,* pp. 55, 56.

36 Browne, Appendix, p. 30; Dossie, I, 200.

37 Browne, Appendix, p. 30.

38 *Traité de la peinture au pastel,* pp. 330 ff.

39 Leonardo, in Richter, I, 359.

40 Berger, I, 348, 349.

41 Browne, Appendix, p. 30.

42 *Ibid.;* Volpato, in Merrifield, II, 752.

43 Dossie, I, 201, 204; Taylor, p. 108. Meder seems to have been unaware of the soaking of fabricated chalks with fatty substances, although he was familiar with the impregnation of charcoal with oils (*Fettekohle, Ölkohle*).—Meder, pp. 106–9.

44 Olive oil, which has nondrying properties, does not have this limitation of linseed oil. Charcoal sticks, when soaked for several hours in either linseed oil or olive oil, produce black, oily strokes which are indistinguishable from each other. However, within a week, charcoal which has been dipped in linseed oil will become hard and produce unsatisfactory strokes of a gray, uneven character while that impregnated with olive oil remains usable for an indefinite time.

The drying characteristic of linseed oil was recognized by the eighteenth-century author of the *Anweisung zu der Mahler-Kunst,* who recommended the immediate use of oil-impregnated charcoal sticks.—Meder, p. 107.

45 *Annales de chimie et de physique,* 2nd ser., IX, 334–35.

46 Salmon, Addendum after section XVIII, p. 8.

47 Dossie, I, 204. This reference to wax crayons was quite distinct from Dossie's discussion of crayons which were to be used in a form of encaustic painting.

48 *British Patent Reports,* Old Series, 1780–81, No. 1301.

49 Lomet, in *Annales de chimie,* 1st ser., XXX, 284 ff.

50 Hochheimer, sec. III, p. 234.

51 Senefelder, pp. 118–21.

52 To lengthen short bits of chalk, a goose quill served in lieu of a *porte-crayon.* — *The Excellency of the Pen and Pencil,* p. 12.

53 Browne, Appendix, pp. 28–29; De la Tour letter to Mlle de Zuylen, April 14, 1770, in de Goncourt, p. 205.

54 Dossie, I, 196.

CHAPTER 6

1 The introduction of "gum" or "rubber" erasers followed the importation of *caoutchouc* and a recommendation of its usefulness for erasing by the English chemist Joseph Priestly in 1770. This prototype of our modern erasers, variously called "India rubber," *gomme élastique, gomme élastique de Cayenne,* or simply *caoutchouc* first seems to have been mentioned in a manual on art in 1786. Buc'Hoz reported the advantages it possessed over bread crumbs: "Il faut prendre de la résine ou gomme élastique de Cayenne, & en frotter les traits du crayon, ils s'effacent beaucoup mieux qu'avec de la mie de pain. . . ."—Buc'Hoz, III, 160.

Binder	Solution	General characteristics of chalks
Glue	½ oz. to 8 oz. of water	Hard and crusty (outside surface must be scraped before drawing)
	½ oz. to 12 oz. water	Moderately soft, crusty
Gum arabic	¼ oz. to 12 oz. water	Wide range from hard to moderately soft, crusty, difficult to roll
	¼ oz. to 36 oz. water	Soft, easy to roll
Gum tragacanth	¼ oz. to 24 oz. water	Wide range from hard to soft
Milk	Undiluted	Soft, very crusty
	Diluted with equal part of water	Soft, tendency to break
Whey	Undiluted	Moderately soft, very breakable
Beer	Undiluted	Moderately soft, breakable
Beerwort	Undiluted	Soft, very breakable
Oatmeal liquor	Undiluted	Hard to medium hard, firm
Rotten glue	½ oz. to 8 oz. water	Medium hard, breakable
Plaster of Paris	2 to 1 pigment plus water	Very hard, crusty
	1 to 2 pigment plus water	Hard, crusty
	1 to 3 pigment plus water	Moderately soft, crusty
Kaolin	8 to 1 pigment plus water	Very soft, easily breakable

2 Cennino, in Thompson, *The Craftsman's Handbook,* pp. 42–43; Vasari, in Maclehose, p. 213.

3 Vasari, in Maclehose, p. 213; *L'Art sacré,* Nos. 11–12, p. 6.

4 Vasari, in Maclehose, p. 213; Lomazzo, in Haydocke, p. 100; Le Brun, in Merrifield, II, 790; Sanderson, p. 29; Volpato, in Merrifield, II, 752.

5 Cennino, in Thompson, *The Craftsman's Handbook,* p. 19.

6 Borghini, p. 118.

7 Volpato, in Merrifield, II, 752.

8 Gesner observed (II, 104–5) that some called the substance English antimony. Caesalpino (pp. 186–87) referred to the substance variously as molybdenum (or molybdenite?), Flemish stone, and German bismuth.

9 In 1585, describing various blacks for drawing, Lomazzo included *la pietra todescha* which was translated thirteen years later by Richard Haydocke as "black lead," a term which was used (along with plumbago and graphite) for graphite in England from that time through the nineteenth century.—Lomazzo, p. 192; Lomazzo, in Haydocke, p. 100.

Meder's assumption that a statement of Borghini, in 1584, represented the first reference to the use of graphite for artistic purposes in Italy is unacceptable. His misunderstanding of Borghini's remarks with reference to natural red chalk drawings, their relationship to the preceding and following comments on lead-tin and silver styluses respectively, and his apparent unfamiliarity with the behavior of the materials involved led him to believe that Borghini was warning the artist against the use of *graphite* for the preliminary strokes of a red chalk drawing, supposedly because the former "smeared" (macchiato). Rather, it seems that Borghini was indicating that if one used a lead-tin stylus the red chalk lines would be interrupted as they passed over the slick metallic strokes, thereby causing a "spotty" effect, an unpleasant feature which

may be determined by drawing with such a combination of media. Furthermore, Borghini then proceeded to recommend that one sketch the outlines with silverpoint, a stylus which does not leave any of its metal on ungrounded papers but only a series of fine depressions in the surface. It is true that these may cause interruptions in the chalk lines, if they are relatively deep, but they in no way present the disturbing effects resulting from the shining metallic strokes of the lead-tin stylus. Such a drawing procedure, where the silverpoint left no true stroke, undoubtedly explains some of the instances, observable in many old-master drawings produced with natural red chalk, where the lines are thus broken. See Meder, p. 141, and Borghini, p. 115.

10 Pratt, in Gunther, p. 20.

11 Sanderson, p. 29.

12 *The Excellency of the Pen and Pencil,* pp. 11 ff.

13 Pomet, Pt. II, Bk. I, Ch. LXVII, p. 42.

14 *Encyclopédie ou dictionnaire raisonné des sciences, des arts, et des metiers,* IV, 429; Buchotte, p. 19.

15 ". . . comme la pierre de mine fine dont ces crayons sont faits, vient d'Angleterre, lorsque'on est en guerre avec cette nation, ces crayons sont fort chers: en voici donc les prix au plus haut."—Buchotte, pp. 194–95.

16 *Annales de chimie,* 1st ser., XX, 370–81.

17 Our modern systems of grading graphite pencils from soft to hard were established by Conté's designations of Nos. 1, 2, etc., and those of Brookman of London in the early nineteenth century which were identified as BB, B, F, HB, H, and HH.—Constant-Viguier and de Longueville, pp. 221, 229.

18 Buchwald, pp. 9, 19.

19 For a discussion of scientific analyses of old graphite specimens and remains of graphite strokes on documents, see Mitchell, pp. 86 ff.

20 *Lettres de Vincent van Gogh à son frère Théo,* pp. 65, 66.

Index

ACID, gallic: in inks, 71
Acid, tannic, 71
Agate burnisher: for polishing metalpoint grounds, 14
Ale: in fabricated chalks, 112, 113
Ale wort: in fabricated chalks, 112, 116
Aloes: in inks, 71
Altdorfer, Albrecht: chiaroscuro drawing, 36, 38
Alum, 85
Aluminum, hydrous silicate of. *See* Clay, tobacco-pipe; Clay, porcelain; Clay, china; Kaolin
Amatita della rossa, 94. *See also* Chalk, natural red
Ampelite. *See* Chalk, natural black
Ampélite. See Chalk, natural black
Ampelitis. See Chalk, natural black
Anonymous Franco-Flemish artist: metalpoint drawing, 16
Antimony: in graphite pencils, 142
Aulmont: use of soapy water in fabricated chalks, 118
Azure: in colored ink, 84

BAILDON, M. John. *See* De Beau Chesne
Balbus, Johannus: metalpoint, 4; quill pen, 4; reed pen, 4, 54
Baldinucci, Filippo: black carbon ink, 68; bistre ink, 74; natural red chalk, 94
Baldung, Hans: diagrams of metalpoint styluses, 11; chiaroscuro drawing, 38
Bamboo. *See* Reed
Bark, of trees: in inks, 71
Bartolommeo, Fra: natural chalk drawings, 110
Beckwith, Thomas: fatty crayons, 119
Beer: in fabricated chalks, 112, 113
Beeswax: in crayons, 118, 120; charcoal soaked in, 119; in graphite pencils, 142
Bentonite: in fabricated chalks, 124, 125
Bile: in colored ink, 85
Biringuccio, Vannoccio: description of Renaissance metals and alloys, 17, 18
Blackberries: in colored ink, 85
Bleigriffel. See Metallic "pencil"
Bleistift. See Metalpoint
Bloodwort berries: in colored ink, 85
Boards: as carriers for fabricated chalk drawing, 116
Boccaccio, Giovanni: metalpoint drawing, 4
Boltraffio, Giovanni Antonio: fabricated chalk drawing, 112

Bone: sheets for writing, 8
Bone, Muirhead: metalpoint drawing, 8
Bone dust: ingredient in metalpoint grounds, 4, 13, 14, 15, 16; ingredient in molds for casting bronze, 13; as white pigment for modeling lights in metalpoint drawings, 32
Bones, carbonized: for making black carbon ink, 67
Bones, of fowl, lamb, horse, stag, stag-horn, swine, sheep, goats' horn, donkey, mule. *See* Bone dust
Borax: and rosin in ink, 69
Borghini, Raffaello: description of chiaroscuro drawing, 36; on preparing charcoal, 132
Boschini, Marco: reed pen drawing, 56
Botticelli, Sandro: metalpoint drawing, 6
Bouchardon, Edme: natural chalk drawing, 98
Boucher, François: natural chalk drawing, 110
Boxwood: as carrier for metalpoint grounds, 12, 16, 28, 29; density of pores, 156, *n36*
Brass, 156, *n42*
Brasspoint, 10, 12, 13
Brass powder or filings, 84
Brazil wood: in ink, 72, 84, 85
Bread, burnt: in black carbon ink, 68
Bread crumbs: as an eraser, 130
Bronzepoint, 10
Brookman: graphite pencils, 142
Browne, Alexander: black carbon ink, 68; soaking chalks with olive oil, 118; colored papers for chalk drawing, 124
Browning, Robert: on silverpoint drawing, 8
Brush: for chiaroscuro drawing, 38, 42
Buchotte, M.: quill pens, 48; ink, 67; recipe for making bistre ink, 74, 76; graphite, 142
Buckthorn berries: in colored ink, 84, 85
Buds, of trees: in ink, 71
Burgkmair, Hans (the Elder): charcoal drawing, 132

CADMIUM red, 125
Cadmium yellow, 125
Cadmus, Paul: silverpoint drawing, 10
Caesalpino, Andrea: graphite, 138
Calcite, 108; as ingredient in metalpoint grounds, 13, 14
Calcite, chalk variety, 106
Calcium carbonate, 13. *See also* Calcite; Whiting
Calcium phosphate, 13

Caligine. See Ink, bistre
Caligo. See Ink, bistre
Cambiaso, Luca: ink drawing, 73
Campeachy. *See* Logwood
Canaletto (Antonio Canale): pen and ink drawing, 68
Cane. *See* Reed
Canepario, Pietro Maria: iron-gall ink, 70
Carbon: in natural black chalk, 100
Carbonaceous shale, 100. *See also* Chalk, natural black
Carbonate of calcium, 106. *See also* Calcite, chalk variety
Carbon black: as pigment for chiaroscuro drawing, 38
Carmine. *See* Cochineal
Carrier: for metalpoint grounds, 12, 13, 15, 16, 28, 29; for grounds for chiaroscuro drawings, 40; for fabricated chalks, 116. *See also* Linen; Parchment; Paper; Vellum; Wood
Casein paint, 30; white, 33; for tinting papers, 124
Cassel earth, 82, 83
Cennini, Cennino: metalpoint booklets, 3; bone dust in metalpoint ground, 4; white lead in metalpoint ground, 4; description of lead-tinpoint, 11; description of metalpoint grounds, 15; natural white chalk, 108; charcoal, 130, 131; preparing charcoal, 132
Ceruse, 124. *See also* White lead
Chalk: as ground for metalpoint, 4; strokes compared with those of metalpoints, 24; as white pigment for modeling lights in metalpoint drawing, 32
Chalk, fabricated: historical references to, 112–16; characteristics of, 112, 113, 116; binding media for, 112, 113, 114, 124, 125, 126; firing of, 116; carriers for, 116
Chalk, fabricated black: contrasted with charcoal, 136
Chalk, natural: nature of, 91, 92
Chalk, natural black, 100–106; characteristics of, 104, 106; historical references to sources of, 100, 104; decline in use of, 106
Chalk, natural brown, 110
Chalk, natural gray, 110, 112
Chalk, natural red, 92–100; used to transfer drawings, 6; bistre ink mixed with dust of, 83; characteristics of, 94, 95; wetting to produce accents, 96; variations in hue, 96; effects of rubbing, 96; decline in use of, 98
Chalk, natural red-brown, 110
Chalk, natural white, 106–10; characteristics of, 108, 110
Chalk, tailor's, *See* Soapstone; Chalk, natural white
Charcoal: used to transfer drawings, 6; strokes compared with those of metalpoints, 24; for sketching, 31; in black carbon ink, 67; physical characteristics, 130, 136; for preliminary designs, 130, 132; preparation of, 132, 136; commercially prepared, 138
Charcoal dust: used to transfer drawings, 8
Chardin, Sir John: reed pens, 58
Cherries: in colored ink, 85

Chiaroscuro drawing: removal of drawing from ground, 43; ink used for, 69
Chicory: in colored ink, 83
Chinese ink, 42, 66, 67, 69, 70, 83, 86. *See also* India ink; Ink, black carbon
Christus, Petrus: metalpoint drawing, 6
Clay: in natural chalks, 92; in natural black chalk, 100
Clay, ball, 125
Clay, brick, 110
Clay, China: in fabricated chalks, 116. *See also* Kaolin
Clay, inert: in fabricated chalks, 91
Clay, porcelain: in fabricated chalks, 116. *See also* Kaolin
Clay, tobacco-pipe: in fabricated chalks, 114, 116. *See also* Kaolin
Cloth: as carrier for metalpoint ground, 12
Cloth, damp: used for polishing metalpoint grounds, 29, 30; used for burnishing grounds for chiaroscuro drawing, 42; used for removal of chiaroscuro drawing, 43
Clouet, François: natural chalk drawing, 94, 96
Cochineal: in colored ink, 85
Cologne earth, 82, 83
Colors, coal tar, 86
Colors, provisional: in inks, 72
Constant-Viguier, S. F., and F. P. Langlois de Longueville: recipe for sepia ink, 80; mixture of black carbon ink and carmine, 83
Conté, Nicolas-Jacques: development of graphite pencils, 142
Conté crayon, 98, 128
Copperas, 70, 71. *See also* Ferrous sulphate
Copper carbonte, 20
Copperpoint, 8, 10, 12
Copper sulphate, 87
Corot, Camille: ink drawing, 73
Cranach, Lucas (the Elder): metalpoint drawing, 6
Crayon: binding media for, 118; historical references to, 118, 119, 120
Crayon, black, 106
Crayon, lithographic, 122
Crayon rouge, 94. *See also* Chalk, natural red
Currant berries: in colored ink, 85
Cuttlefish: source of sepia, 78, 79
Cuyp, Aelbert: graphite drawing, 144

DALIWE, Jacques: metalpoint drawing, 16
D'Argenville, Antoine-Joseph Dezallier: natural white chalk, 108
David, Gerard: metalpoint drawing, 6
De Beau Chesne, John, and Baildon, M. John: iron-gall inks, 70
Degas, Edgar: chiaroscuro drawing, 38; fabricated chalk drawing, 114; charcoal drawing, 136; graphite drawing, 144, 145
Delacroix, Eugène: graphite drawing, 144

De Mayerne: metalpoint booklets, 3

Desmarest: chalks and crayons, 120

Dix, Otto: silverpoint drawing, 10

Dossie, Robert: black carbon ink, 68; soaking chalks in linseed oil, 118; wax crayons, 119; differences in same kinds of pigments, 124

Dry colors. *See* Dry pigments

Dry pigments, 112; in metalpoint grounds, 13, 15, 16, 22, 29; in chiaroscuro grounds, 40, 42; in fabricated chalks, 113

Dürer, Albrecht: metalpoint drawing, 6; possible reference to chiaroscuro drawing, 36; chiaroscuro drawing, 36, 38; quill pen drawing, 50; natural chalk drawing, 110

Dyes: in inks, 66, 86

Dyes, aniline, 85; in inks, 72

EARTHS, colored: used for natural chalks, 91

Egg, yolk of: in mixture for tinting papers, 124

Eggshell, pulverized: ingredient in metalpoint grounds, 13, 14; as white pigment for modeling lights in metalpoint drawings, 32

Eisler (ink maker), 67, 70; iron-gall recipe, 87

Elderberries: in colored ink, 85

Eraclius: black carbon ink, 67

Eraser, "gum," 130

Erasmus of Rotterdam: reed pen, 54

FEATHER: as an eraser, 130

Fernambouc. See Brazil wood

Ferrous sulphate, 87; in ink, 71, 73

Fialetti, Odoardo: reed pen drawing, 56

Fichet, Guillaume: red and quill pens, 54

Fig milk: in fabricated chalks, 112

Fig wood: as carrier for metalpoint grounds, 12, 16

Flamma, French. *See* Gladiola

Fragonard, Jean-Honoré: wash drawing, 82; crayon drawing, 122

Franco, G. B.: quill pen drawing, 50

French berries: in colored ink, 85

Fruit stones, carbonized: in black carbon ink, 67

Fuliggine (and *fuligine*). *See* Ink, bistre

Fuligo. See Ink, bistre

GAINSBOROUGH, Thomas: graphite drawing, 144

Gall, fish: in colored ink, 84

Gall, ox: in colored ink, 84

Gall apples. *See* Gall nuts

Gall nuts: in ink, 71, 87, 70, 73

Galls. *See* Gall nuts

Gall stones: in colored ink, 85

Gamboge: in colored ink, 84, 85

Gellée, Claude: wash drawing, 82

Gericault, Théodore: chiaroscuro drawing, 38; wash drawing, 83

Gesner, Conrad: on graphite, 138

Gesso, 108

Giotto: metalpoint drawing, 4

Gladiola, juice of: in colored ink, 84

Glove leather. *See* Glue

Glue, 30, 42, 43; in metalpoint grounds, 15, 29; in ink, 68; in fabricated chalks, 112, 113

Glue, gelatin: ingredient in grounds for chiaroscuro drawings, 40

Glue, rabbit skin: ingredient in metalpoint grounds, 29, 30; in ink, 86

Glue water. *See* Glue

Gogh, Vincent van: reed pen drawing, 56; ink drawing, 73; graphite drawing, 145

Goldpoint, 8, 10, 13

Gouache paint, 30; white, as medium for modeling lights in drawings, 33, 42; for tinting papers, 124

Graphite, 10, 16, 42, 91; used to transfer drawings, 6; for miniature drawings, 8; strokes compared with those of metalpoint, 24; historical references to, 138, 142; characteristics of strokes, 142, 144; development of modern pencils, 142; characteristics of, 145

Graphite pencil. *See* Graphite

Gregorius, Petrus: fabricated chalks, 112

Greuze, Jean-Baptiste: natural chalk drawing, 110; crayon drawing, 122

Grisaille painting: as similar to chiaroscuro drawing, 34

Grosz, George: reed pen drawing, 56

Ground: for metalpoint writing, 3; for miniatures and metalpoint, 6; gesso for painting, 12; for metalpoint drawing, 12, 13, 14, 16; colored, for metalpoint drawing, 15, 29; preparation of for metalpoint drawing, 28, 29, 30; for chiaroscuro drawing, 36, 40, 42

Grünewald, Mathias: with reference to pen drawing, 44

Guercino (Giovanni Francesco Barbieri): quill pen drawing, 50; natural red chalk drawing, 96

Gum. *See* Gum arabic

Gum, apple, 32

Gum, cherry, 15, 32

Gum, plum, 15, 32

Gum acacia. *See* Gum arabic

Gum arabic: ingredient in metalpoint ground, 15; as binding medium of general use, 30, 32, 33, 38, 42, 43; in inks, 67, 68, 69, 70, 71, 76, 78, 80, 88; mixed with natural white chalk, 108; in fabricated chalks, 112, 113, 124, 126; in mixture for tinting papers, 124

Gum arabic "tears," 32

Gums: in graphite pencils, 142

Gum tragacanth: in fabricated chalks, 112, 114, 124, 126

Gypsum: as white pigment for modeling lights in metalpoint drawing, 32

Gypsum, calcined. *See* Plaster of Paris

HARDMUTH: graphite pencils, 142
Hare's foot: for brushing excess bone dust from metal-point ground, 16
Haydocke, Richard: graphite, 138
Hematite, 93, 94. *See also* Chalk, natural red
Hematite, red ochre variety of, 93. *See also* Chalk, natural red
Hochheimer, C. F. A.: crayons, 120
Holbein, Hans (the Younger): portrait of Erasmus, 54; natural chalk drawing, 106
Honey: in fabricated chalks, 112, 124, 126
Hoogstraeten, Samuel van: reed pens, 56; bistre ink, 74; mixing bistre with natural red chalk dust, 83
Horse-beans: carbonized for making black carbon ink, 68

IMPRIMATURA, 108
India ink, 68, 69. *See also* Chinese ink; Ink, black carbon
Indian ink, *See* India ink
Indigo: as provisional color in ink, 72; in colored ink, 84, 85
Ingres, Jean Auguste Dominique: graphite drawing, 122, 144; crayon drawing, 122
Ink: diluted as wash, 31; general characteristics of, 66; acidity in, 73
Ink, bistre: 66, 68, 69; in contrast to iron-gall inks, 73; historical references to, 74; as a wash, 74; made from soot of various woods, 76; texture, 78; coloration, 78; recipe for, 87, 88
Ink, black carbon: 85; for modeling darks in chiaroscuro drawings, 42; antiquity of, 67; ingredients of, 67; mixed with other colors, 83. *See also* Chinese ink, India ink
Ink, Chinese. *See* Chinese ink
Ink, colored: for tinting papers, 124
Ink, "common." *See* Ink, iron-gall
Ink, iron-gall: 66, 67, 69; change in coloration, 68; as writing ink, 69, 70; coloration of, 71, 72
Ink, sepia: 66, 88; source of, 78; misuse of term, 80; recipe for making, 80; mixed with other colors, 80, 82, 83
Ink, waterproof drafting, 66, 86
Iris, juice of blue: in colored ink, 84
Iris, petals of blue: in colored ink, 85
Iron oxide: in ink drawings, 73; in natural red chalk, 93, 94. *See also* Chalk, natural red
Isadore of Seville. *See* St. Isadore
Isinglass: in ink, 68
Ivory: metalpoint drawing on, 4, 16; as carrier for miniatures, 8; sheets for writing, 8
Ivory, carbonized: for making black carbon ink, 67
Ivory black dry color: for modeling darks in chiaroscuro drawings, 42; in inks, 68
Ivory black watercolor: for modeling darks in chiaroscuro drawings, 42

Ivy sap: in colored ink, 84

JORDAENS, Jacob: drawing with mixed media, 83; natural chalk drawing, 98

KAOLIN: in fabricated chalks, 116, 125
Kranach, Hans: diagrams of metalpoint styluses, 11, 12

LAMP black, 86; in ink, 68; in graphite pencils, 106, 142
Lapis rosso, 94. *See also* Chalk, natural red
Lead-bismuthpoint, 10, 13
Lead carbonate, 20
"Lead" pencils. *See* Graphite
Leadpoint, 4, 8, 10, 13; for ruling manuscript pages, 3; as described by Retermond, 11
Lead-tinpoint, 10, 13; as described by Cennino Cennini, 11
Le Begue, Jehan: bistre-like substances, 74
Legros, Alphonse: metalpoint drawing, 8
Leighton, Sir Frederick: metalpoint drawing, 8
Leonardo da Vinci: metalpoint drawing, 6; possible reference to chiaroscuro drawing, 38; iron-gall ink, 70; natural red chalk studies, 94; crayon, 118
Leu, Hans (the Younger): chiaroscuro drawing, 38
Lewis (inkmaker), 70
Licorice, Spanish: in ink, 68
Linen: as carrier for metalpoint ground, 13; as carrier for fabricated chalk drawing, 116
Linseed oil: ingredient in metalpoint ground, 12, 15, 30; in chalks and charcoal, 118
Lippi, Filippino: metalpoint drawing, 14
Litharge: in colored ink, 84
Lithographic crayons, 120
Litmus: in colored ink, 85
Logwood: as provisional color in ink, 72; in colored ink, 85
Lomazzo, G. P.: bistre ink, 74; fabricated chalks, 112
Lomet, A. F.: experiments on a substitute for natural red chalk, 98; chalks and crayons, 119, 120
Luini, Bernadino: natural chalk drawing, 112

MABUSE: painting illustrating metalpoint stylus, 12
Madder: in colored ink, 85
Magnesium, hydrous silicate of, 106, 108
Malvasia, Carlo Cesare: reed pens, 56
Marquet, Albert: reed pen drawing, 56
Mars brown, 82, 83
Martini, Simone: metalpoint drawing, 4
Masonite: as carrier for metalpoint grounds, 28
Matisse, Henri: reed pen drawing, 56; charcoal drawing, 132
Matita rossa, 94. *See also* Chalk, natural red
Meder, Joseph: metalpoint booklets, 3; description of metalpoints, 12

Menzel, Adolph von: graphite drawing, 145

Metallic "pencil," 11, 17; Arcet's, Carlier's, and Rose's formulas for, 156, *n41. See also* Metalpoint

Metalpoint, 42, 91, 138; for writing, 4; construction of, 11, 12, 25, 26, 28

Metalpoint booklets, 3, 16

Metalpoint drawing: characteristics of, 22, 23; scale of, 24

Metalpoint ground: for miniatures, 4

Metalpoint strokes: change in coloration, 10; coloration of, 18, 20, 21, 22; transparency of, 21, 22; light-dark value range, 23, 24; flexibility in, 24; textural substance, 24; strength reduced by dark grounds, 31

Metalpoint writing: on ivory sheets, 4

Metals: characteristics of, as metalpoints, 16, 17; color and color changes, 18, 20

Metal wire: for making a metalpoint stylus, 25

Methylcellulose: in fabricated chalks, 114, 124, 125, 126

Milk: in fabricated chalks, 112, 113

Miniatures: metalpoint drawing in, 4, 6, 8; graphite drawing in, 8; on ivory, 8; on parchment, 8

Moore, Henry: chiaroscuro drawing, 36, 38; crayon drawing, 122

Moss, archal: in colored ink, 85

Mulberries: in colored ink, 85

NECKAM, Alexander: medieval leadpoint, 3

Nightshade, juice of leaves: in colored ink, 84, 85

Norgate, Edward: silver pen, 60

OAK-APPLE. *See* Gall nuts

Oatmeal (liquor): in fabricated chalks, 112

Ochre, brown: as wash, 83

Ochre, burnt: as wash, 83

Oils: for making black carbon ink, 67; in crayons, 119. *See also* Linseed oil; Olive oil

Olive oil: for soaking chalks and charcoal, 118

Orpiment: in colored ink, 84

PANNINI, Giovanni Paolo: wash drawing, 82

Paper: as carrier for metalpoint grounds, 10, 28, 29; for chiaroscuro drawings, 40; as carrier for fabricated chalk drawing, 116; for chalk drawing, 124

Papier plâtre. See Ivory; Parchment

Parchment: for manuscript pages, 3, 16; carrier for miniatures, 6, 8; carrier for metalpoint grounds, 10, 12, 16, 28, 29

Parchment clippings. *See* Glue

Parsley, juice of: in colored ink, 84

Pastels. *See* Chalk, fabricated

Pecham, Georg: Pen and wash drawing, 83

Pen, brass, 59, 60

Pen, bronze, 59

Pen, gold alloy, 59

Pen, metal: development of, 59

Pen, quill: for chiaroscuro drawing, 38, 42; for letter-ing and designs in manuscripts, 44; membrane of, 48; most desirable for making pens, 48; hardening of the barrel, 48, 49, 62; characteristics of, 49, 50; structure of, 50; nature of strokes, 50, 52; in contrast to reed pen, 58, 59; plated with metal, 59; removal of vane, 62; removal of membrane, 62; cutting, 63, 64

Pen, reed: antiquity of, 52, 54; as writing instrument, 52, 54, 56; characteristics of, 58, 59; cutting of, 58, 65. *See also* Reed Pen silver, 59

Pen, steel, 42; unsuited for drawing on old papers, 52; in contrast to reed pen, 58, 59; development of, 60; structure of, 60; nature of strokes, 60, 61

Pencil, lead. *See* Graphite

Pencils, "black lead," 138. *See also* Graphite

Perlin, Bernard: silverpoint drawing, 10

Perry, James: development of steel pen, 60

Perugino, Pietro: metalpoint drawing, 14; natural black chalk drawing, 106

Petrarch: on metalpoint drawing, 4

Phytolacca berries: in colored ink, 85

Picasso, Pablo: crayon drawing, 122

Pietra rossa, 94. *See also* Chalk, natural red

Plaster of Paris: in fabricated chalks, 112, 113, 114, 118, 125

Pomegranate berry: rind of, in ink, 71

Pomet, Pierre: on graphite, 142

Poussin, Nicholas: wash drawing, 82

Pratt, Sir Roger: quill pen, 60; brass pen, 60; graphite, 138

Prussian blue: in colored ink, 85

Pumice: used on carriers for fabricated chalk drawings, 116

QUICKSILVER, 84

RAFFET, Auguste: wash drawing, 83; pen and ink drawing, 83

Raphael: quill pen drawing, 50

Raspberries: in colored ink, 85

Raw umber, 125

Reed: in making of metalpoint stylus, 28; habitat and characteristics, 56, 58

Rembrandt: metalpoint drawing, 6; quill pen drawing, 50; reed pen drawing, 58; ink drawing, 69, 78; natural chalk drawing, 96

Reni, Guido: charcoal drawing, 132

Resin: for making black carbon ink, 67

Resin, melted: charcoal soaked in, 119

Retermond: description of leadpoint, 11

Ribaucourt (ink maker), 67, 70; iron-gall ink recipe, 86

Richter, Ludwig: graphite drawing, 145

Robert, Hubert: natural chalk drawing, 110

Rötel, 94. *See also* Chalk, natural red

Romney, George: ink drawing, 78; graphite drawing, 144

Root Krijt, 94, *See also* Chalk, natural red
Rosa Salvator: ink drawing, 78
Rosin: and borax in inks, 69; in graphite pencils, 142
Rubens, Peter Paul: with reference to pen drawing, 44
Rue, juice of: in colored ink, 84

SAFFRON: in colored ink, 84
Saftfarben (sap color); in colored ink, 85
St. Isadore: quill pens, 44
Sal ammoniac, 84
Saliva: ingredient in metalpoint grounds, 15; in an ink described by Leonardo, 70
"Sallet Oyl." *See* Olive oil
Salmon, William: bistre ink, 74
Salt: in colored ink, 84
Sanderson, William: graphite, 138
Sanguine, 94. *See also* Chalk, natural red
Sarto, Andrea del: natural black chalk drawing, 104
Schoornsteenroet. See Ink, bistre
Sea shell: scrapings as ingredients in metalpoint grounds, 13; as white pigment for modeling lights for metalpoint drawings, 32
Seeds, carbonized: for making black carbon ink, 67
Senefelder, Alois: crayons, 120
Sepia. *See* Ink, sepia
Sepia, "Roman," 82
Sepia, "Warm," 82
Shellac: in making of metalpoint stylus, 26; in ink, 69; in crayon, 120; in graphite pencil, 142
Silverpoint, 8, 10, 12, 13, 31; for writing, 3; misuse of term, 22
Silverpoint kits, 8
Silver sulphide, 20
Sindone. *See* Linen
Size (glue water). *See* Glue
Soap: in chalks and charcoal, 118; in crayons, 120
Soapstone, 106, 108
Sodium benzoate solution: as preservative for binding media, 33, 88
Soot, candle: for making carbon inks, 67. *See also* Lampblack
Soot, wood, 74, 76, 87. *See also* Ink, bistre
Spermaceti: in crayons, 120; in graphite pencils, 142
Sponge: for applying tints over papers, 124
Squid: source of sepia, 78
Starch: in fabricated chalks, 112, 124, 126
Steatite, 106, 108
Steel wool: for polishing metalpoint grounds, 25, 29, 30; for polishing tip of metalpoint stylus, 26
Strang, William: metalpoint drawing, 8
Stump: of paper or leather for smudging strokes, 113, 145
Sugar candy: in sepia ink, 80; in fabricated chalks, 112
Swammerdam, Jan: Chinese ink, 80

TAFFETA: as carrier for fabricated chalk drawing, 116

Talc, 106, 108
Tallow: in crayons, 120
Taylor, Charles: natural red chalk, 98; natural white chalk, 108; soaking chalks in linseed oil, 118
Tchelitchew, Pavel: silverpoint drawing, 10
Tempera paint, white, 33, 42
Teniers, David: graphite drawing, 144
Terra Japonica: as wash, 83
Terre Verte, 125
Theophilus: metalpoint, 4; use of chalk as ground for metalpoint, 4; metalpoint drawing on ivory, 4; preparation of ivory for metalpoint drawing, 16; quill pen, 44
Tiepolo, G. B.: ink drawing, 78; graphite drawing, 144
Tinpoint, 4, 10
Tin salts, 20
Titanium white: as ingredient in metalpoint grounds, 13, 14, 29, 30; for modeling lights in metalpoint drawings, 33; for modeling lights in chiaroscuro drawings, 42
Tobacco-pipe clay: in fabricated chalks, 118. *See also* Kaolin
Tooth, of a boar: for polishing metalpoint grounds, 14
Tormentil root: in colored ink, 85
Toulouse-Lautrec, Henri de: crayon drawing, 122
Tour, Quentin de la: tinting papers for chalk drawing, 124
Tumeric root: in colored ink, 85
Turnsole: in colored ink, 84
Twigs, carbonized: for making black carbon inks, 67

ULTRAMARINE blue, 84
Underpainting: as similar to chiaroscuro drawing, 34
Urine: in ink, 74; in colored ink, 85

VANDYKE brown, 82, 83
Vasari, Georgio: natural red chalk, 94; natural white chalk, 108; charcoal, 132
Vellum: for manuscript pages, 3, 16; carrier for metalpoint ground, 12, 16, 28, 29; carrier for fabricated chalk drawing, 116
Venetian red, 124
Verdigris: in colored ink, 84, 85
Vermilion: in colored ink, 85
Veronese, Paolo: chiaroscuro drawing, 38
Vine: for charcoal, 132
Vinegar: for soaking eggshells in making bone dust, 13; in ink, 67, 70; in colored ink, 84
Vitriol. *See* Ferrous sulphate
Vitriol, Roman: in ink, 71
Volpato: preparing charcoal, 136

WAD, 110
Wash: of black carbon ink, 68, 69; of sepia ink, 78, 88. *See also* Ink
Watercolor: white, in tubes, 33; black, similar to black

Watercolor (*cont.*):
carbon ink, 69; ivory black, 86; for tinting papers, 124
Watteau, Antoine: with reference to pen drawing, 44; natural and fabricated chalk drawing, 96; on quality of natural red chalk, 98; natural chalk drawing, 110; graphite drawing, 144
Wax. *See* Beeswax, Spermaceti
Weyden, Roger van der: pictorial illustration of an old metalpoint, 12
Whey: in fabricated chalks, 112, 113
White lead: in metalpoint grounds, 3, 4, 13, 14; for modeling lights in metalpoint drawing, 31, 32; for modeling lights in chiaroscuro drawing, 38; in fabricated chalk, 114
Whiting, 108; in fabricated chalk, 114
Whortleberries: in colored ink, 84
Wine: in ink, 70, 74; in colored ink, 84
Wire: iron or copper used in preparing charcoal, 132

Wood: as carrier for metalpoint ground, 12, 16, 28, 29; for making black carbon ink, 67; for charcoal, 132, 136
Wool, carbonized: for making black carbon ink, 67
Wool, felt: on carrier for fabricated chalk drawing, 116
Wool dust: on carrier for fabricated chalk drawings, 116

YELLOW berries: in colored ink, 84
Yellow ochre, 124

ZEDOARY root: in colored ink, 85
Zephiran chloride solution: as preservative for binding media, 33
Zinc white: ingredient in metalpoint ground, 13, 14, 29, 30; for modeling lights in metalpoint drawing, 33; for modeling lights in chiaroscuro drawing, 42

This book was designed by William Nicoll, of Edit, Inc., Chicago. The type face is Fotosetter Garamond. Phototypography was done by Westcott & Thomson, Inc., Philadelphia. Photography and offset printing was done at the Meriden Gravure Co., Meriden, Connecticut, under the supervision of Harold Hugo. Binding was done by the J. F. Tapley Company, Long Island City, New York.